STAGING THE SUPERNATURAL

Ghosts and the Theater in Japanese Prints

Kit Brooks and Frank Feltens

Freer Gallery of Art and Arthur M. Sackler Gallery
National Museum of Asian Art
Smithsonian Institution, Washington, DC

Distributed by Smithsonian Books

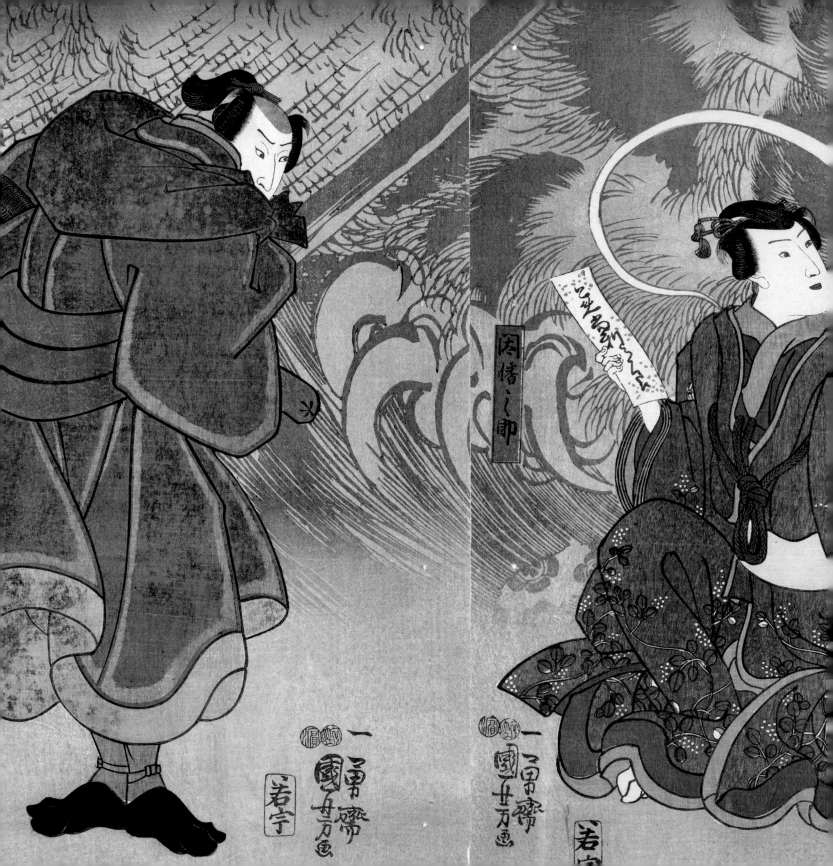# 肉惜之助

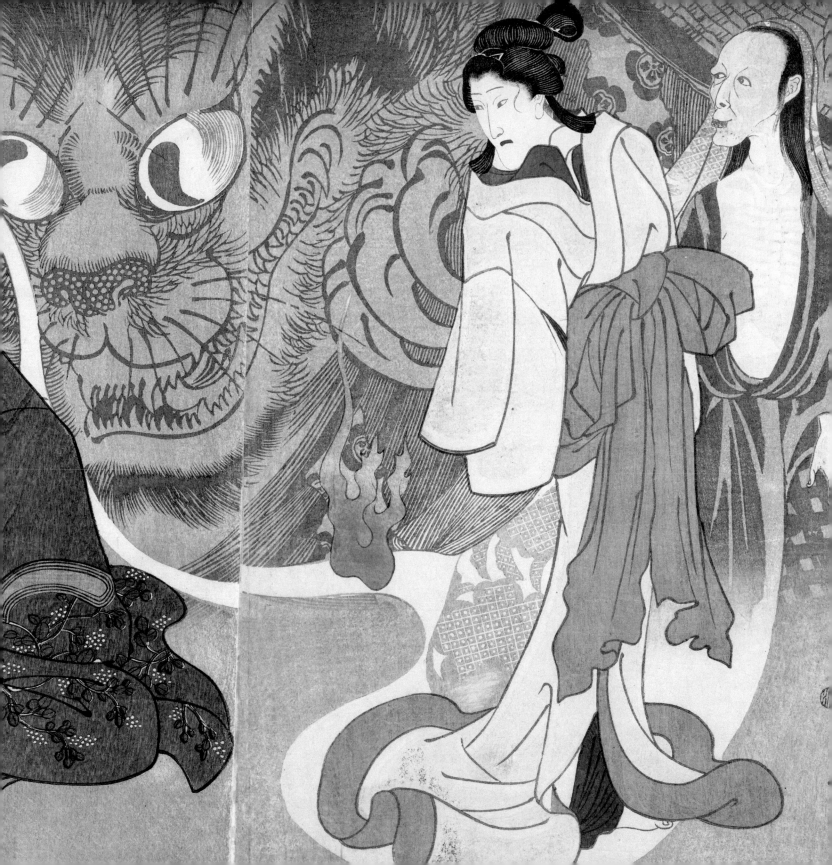

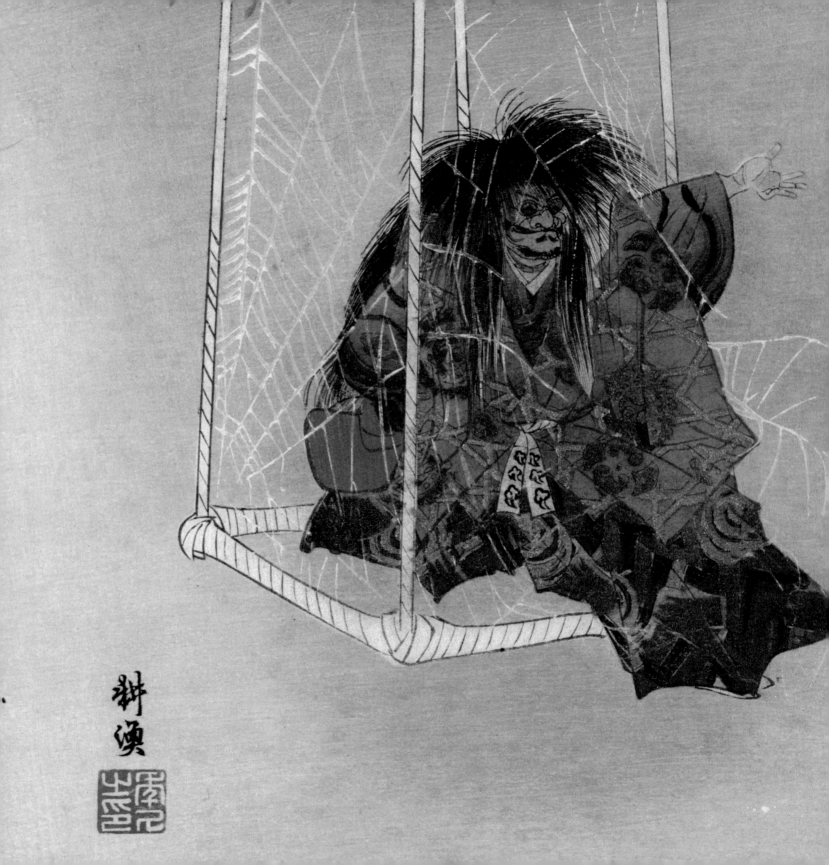

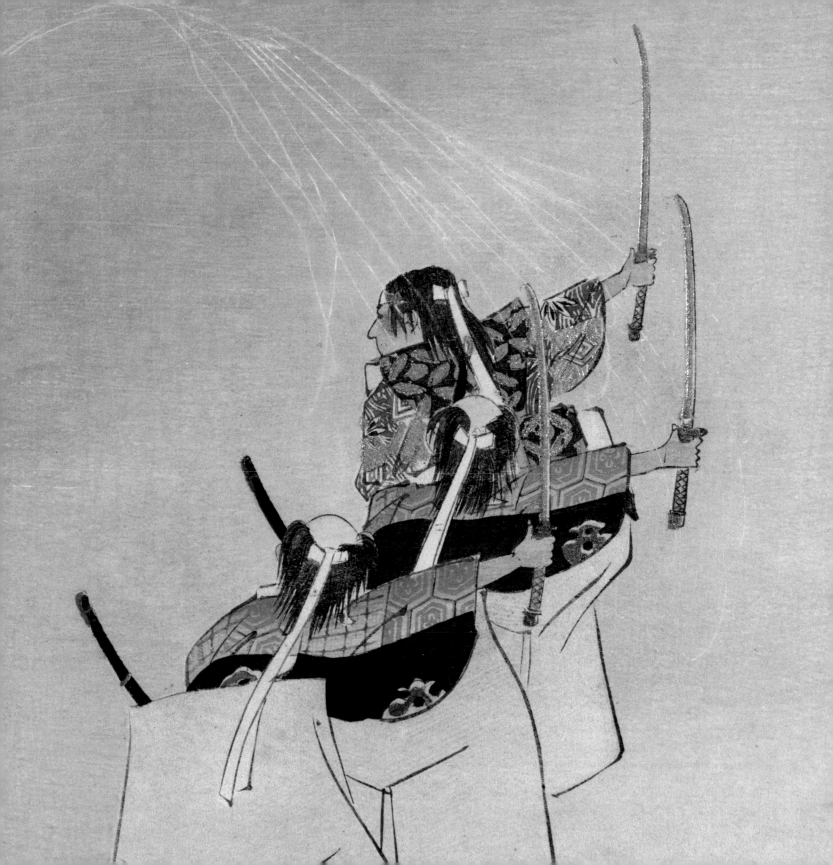

Staging the Supernatural
Ghosts and the Theater in Japanese Prints

Kit Brooks
Frank Feltens

Published by the Freer Gallery of Art and Arthur M. Sackler Gallery, National Museum of Asian Art,
Smithsonian, Washington, DC
Distributed by Smithsonian Books, Washington, DC

ISBN: 978-1-58834-720-6

Editors: Joellyn Powers and Amelia Meyer
Designer and production manager: Adina Brosnan McGee

Typeset in Benton Sans and Effra
Printed in Canada

This book may be purchased for educational, business, or sales promotional use.
For information, please write: Special Markets Department, Smithsonian Books,
P.O. Box 37012, MRC 513, Washington, DC 20013

Library of Congress Control Number: 2023911368

Table of Contents

Foreword and Acknowledgments

Throughout history, the division between the real world and the world of supernatural beings has been remarkably porous in Japanese culture. Certain sites, states of mind, or periods in the lunar cycle made humans particularly vulnerable to ghostly intervention. The Edo period (1603–1868) was a crucial stage in the development and solidification of ideas about the supernatural, as many of the beliefs that gained currency at this time are still held as conventional wisdom in contemporary Japan. Rapid urbanization brought diverse populations from across different regions—each with their own folkloric traditions—into close contact with one another, and the high level of literacy and wide availability of printed books aimed at a general audience helped circulate and standardize these ideas in the cultural imagination.

In popular culture, these entities were given life on the stages of noh and kabuki theater and in the retelling of legends and contemporary events in vibrant, multicolor woodblock prints and illustrated books. This volume focuses on the representation of supernatural beings in images of nineteenth- and early twentieth-century theater in Japan. While the kabuki theater had a broader appeal among the commoner classes in urban centers, noh was a more elevated form with sophisticated literary roots. Nonetheless, the character of both theatrical forms—whether the bombastic special effects of kabuki techniques or the otherworldly aura of the multiple layers of historical memory that descend over the noh stage—is masterfully captured in nineteenth- and early twentieth-century Japanese woodblock prints. It is the ability of these works to express the vibrant tradition of storytelling through theater that captivated Pearl and Seymour Moskowitz, whose gift in 2021 of over 650 Japanese prints has transformed the museum's collections of works depicting supernatural subjects. Several decades earlier, in 1971, the Embassy of Japan gifted to the museum David Wallace's collection of nearly 120 prints depicting the noh theater as envisioned by the artist Tsukioka Kōgyo (1869–1927). The gift laid an important foundation for examining the shifting notions of theater in modernizing Japan, and it was further enhanced by the roughly 230 noh prints by Kōgyo in the Robert O. Muller Collection gift of 2003. This book is one of the first studies to present the spirits of kabuki and noh alongside one another, bringing striking similarities and puzzling differences to the fore.

Two essays form the core of this volume along with a contribution by collector Pearl Moskowitz. Kit Brooks's essay examines the development of special effects in ghost plays in the popular theatrical form of kabuki and how these effects would manifest in commercial woodblock prints. The publication of such prints was timed to coincide with the release of new plays, and they operated as mementos for the event and as collectibles for fans who desired images of their favorite stars. For the production of *Tōkaidō Yotsuya kaidan*

in 1825, which featured a terrifying female ghost in a domestic play, stage techniques were developed that allowed her gruesome fate to be enacted in increasingly terrifying ways, such as through quick costume changes and synthetic blood bags hidden in wigs. Similarly innovative printing techniques were engineered to capture these effects in printed images, contributing to the story's legendary status in the cultural imagination, even today.

Frank Feltens's essay focuses on the first artist to render the nuances of the noh theater in prints. Tsukioka Kōgyo, the adopted son of one of the nineteenth century's most prolific artists of supernatural imagery, carries the viewer into the ethereal world of the noh stage. At their core, most noh plays feature a spectral being who transports the audience back in time. The superlative use of print techniques in Kōgyo's works captures these eerie sensations for new audiences. Feltens traces the methods through which spirits have been depicted in Japanese art throughout the centuries, highlighting the emphasis placed on new ways of perceiving reality and its effect on the means through which spirits were enacted on the noh stage.

The production of a book is always a result of the collective efforts of a great number of individuals. We would like to express our sincerest thanks to the many colleagues who made this publication possible. Takako Sarai was exemplary in securing reproduction rights and otherwise keeping the work on track. Karen Sasaki enabled a smooth workflow, and Adina Brosnan McGee created a striking design for the book. Amelia Meyer and Joellyn Powers applied their editorial acumen to polishing the manuscript into publishable form. Colleen Dugan and Cory Grace provided photography for our museum's works. We also thank the collectors and rights holders whose works form the backbone of the book. Among them, Pearl and Seymour Moskowitz deserve special gratitude. We also thank Darrel C. Karl for letting us reproduce works in his collection and Keiji Shinohara for allowing us to use images of him at work to illustrate the woodblock printing process.

We hope these pages will offer new insights into the role of the supernatural in the two major forms of Japanese theater and will inspire readers to explore these connections further.

Kit Brooks and Frank Feltens

My Ghosts: A Collector's Tale

The word *ghosts* alone is meant to send shivers up one's spine, and it is a perfect lead-in to my favorite story, the *hyakumonogatari kaidan*. One hundred samurai are seated around a table at night, and a candle is placed before each of them. Each samurai tells a ghost story and then blows out his candle. After the last tale is recounted and the final candle is extinguished, with the room now in total darkness, a ghost is said to appear. The setting, the ghost stories, and the total darkness are sure to awaken the spirits and test the fortitude of even the most battle-hardened warriors.

Ghost stories are deeply embedded in Japan's culture; the country's many stories are reinforced in the narratives of books, a ready source for plays in the kabuki theater and an inspiration for artists in the world of prints. As a collector of Japanese woodblock prints, I am fascinated by these stories that are, in some cases, centuries old yet never lost to time, instead being retold into the present day. I love matching an eighteenth- or nineteenth-century ukiyo-e print to a twentieth-century print to compare how these tales are reimagined in contemporary times. Once I purchased my first ghost print, collecting in this genre became addictive. The stories of murder, betrayal, greed, bravery, and revenge enacted in these prints are palpable, and favorites are told and retold time and again. Who could not respond to the story of a faithful wife, Oiwa, poisoned by her husband so he can marry his rich neighbor (cats. 6–11)? The poison causes her hair to fall out in clumps and her eye to swell and bulge until her husband ties her to a board and throws her in a river to die. One day when he returns to the river, both the board and Oiwa rise from the water, and from that day forward her ghost will haunt him as he moves from village to village, until he dies on Snake Mountain. The imagery of Oiwa holding clumps of her hair in her hand and of her bulging eye became iconic symbols used in the many graphic prints that tell her sad story.

Then there is the story of Matahachi and Kikuno, accused of adultery by two others who are trying to cover up their own affair. Matahachi and Kikuno are tied back to back in a basket and are sent down a river to die (cat. 19). In a darkened room lit only by a small lamp, their accusers are haunted by the two innocents, who are seen on a painted screen floating down a river—a chilling scene sure to make the hairs on the back of one's neck stand up.

While some of these stories are retellings or reimaginings of true events, others embellish historical facts, such as the Battle at Dan-no-ura bay in 1185—the last major battle between the Taira and Minamoto clans. The Minamoto were the victors of this battle, and a glorious triptych by Toyohara Kunichika (1835–1900) depicts their ship as it is tossed about on a rising sea in the darkness of night, when up from the waters come the ghost warriors of the Taira clan, howling for revenge (fig. 1). In a harrowing scene, these ghosts try to mount the ship, and the Minamoto must fight once again to regain what they had won during the day. It is a triptych filled with action, movement, color, and terror.

Are these ghost stories merely tales to scare us? To send shivers up our spines on a hot summer's evening? My guess is these tales of ghostly hauntings acted as forms of justice in a feudal society in which the authority of the ruling class was absolute. One tale that best emphasizes this message is of a village headman who goes to the governor of his province to plead for relief from the onerous taxes imposed by their feudal lord, knowing in advance his cause will fail and he and his family will be put to death (cats. 13-1 and 13-2). Many artists have used this tale to show the village headman haunting the governor who has treated his vassals so brutally. It is the only means for the helpless to find some justice—in a story, rather than in life.

Although most ghost stories are meant to be scary, every now and then an artist will put tongue in cheek and tease us about our fears. One print by Tsukioka Yoshitoshi (1839–1892) always makes me smile (fig. 2). It is night in a forest, and a ghostly figure awaits his next victim. . . . Along the path comes an old man, but, seeing a figure before him, the old man must first put his glasses on his nose and hold up his lantern to see clearly who is on the path, kind of taking the air

11

Fig. 1 Detail: Toyohara Kunichika (1835–1900), *The Typhoon at Daimotsu Bay in Settsu Province in 1188 (Bunji yonen Sesshū Daimotsu no ura nanpū no zu)*, 1860, 4th month. The Pearl and Seymour Moskowitz Collection, Arthur M. Sackler Gallery, S2021.5.356a–c

Fig. 2 Detail: Tsukioka Yoshitoshi (1839–1892), *A Ghost Jizō Startles a Near-sighted Old Man at Asajigahara*, from the series *Crazy Pictures of Famous Places in Tōkyō (Tōkyō kaika kyōga meishō)*, 1881. The Pearl and Seymour Moskowitz Collection, Arthur M. Sackler Gallery, S2021.5.363

out of this haunting! Or there is the print by Utagawa Hiroshige (1797–1858) called the "Laundry Ghost," where sheets drying on a line have caused the two men in the scene to fall back when their imagination plays tricks on them (fig. 3). Though this form of ghost print is certainly not the norm, it does give us a moment of relief from the brutal tales that capture our imagination.

As a child brought up on Western fairy tales, it was inevitable that once I was introduced to these ghost stories, it would be a genre that would capture my heart, and the hunt for these prints would become addictive once I became a collector: smiles when I found a wonderful ghost print, regrets when I lost a print at auction or when another collector had gotten to a dealer first, success when a print I missed out on buying was found, opening a catalogue and finding a print I never knew existed and adding it to the collection. It is the nature of collecting that the hunt never ends.

So the question arises: Did I find these ghostly prints, or did they find me? There is no answer, but it is a fun game to play with one's imagination and the ghosts that now form part of my psyche.

Pearl Moskowitz, 2023

Fig. 3 Detail: Utagawa Hiroshige (1797–1858), *Futakawa: Yaji and Kitahachi from Hizakurige,* from the series *Fifty-three Pairings for the Tōkaidō (Tōkaidō gojūsan tsui),* ca. 1845–46. The Pearl and Seymour Moskowitz Collection, Arthur M. Sackler Gallery, S2021.5.474

Note to Reader

Japanese proper names throughout the volume are given in the traditional order, last name followed by first name, such as Tsukioka Kōgyo, except for instances where the holders use the Western form.

Life dates do not appear where dates are unknown.

Japanese characters for names and specialized terms are included in the glossary. Wherever possible, romanizations of Japanese terms appear in the text following the word's English translation.

Full image credits for figures appear in the appendix.

Chronology of Japanese Historical Periods

Jōmon	ca. 14,000–300 BCE
Yayoi	300 BCE–300 CE
Kofun	300–538
Asuka	538–710
Nara	710–794
Heian	794–1185
Kamakura	1185–1333
Muromachi	1333–1568
Momoyama	1568–1603
Edo	1603–1868
Meiji era	1868–1912
Taishō era	1912–1926
Shōwa era	1926–1989
Heisei era	1989–2019
Reiwa era	2019–present

Pictorializing the Paranormal in Kabuki Ghost Plays

Kit Brooks

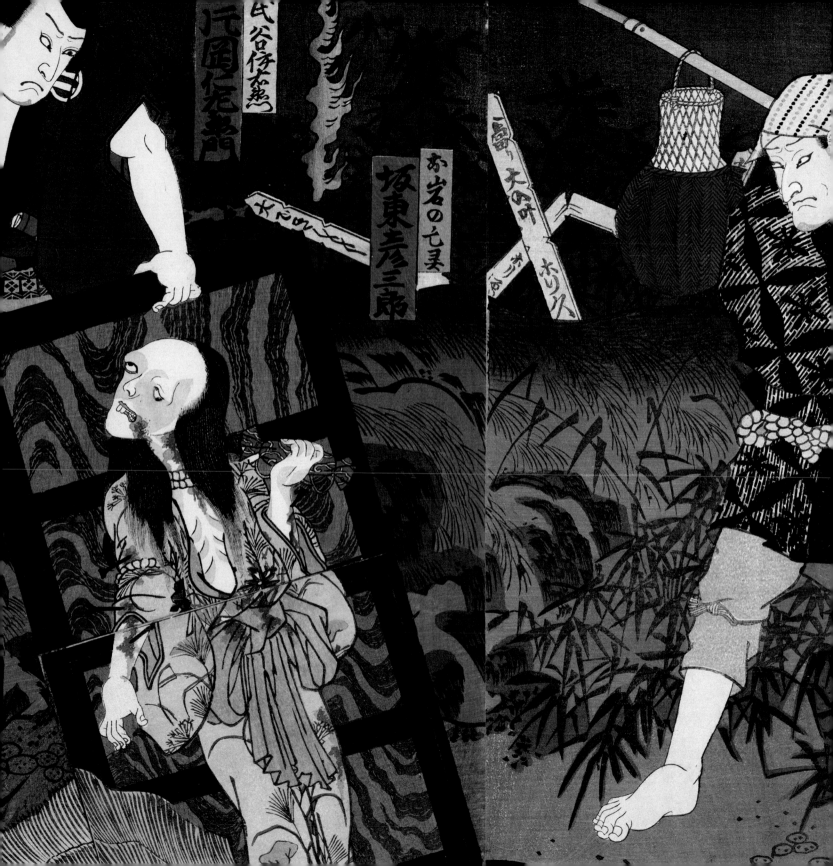

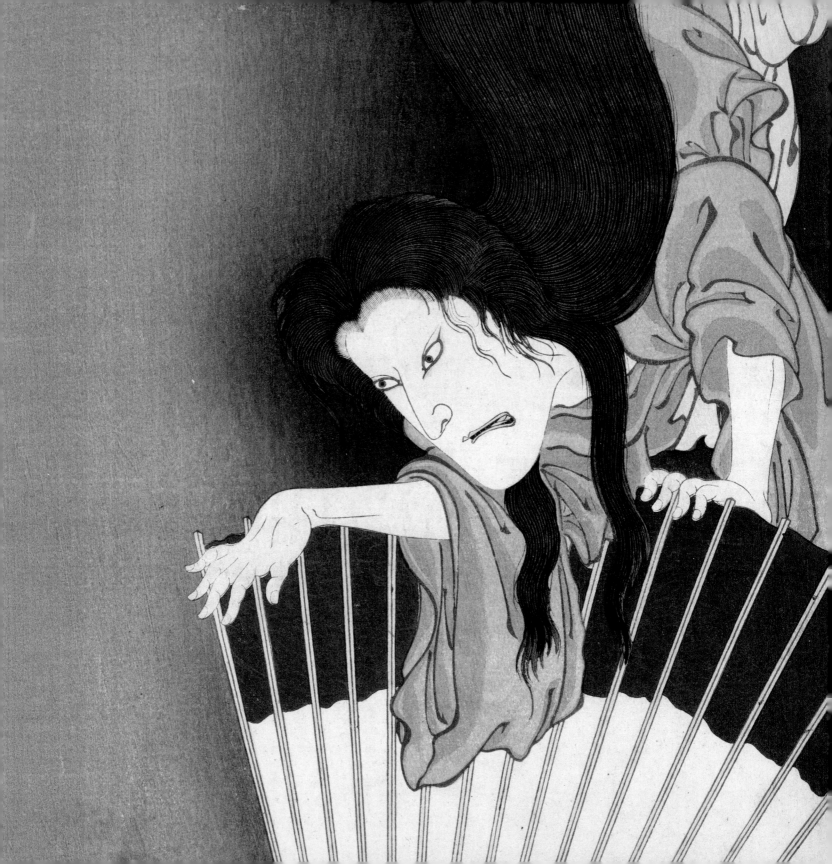

Trick or Treat?
Stage Tricks in Nineteenth-Century Kabuki Ghost Plays

The graphic representation of theatrical scenes has been a vital means through which kabuki has been perpetuated and sustained since the seventeenth century, when painters in Osaka and Edo were hired to paint billboards outside theaters as a way of advertising new performances. In subsequent decades, shifts within the realms of the kabuki theater and woodblock printing have responded to audiences' changing expectations for these intertwined media forms. For example, in early eighteenth-century woodblock printing, artists represented actors individually or in pairs, in restrained poses, with the actors' costumes or crests providing the only clues as to their role and the production being referenced. Artists of the next generation, such as Katsukawa Shunshō (1726–1793), initiated a representational shift away from stylistic approximations and toward depicting the physical likenesses of actors and the psychological states of their roles, and prints increasingly came to include identifying information in text cartouches. By the mid-nineteenth century, as plays became more complex and involved more and more spectacular sequences, woodblock prints also evolved into cinematic panoramas that could dynamically unite all three sheets of a triptych.

Impressive technical effects were a significant component of ghost plays, which grew in popularity and intensity after the 1825 debut of the play *Ghost Story of Yotsuya on the Tōkaidō* (*Tōkaidō Yotsuya kaidan*). Just as innovative stage tricks, known as *keren*, were developed to convey new and horrifying elements in those plots, print techniques were adapted to approximate them for the print-buying audience. Such prints served as both an aid to memory for those who had seen the performance and as a proxy for those who could not. This essay introduces several *keren* from ghost plays and their print corollaries to explore how the latter convey the monstrosity and ingenuity of the haunting presences depicted onstage.

Ghost plays and the Onoe family

Although the ghost play genre is generally considered to have come into full force with *Tōkaidō Yotsuya kaidan* (hereafter *Yotsuya kaidan*), ghost roles had been depicted onstage and in print prior to its production. However, the ghosts in those plays did not feature as central plot components in the manner they would later occupy.[1] For example, in *The Tale of Tenjiku Tokubei from India* (*Tenjiku Tokubei ikoku banashi*), the father of the titular character appears as a ghost in a dream sequence to guide Tokubei in his future course of action.

(left) Detail from cat. 12; Previous pages, detail from cat. 9

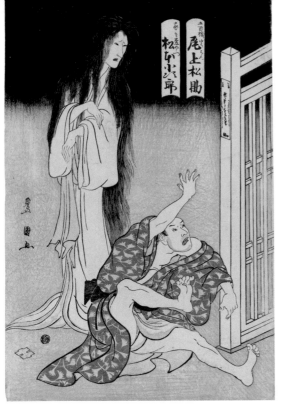

Written by Tsuruya Nanboku IV (1755–1829), the same playwright who would later author *Yotsuya kaidan*, this play was an unexpected hit when it debuted in the summer months of 1804. Summer had traditionally been considered the "slow season" in the kabuki theater, with the principal actors taking time off or performing in regional theaters outside the main cities. Perhaps exploiting this relative freedom from the expectations of the regular schedule, Nanboku began to experiment with new material. Notably, the play also featured another ghost, that of the wet nurse Iohata, played by the same actor in the lead role of Tokubei. Audiences were aware of this duality, and it would have imbued Iohata's character with more presence and their actions with greater significance. When the ghost of the murdered Iohata emerged in the white robe traditionally used to dress corpses, the shiver that ran through the audience would have provided a welcome chill in the heat and humidity of the summer (fig. 1).

The success of *Tenjiku Tokubei* led Nanboku to produce even more frightening plotlines and characters, and he is often credited with establishing ghost plays as an

18 independent genre.[2] However, Nanboku did not act alone; he relied on specialist scene technicians like Hasegawa Kanbei XI (1781–1841) to realize his visions. Moreover, the characters of the magical adventurer Tokubei and the vengeful wet nurse Iohata were developed in close collaboration with the actor Onoe Matsusuke I (1744–1815).[3] This playwright-actor partnership became an ongoing family affair, as Nanboku created the immortal roles of the female ghosts Oiwa (cats. 6–11) and Kasane (cat. 18) together with Matsusuke's

adopted son Onoe Kikugorō III (1784–1849). The Onoe family lineage is particularly recognized for their performances of supernatural characters, such as sorcerers, shape-shifting magical animals, and ghosts. The choice of actor to portray female ghosts was not straightforward: traditional kabuki is an all-male theater form, and the conventional actors of female roles, known as *onnagata*, relied on their presentation of a transcendent ideal of female beauty for their success. The grotesque transformations required to play Oiwa, Kasane, and others in their afterlives would detract from the

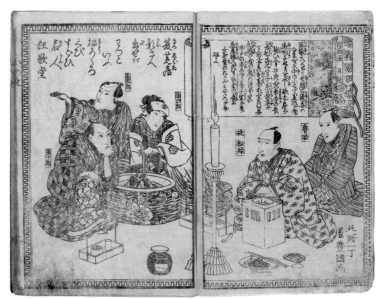

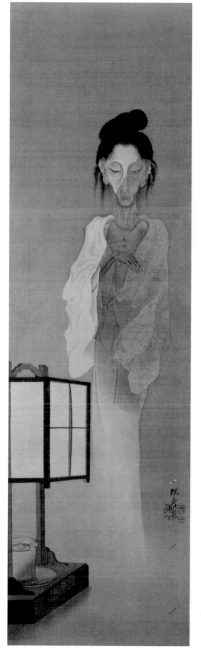

sexual magnetism that *onnagata* usually hoped to project, and so the performance of female ghosts was often undertaken by a subset of actors who could skillfully portray different characters and multiple states of existence within the same setting.

Contemporary illustrations suggest these actors discussed their techniques with one another, drawing from their own experiences of the supernatural and blending them with real-life contemporary events of the gruesome and the strange. For example, in the 1826 book *Ghost Stories of Onoe Shōroku (Onoe Shōroku hyakumonogatari)*, illustrated by Utagawa Kunisada (1786–1865) and published only a few months after *Yotsuya kaidan*'s successful premiere, a group of actors is depicted around the by-then deceased Matsusuke, who was also known by the name Shōroku (fig. 2). All specialists of ghost roles, the actors—from right to left: Iwai Hanshirō V (1776–1847), Onoe Kikugorō III, and Ichikawa Danjūrō VII (1791–1859)—gather to hear Matsusuke's ghost story, which had ostensibly been told to him by a real ghost.[4] Although the book is presented as though it is Kikugorō III's faithful recording of Matsusuke's recitation, the book was actually *ghost*written by Nanboku's student Hanagata Bunkyō (1785–1860), who is depicted seated behind Matsusuke.[5] Though it may be a fanciful imagination rather than a depiction of an actual gathering, it suggests the public image of ghost role specialists was as recipients of direct knowledge from the supernatural realm. Supporting this common perception, some members of the Onoe lineage seem to have been particularly committed to the accuracy of their portrayals and carried this interest into their private lives. One later member of the Onoe family, Onoe Kikugorō V (1844–1903), owned several ghost paintings that may have served as visual inspiration for his performances. One example from Kikugorō V's former collection by Kawanabe Kyōsai (1831–1889) shows the gaunt figure of a female spirit; the foreshortening used for the square-framed lantern in the foreground provides a realistic anchor for the supernatural vision, thereby making the ghost seem all the more plausible by comparison (fig. 3).[6]

19

Fig. 1 (top left) Utagawa Toyokuni I (1769–1825), *Onoe Matsusuke I as the Ghost of Iohata and Matsumoto Kojirō as Mokuemon*, 1804, 7th month. The Anne van Biema Collection, Arthur M. Sackler Gallery, S2004.3.107 **Fig. 2** (bottom left) Author: Onoe Kikugorō III (1784–1849), Illustrator: Utagawa Kunisada (1786–1865), *Ghost Stories of Onoe Shōroku (Onoe Shōroku hyakumonogatari)*, vol. 1, 1826. Senshū University Library Collection **Fig. 3** (above) Kawanabe Kyōsai (1831–1889), *Ghost*, ca. 1868–70. Israel Goldman Collection

Oiwa's story

Although Nanboku and successive generations of actors brought Oiwa to life on the stage, her tragic tale was fabricated by combining a real-life woman named Oiwa who had died in Edo in 1636 with a selection of unfortunate events that were rumored to have occurred in the Yotsuya area during the seventeenth century.[7] In Nanboku's play, Oiwa is married to the low-ranking samurai Tamiya Iemon, who is living in the lower-class neighborhood of Yotsuya and is reduced to selling umbrellas to make money after the downfall of his lord's house. When Oiwa's father discovers that Iemon has betrayed his master, he is determined to bring his daughter back to the family home and away from such a faithless and self-serving man. Iemon murders his father-in-law to prevent his deceptions from coming to light and, claiming that the murderer is an unknown assailant, promises Oiwa he will avenge her father if she stays by his side. Iemon is cruel, and their marriage is deeply unhappy, but Oiwa remains out of love for her father and their newly arrived, firstborn son.[8] Oiwa has become very ill after the birth, but a neighbor sends her a gift of a package of medicine to improve her blood circulation.

Iemon goes to the neighbor to offer his thanks, arriving at the household of a wealthy doctor named Itō Kihei. Iemon is informed that Kihei's granddaughter, Oume, has fallen in love with Iemon to the point of obsession—threatening suicide if they cannot be together. Given Iemon's treacherous and unpleasant behavior, this attraction may be surprising. However, *Yotsuya kaidan* was not only written for Kikugorō III in the role of Oiwa but also for the heartthrob Ichikawa Danjūrō VII to play Iemon. Iemon is an example of the archetypal kabuki villain called an *iroaku*, an evil male character who is "simultaneously attractive and repulsive, erotic and loathsome."[9] Kihei supports his granddaughter's infatuation and confesses to Iemon that the package of medicine he sent over earlier is actually poison that will horrifically disfigure Oiwa. Oiwa has already taken the "medicine," and it has caused a large tumor to develop over one eye. Kihei had hoped that the loss of Oiwa's beauty would make Iemon amenable to a new marriage with Oume. However, it is the promise of riches and adoption into the Itō household that convinces Iemon, and he agrees to leave Oiwa for Oume. His plan is to pay a local brothel owner, Takuetsu, to sexually assault Oiwa so he can claim infidelity and be free to marry Oume.

Iemon makes the offer to Takuetsu, who initially agrees. However, when he sees the extent of Oiwa's disfigurement, Takuetsu instead confesses to her Iemon's entire scheme. She is utterly distraught and is determined to confront the new couple, who have arranged to marry that same evening. Oiwa begins to get dressed, though Takuetsu tries to stop her. In the struggle, Oiwa stumbles and falls, accidentally cutting her throat with the blade of a sword and cursing Iemon as she dies. Takuetsu flees the house in horror, encountering Iemon on the way. When Iemon enters the home and finds Oiwa's body, he decides to make their household servant Kohei his scapegoat. Kohei has heard everything, so Iemon murders him, quickly formulating a story that Kohei and Oiwa were having an adulterous affair and have run away together. While his cronies remove the bodies, Iemon prepares for his wedding night. When the couple heads to bed and

Oume looks up at her new husband, Iemon instead sees Oiwa's twisted face staring back at him. Iemon's martial arts training takes hold, and he immediately reaches for his sword and beheads her—quickly realizing it was just an illusion and he has decapitated his bride. Running for help, Iemon sees the murdered Kohei cradling his and Oiwa's newborn son, Kohei's mouth bloody from devouring the infant. After drawing his sword and killing Kohei for the second time, Iemon realizes too late that he has been victim to another ghostly illusion and has killed his new grandfather-in-law, Kihei.

In the next act, Iemon is fishing by a river as he tries to gather his thoughts and determine his next course of action. He meets his mother, who hands him a letter of guarantee from her previous employer so that Iemon might find service in that household. Now content his future is secure, Iemon relaxes to fish, only to find that his hook is caught by something underwater. In a gruesome sequence, he pulls up a wooden raindoor and discovers two bodies: Oiwa is nailed to one side of the door and Kohei to the other, and their reanimated corpses curse and plead with him in turn before he throws them in the river once more. Fleeing the city, Iemon takes refuge in a Buddhist hermitage. However, he cannot escape Oiwa's ghostly visions, and he and his associates are tormented before they are all killed by her manifestations, one by one.

Technical trickery

More than Iemon's treachery, it is Oiwa's physical and supernatural transformations that have captured audiences' imaginations over the centuries. Of the various torments Oiwa inflicts during her revenge, her transformation out of a paper lantern is the most easily recognizable in the popular imagination. The choice of a lantern seems to be a particularly horrific mockery to torment Iemon, as lanterns are objects meant to provide safety and assurance against darkness and fear. Lanterns have an additional connection with the afterlife in Japan, as they are an important component of the Obon festival, which is held every year in mid-August to commemorate departed ancestors. Spirits are welcomed by lighting Obon lanterns (Obon *chōchin*), which are then released into a body of water at the end of the festival as the ancestors return to the afterlife. Oiwa's possession of a lantern is emblematic of how her path to the other world has been obstructed.

The paper lanterns used on the kabuki stage for Oiwa's transformation were set on fire for this part of the performance. The stage trick used to create the illusion of Oiwa morphing out of a lantern is known as *chōchin nuke*, or "lantern escape," and requires the assistance of several stagehands, prop equipment, acrobatics, and impeccable timing. In a similar manner to popular television shows that reveal the secrets of a magician's tricks, how the *chōchin nuke* and other *keren* were achieved was made known to nineteenth-century kabuki fans through publications such as the two-volume *What Really Happens Backstage* (*Okyōgen gakuya no honsetsu*) (1858–9). The *chōchin nuke* is shown just prior to execution by a stagehand assisting an actor playing a female ghost (fig. 4). The large prop lantern uses an interior framework made of metal rather

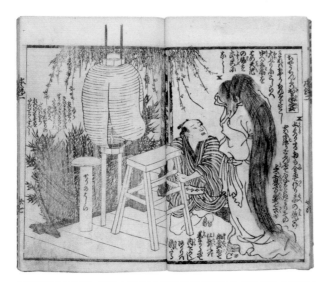

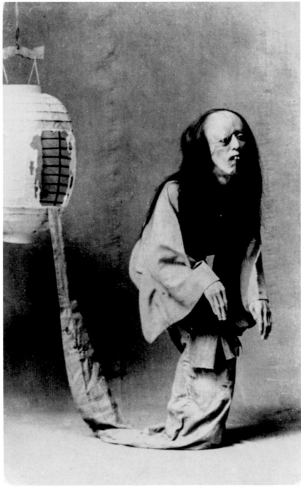

than the usual bamboo, and certain areas of the surrounding paper body are coated with an incombustible substance.[10] The lantern is set on fire, and with careful timing, the stagehand holds a short ladder so the actor can emerge from the burned-out hole. Leaning forward, the actor grips the stand positioned before the lantern, which is hidden from the audience by mock foliage. This allows for the ghost to appear in a gravity-defying pose, their upper body positioned below their waist and legs (see cat. 10).

The implausible physiognomy expected of ghosts was encouraged onstage by the use of a tapered, funnel-shaped robe called a *jōgo*. As seen in this early twentieth-century photograph of Kikugorō III's great-grandson Onoe Baikō VI (1870–1934) in the role of Oiwa, the use of a *jōgo* robe would make the emergence from the lantern appear even more ethereal (fig. 5). In Japan, ghosts are believed to emit spirit flames (*shinka*), and pieces of fabric held close to the actor by a stagehand could also be set on fire to approximate this otherworldly effect. To create the flames, a ball of cotton cloth is soaked in a phosphorescent mixture of grain alcohol (*shōchū*) and is then set alight to create a different kind of (alcoholic) "spirit" flame, *shōchūbi*. This chemical mixture causes the blue and green flames that are associated with the supernatural, and they can be seen as a curling cluster of upright flames in many prints of ghost characters, held aloft by a stagehand dressed in black (*kurogo*) (fig. 6). Such effects were used in combination with standard indicators for ghost characters in kabuki, such as the instrumental accompaniment that signals their arrival onstage—the reedy, haunting sounds of the flute and the low, repetitive drumbeat known as *doro doro*—and the specialist stage makeup, or *kumadori*, of a white face with blue contour and black or blue lips. Oiwa's makeup also involves a prosthetic over one eye and all-over blue makeup, as captured in this

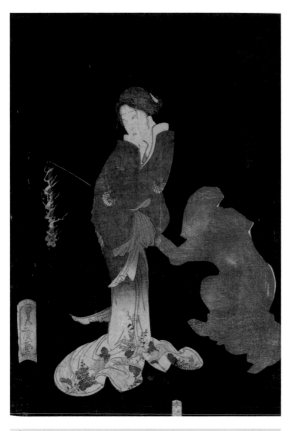

kumadori print from 1925 (fig. 7). The proper appearances of various undead humans had been published in 1806 as part of the multivolume *Illustrated Encyclopedia of the Theater* (*Shibai kinmō zui*) (cat. 1). In providing the illustrations, it is likely the designer, Katsukawa Shun'ei (1762–1819), took directly from the works of his teacher Shunshō, as the costume for the skeleton is an inverted but otherwise identical replica of an image Shunshō produced of a stage production twenty years earlier (fig. 8).

Fig. 4 (top far left) "Ghost coming out of a lantern (Chōchin no deru yūrei)" from *What Really Happens Backstage (Okyōgen gakuya no honsetsu)*, vol. 2, 1859. Collection of Waseda University Theater Museum **Fig. 5** (bottom far left) Unknown photographer, *Onoe Baikō VI as the Ghost of Oiwa in the Hermitage at Snake Mountain* in the play *Katamigusa Yotsuya kaidan*, October 1909. National Theater Collection **Fig. 6** (top left) Utagawa Sadahiro (act. ca. 1830–53), *Onoe Kikugorō III as the ghost of Usugumo*, 1835. The Pearl and Seymour Moskowitz Collection, Arthur M. Sackler Gallery, S2021.5.603 **Fig. 7** (bottom left) Hasegawa Sadanobu III (1881–1963), *Oiwa* in the play *Tōkaidō Yotsuya kaidan* from the series *Collection of One Hundred Makeups from Kabuki (Kabuki kumadori hyakumenshū)*, vol. 2, November 15, 1925. Darrel C. Karl Collection **Fig. 8** (bottom right) Katsukawa Shunshō (1726–1793), *The actors Ichikawa Danjūrō V as a skeleton, spirit of the renegade monk Seigen (left), and Iwai Hanshiro IV as Princess Sakura (right)*, 1783. Clarence Buckingham Collection, Institute of Art Chicago, 1938.491

23

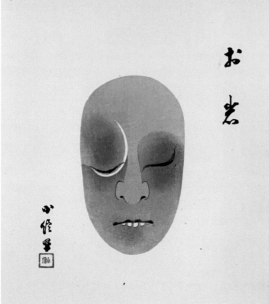

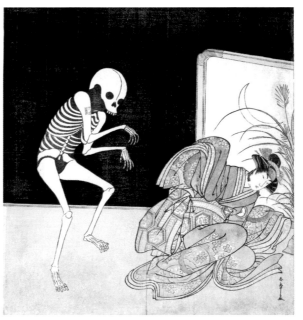

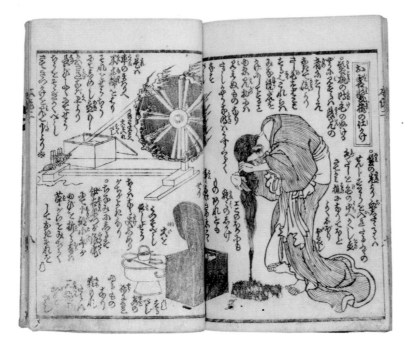

Another haunting technique used in *Yotsuya kaidan* is deployed in the *kamisuki*, or "hair-combing," scene, which occurs in Act II after Takuetsu reveals Iemon's plans to Oiwa and she prepares to confront him. This moment is as powerful in performances today as it was when it was developed by the special effects technician Hasegawa Kanbei XI in 1825, as it occurs when Oiwa is made fully aware of the extent of her disfigurement at the same time as the audience. Oiwa sees her reflection in a mirror, and in a gesture that is both horrific and heartbreaking, she attempts to make herself more presentable by brushing her hair to cover the facial tumor caused by Kihei's poison. Her hair falls out in clumps, and the visceral horror is amplified when blood begins to pour from her shed hair. Onstage, this is achieved by the actor holding a pouch of synthetic blood inside a partial wig, as described in *What Really Happens Backstage* (fig. 9). According to the text, the "pouch" was actually the carcass of a puffer fish, used like a squirt toy, and the fake blood was made from boiled sappanwood dye (*suō*), which is suitably blackish red in color. To the accompaniment of wooden clappers that emphasize the sound of dripping blood, the actor squeezes the wig over a standing screen of white paper that has been knocked over. The contrast of color is arresting, and print designers also sought to replicate this stunning moment in woodblock prints. In cat. 8, the printer, named on the print as Kozenki (act. mid-nineteenth century), has blown red pigment through a straw to achieve convincingly realistic splatters. Ukiyo-e prints were made in the hundreds and thousands by a tightly orchestrated and streamlined process, and this extra level of detail outside of the standard range of printing techniques would have been a considerable outlay of a publisher's money and a printer's time. Examples such as this, where the emergence of specific *keren* influenced the application of specialist printing techniques, demonstrate the interconnectedness of kabuki and the woodblock printing industry as well as the familiarity audiences had with both media forms.

Perhaps the clearest example of a ghost *keren* encouraging the use of innovative woodblock technology is the depiction of the *toitagaeshi*, or "raindoor flip," stage technique in Act III, when Iemon discovers Oiwa's and Kohei's bodies. Since the time of Nanboku's initial production of *Yotsuya kaidan* with Kikugorō III in 1825, the roles of Oiwa and Kohei have been played by the same actor. Many kabuki plays involve the same actors playing multiple parts, a device that allows them to show off their skill in convincing portrayals of vastly different characters within the same play. An additional level of difficulty is required when the actor must appear in

different roles within the *same* scene. This requires a quick change, or *hayagawari*, to accommodate their sudden appearance in a new guise.[11] For the raindoor flip sequence, the actor must play Oiwa's corpse on one side of the door and Kohei's on the other, with only the length of time while the door is submerged by lemon for the completion of the quick costume change. This effect was developed by Nanboku's son, Naoeya Jūbei (1781–1831), and the secrets of its execution are also

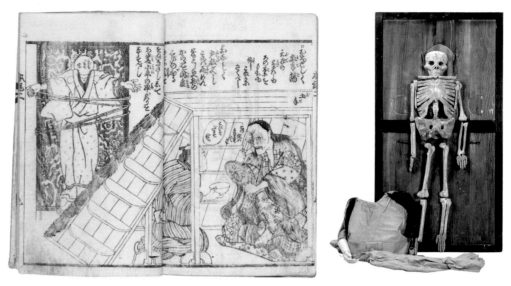

revealed in *What Really Happens Backstage* (fig. 10). In this image, we are literally given a backstage perspective—a rear view of the artificial embankment where the actor changes their makeup for the roles of Oiwa and Kohei, assisted by a stagehand. The actor places their head through the circular hole in the embankment, matched by another hole in the raindoor depicted at the top left, which will be moved into place over the embankment at the appropriate time. The actor first makes their appearance as Oiwa when the raindoor is revealed with her face and a dummy body, before being turned over to reveal a similar setup for Kohei's corpse when the actor has completed the quick makeup change. Although this illustration only shows an aperture for the actor's head, in many productions, additional holes were used for the actor's hands to make the dummy bodies attached to each side of the door appear more animated. As a final step, a cord is pulled that releases the clothing on the Kohei dummy to reveal a skeleton (fig. 11). At the end of the scene, the actor playing Oiwa/Kohei appears again at stage right, as Oiwa's brother-in-law Satō Yomoshichi—the same role in which the actor began Act III—to the delight of the audience.

These techniques are difficult for the actors to execute and perform, and comparably sophisticated techniques were developed to show them in print. Several extant examples that show the *toitagaeshi* raindoor flip are of the category known as *shikake-e*, or "trick picture," where a small piece of paper is glued along one edge

Fig. 9 (left) "Oiwa's Hair-combing Trick (Oiwa kamisugi no shikake)" from *What Really Happens Backstage (Okyōgen gakuya no honsetsu)*, vol. 2, 1859. Collection of Waseda University Theater Museum **Fig. 10** (above left) Raindoor flip stage effect from *What Really Happens Backstage (Okyōgen gakuya no honsetsu)*, vol. 2, 1859. Collection of Waseda University Theater Museum **Fig. 11** (above right) Prop of raindoor (*toita*) used in productions of *Yotsuya kaidan*, ca. 1947–68. Fujinami Prop Company. Image credit: National Museum of Japanese History

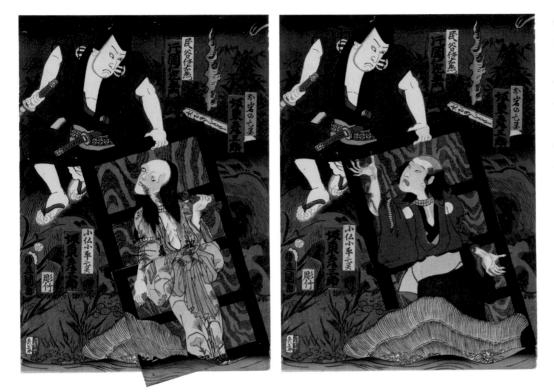

of the print and is pasted over one part of an image; when the pasted paper is lifted up, a new detail on the original sheet is revealed.[12] This technique was mostly used for practical purposes, such as when the name and image of one actor's face were pasted over another if two actors appeared in the same role for alternating performances. It could also be used if a scheduled actor became sick or was unable to perform at the last moment, as in some circumstances it would have been less expensive than carving an entirely new print. An 1861 example by Utagawa Kunisada makes use of pasted paper to depict the raindoor flip: in one configuration, Oiwa is visible in the central sheet of the triptych, but when the pasted paper is lifted up, Kohei's tortured corpse is revealed (figs. 12 and 13, cat. 9).

The raindoor flip was such a phenomenon that it was performed twice for each performance of *Yotsuya kaidan*. The play is set within the world of another famous kabuki play, the *Chūshingura*, or *A Treasury of Loyal Retainers*. The play tells the story of a righteous group of *rōnin* (masterless samurai) who must take revenge on behalf of their former lord, Enya Hangan, after he is forced to commit suicide as punishment for drawing his sword inside the shogun's castle when provoked by his enemy, the evil Kō no Moronao. Based on real historical events known as the Akō Incident (Akō jiken) that occurred in 1701, the story of the *rōnin*'s vendetta became a sensation after its fictionalization for the stage in 1748, and it has been performed almost continuously ever since.

Yotsuya kaidan and *Chūshingura* work in tandem, as the plot of *Yotsuya kaidan* offers a dark, twisted version of the honorable revenge enacted in *Chūshingura*—a domestic vendetta to contrast with a samurai one. Many characters in the *Yotsuya kaidan* are also aligned with the heroes or villains from the *Chūshingura*, immediately providing clues to the audience about their moral status. For example, Iemon had betrayed the noble Enya Hangan, and though Kohei steals from Iemon, he does so to assist the *rōnin* in their vendetta, revealing his loyal heart to the

Figs. 12 and 13 Details from cat. 9

noble cause of *Chūshingura*. Even though Moronao is the sworn enemy of his former lord, lemon consents to the plan to marry Oume when Kihei offers an introduction for him to enter Moronao's service, where Kihei is also employed. The distant affairs of a samurai rivalry were made more immediate to the commoner audience through a relatable domestic setting, just as the historical grounding of *Chūshingura* and the Akō Incident embedded Oiwa's paranormal abilities in a plausible reality.

As *Yotsuya kaidan* is set in the same fictionalized universe as the *Chūshingura*, it was initially performed over two days, with acts from both plays interspersed with one another. On the first day, the first three acts of *Yotsuya kaidan* followed the first six acts of *Chūshingura*. The next day, the third act of *Yotsuya kaidan* —which includes the raindoor flip—was performed again, followed by the remaining acts from both plays. That this sequence was performed twice gives an indication of its immense popularity and its centrality to the identity of the play. Audiences expected to see such *keren* as an essential part of the experience, as they were prominently featured in the playbills advertising upcoming shows; for example, a playbill for an 1844 production of *Yotsuya kaidan* and another play includes vignettes of several of Oiwa's transformations, with the *chōchin nuke* lantern transformation dominating the composition (fig. 14, following page).

Conclusion

Unlike many ghost characters, Oiwa does not achieve salvation once her revenge has been completed. It is perhaps this lack of resolution that explains how Oiwa's curse is still considered a pervasive threat in the twenty-first-century consciousness. Oiwa's character is believed to be based on a real woman, and a memorial to her is located at the Myōkōji, in Nishi-sugamo, Tokyo. After reports of injuries and deaths during the production of modern-day stage and screen versions of *Yotsuya kaidan*, it is now customary for cast and crew members to visit this shrine and pay their respects in order to evade the curse.[13] Oiwa's grotesque appearance also persists, as the female ghosts in the influential Japanese horror film series *Ringu* (*The Ring*, 1998–) and *Juon* (*The Grudge*, 2000–) have female protagonists with long, drooping hair and a misshapen eye that have been cited as a reference to Oiwa.[14]

The challenge of representing a convincing ghostly presence has always been a tantalizing opportunity for creative minds to generate special effects that trick the audience's eye into believing something implausible. However, the increasing presence of *keren* has been derisively viewed by some as either symptomatic or causative of the decline of kabuki in the nineteenth century, in much the same way as contemporary critics dismiss an overreliance on special effects in cinema at the expense of narrative or character development.[15] Nonetheless, *keren* thrill fans, and understanding the complexity of their execution offers a window into a deeper appreciation of their representation in woodblock prints and the continued resonance of Oiwa's horrific transformations to this day.

28

Fig. 14 Unknown artist, *Kabuki Playbill (Tsuji banzuke) for Plays at the Nakamura Theater: Mukashi Mukashi Oiwa no Kaidan, Kiku mo Ureshi Kinuya no Mutsugoto*, 1844, 7th month. William Sturgis Bigelow Collection, Museum of Fine Arts, Boston, 11.27706

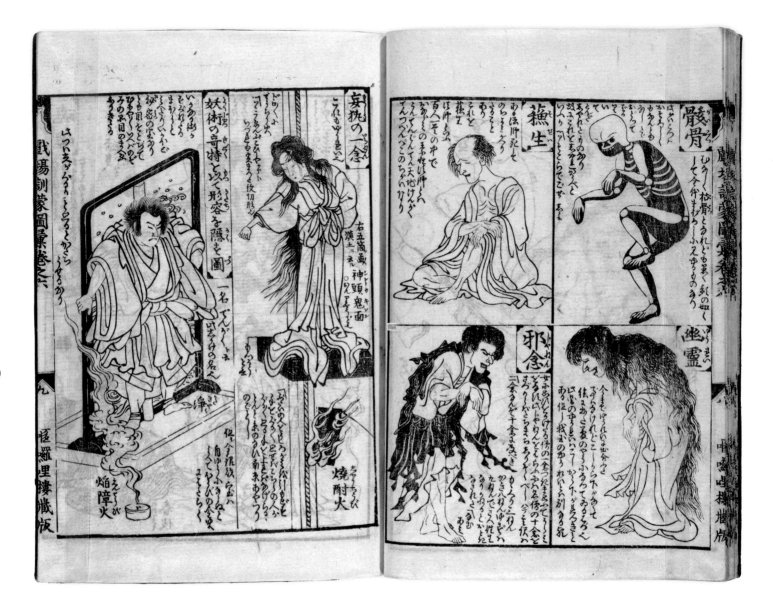

1 *Illustrated Encyclopedia of the Theater (Shibai kinmō zui)*, vol. 4

Author: Shikitei Sanba (1776–1822); Illustrators: Katsukawa Shun'ei (1762–1819), Utagawa Toyokuni I (1769–1825); Calligrapher: Eishōsai Chōki (act. ca. 1780–1810); Publishers: Hanamoto Bunshōdō, Morimoto Bunkindō; Japan, Edo period, 1806 (Bunka 3); Meiji era reprint. Woodblock printed; ink on paper, paper covers; 22.5 × 15.8 × 0.8 cm (each volume, approx.). Purchase, The Gerhard Pulverer Collection—Charles Lang Freer Endowment, Friends of the Freer and Sackler Galleries and the Harold P. Stern Memorial fund in appreciation of Jeffrey P. Cunard and his exemplary service to the Galleries as chair of the Board of Trustees (2003-2007), Freer Gallery of Art Study Collection, National Museum of Asian Art, Smithsonian Institution, FSC-GR-780.157.1–5

The ins and outs of the theater were of enormous interest to kabuki fans, and a subgenre of illustrated books set out to furnish them with behind-the-scenes information about how their favorite plays came to life. The eight-volume *Illustrated Encyclopedia of the Theater (Shibai kinmō zui)* was first published in 1806 and was reprinted several times over the following decades to meet demand.[1] Much of its appeal is attributable to the wit and observational skills of the author, Shikitei Sanba. Sanba's reputation was as an observer of human life who could slip unseen into social situations and relay eavesdropped conversations in a manner that was both naturalistic and entertaining. This was best achieved in his multipart novel *The Ukiyo Bath (Ukiyo buro)* (serialized between 1809 and 1813) that simulates conversations among the types of people encountered in public bathhouses. Other works follow this pattern for the kabuki theater. Although the genre of critiquing actors was well-established and popular among kabuki fans, Sanba turned his lens back onto the reader in *Critique of the Audience (Kakusha hyōbanki)* (1811), which provides comedic commentary on stereotypical types of theatergoers, such as devoted aficionados, country bumpkins, actor impersonators, and tough elderly women.

Sanba's authorial persona as someone who could observe intimate social situations without being noticed was strengthened by several works purportedly based on his time spent in actors' greenrooms, such as *Guide to the Actors' Dressing-rooms (Yakusha gakuya tsū)* (1799) and *Amusements of Actors on the Third Floor (Yakusha sangaikyō)* (1801).[2] *Shibai kinmō zui* is the most encyclopedic of these works, with much of the content appropriated from the earlier *Illustrated Guide to the Three Edo Kabuki Theaters (Ukan sandai zue)* published in 1791, though with a more accessible text and lively images furnished by Katsukawa Shun'ei and Utagawa Toyokuni.[3] In this double-page spread, Sanba provides texts to accompany illustrations for several supernatural figures the viewer may see on the kabuki stage: on the right-hand side are skeletons (*gaikotsu*), the reanimated (*sosei*), ghosts (*yūrei*), and spurned monks (*janen*); illustrations on the left page reveal the stage tricks used for ghosts, such as a device made of cotton strips soaked in grain alcohol that formed a spirit flame, or *shōchūbi*, held aloft by stagehands while standing alongside ghost characters.

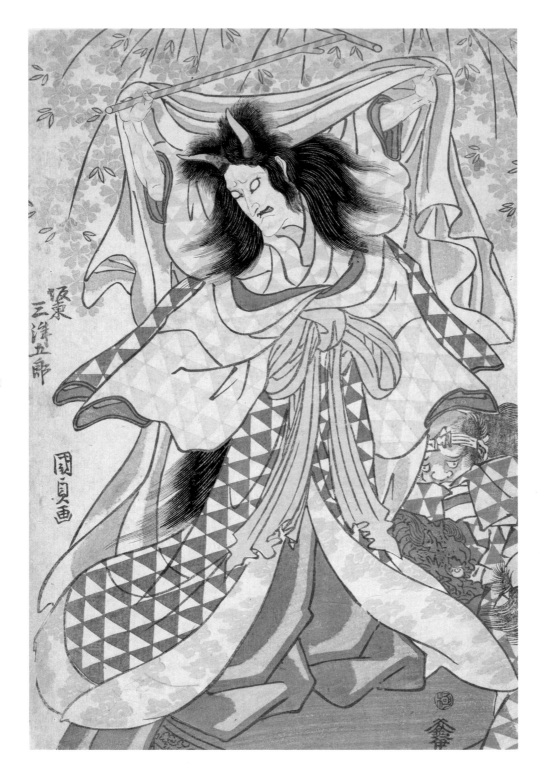

2 Bandō Mitsugorō III as the Maiden of Dōjōji

Utagawa Kunisada (1786–1865); Publisher: Suzuki Ihei (act. ca. 1810–1819); Japan, Edo period, 1816. Woodblock print; ink and color on paper; 36.3 × 25.6 cm. The Anne van Biema Collection, Arthur M. Sackler Gallery, National Museum of Asian Art, Smithsonian Institution, S2004.3.128

The theatrical story of the *Dōjōji* was well established as a noh play (see cat. 26) before it was adapted for the kabuki theater for the first time in 1753. In keeping with kabuki's conventions for bombastic performances with dazzling sets and costumes, the kabuki version belongs to the stylized dance transformation genre, *hengemono*. The central component of these plays is a dance sequence in which the same actor performs multiple roles, transforming between them during the choreography. This is achieved through multilayered costumes that can be quickly removed or adjusted to reveal new sections. As in the noh play, the kabuki version opens with a group of monks delighting over the installation of a new bell at their temple, the eponymous Dōjōji. Due to an infamous sequence of events in the temple's history, there has been no bronze bell on the precincts for many years, and women have also been forbidden from entering. Long ago, a young woman named Kiyohime had fallen in love with one of the acolyte monks, but her advances were rejected. She pursued him during his pilgrimage, and in her rage and resentment, she began to transform into a serpent. When the monk returned to his home temple of Dōjōji, the other monks hid him inside the temple's bell to keep him safe. However, Kiyohime coiled around the bell until the furious lust of her body heat burned him alive. Several years later, the monks consecrated a new bell, and when a young female pilgrim arrives, she is distraught to discover she is not permitted to see it. Sensing her disappointment, the monks allow her to enter and perform a dance. Once she begins, her appearance starts to change until she finally reveals herself to be the demonic serpent form of the original Kiyohime.

The performance depicted here is from a production of *The Maiden of Dōjōji, Tie-dyed in the Capital (Kyōganoko musume Dōjōji)* at the Nakamura theater in Edo, which opened in the 3rd month of 1816.[4] The role of Kiyohime was played by Bandō Mitsugorō III (1775–1831), shown raising one part of the costume to reveal her demonic mask and wearing robes with a tessellating diamond pattern that suggests the scales of a serpent. Crouched under Mitsugorō's left arm, a stagehand is ready to assist in the removal of costume elements. As a symbolic contrast to Kiyohime's ferocious demonic form, the blooming cherry blossoms surrounding her are associated with young female beauty, thereby recalling her original human state and the body of the female pilgrim she has now possessed. Although the print version is static and cannot show the actor's costume changes in action, this use of iconography is able to suggestively capture the different stages of transformation within a single image.

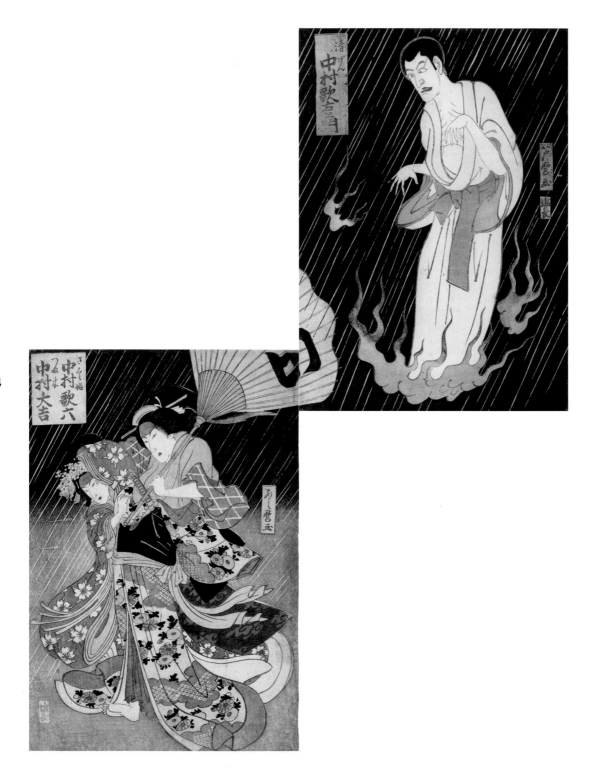

34

3 Nakamura Utaemon III as Seigen, Nakamura Karoku as Sakurahime, and Nakamura Daikichi as Tsutaki

Jukōdō Yoshikuni (act. ca. 1803–1840); Publisher: Shioya Chōbei (act. ca. 1793–1830s); Japan, Edo period, 1814, 1st month. Woodblock print; ink and color on paper; 38.1 × 26 cm (top); 37.4 × 25.7 cm (bottom). The Pearl and Seymour Moskowitz Collection, Arthur M. Sackler Gallery, National Museum of Asian Art, Smithsonian Institution, S2021.5.661a–b

There are many plays about the ill-fated lovers Seigen and Sakurahime, all of which involve reincarnations and tragic deaths. Seigen is a monk at the Kiyomizudera temple in Kyoto who has fallen in love with a young acolyte named Shiragikumaru. The affair causes the neglect of his religious duties, and the two swear to commit a double-love suicide. Each of them takes one half of an incense box, inscribed with the other's name. However, when the time comes, only Shiragikumaru follows through, vowing to be reincarnated as a woman so that he and Seigen can marry. Seigen does not follow his lover in death and returns to the temple.

Seventeen years later, Seigen has risen to the position of abbot of the Kiyomizudera. He encounters a young woman named Sakurahime, whose family has fallen on hard times. She has been born with her left fist tightly closed, but when Seigen offers a prayer, her hand falls open to reveal she has been clutching the part of the incense box inscribed with Seigen's name since the day she was born seventeen years earlier. Convinced he has found his former lover at last, Seigen is committed to being with Sakurahime. She, however, has her own romantic interests, and through a typically convoluted kabuki plot, ends up being sold to a brothel by her lover, Gonsuke, who, unbeknownst to her, had murdered her father and brother and stolen the family's heirloom scroll, causing the downfall of her house. In the same attack, he had sexually assaulted her, resulting in a pregnancy. In his devotion to Sakurahime, Seigen raises the baby, though he is later beaten and left for dead. Reanimated by a stroke of lightning, he attempts to embrace Sakurahime, but she pushes him away. He falls into a grave and is impaled on a knife, dying at last.

The print depicts a scene from a performance of *The Courtesan and the Bell on the Cherry Tree (Keisei tsurigane zakura)* at the Naka theater, Osaka, in the 1st month of 1814.[5] Although Sakurahime's upper-class manners make her a desirable companion, she is visited nightly by Seigen's ghost, who drives her clients away. In her hurry to escape him, she is seen here running barefoot in the rain, accompanied by a young attendant. This split vertical format is unusual, creating a dynamic diagonal that follows the directionality of the umbrella shaft.[6] The artist of this split diptych, Yoshikuni, was an active member of the Osaka literary arts scene and was known as a poet and a singer of chants for the puppet theater in addition to being a print designer. It was perhaps this background in various art forms that gave Yoshikuni the confidence to experiment with such an unusual compositional format.

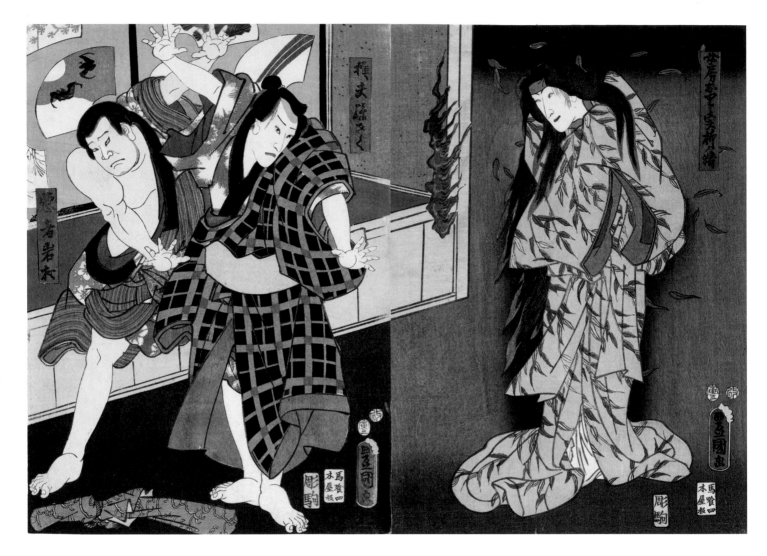

4 Nakamura Tomijūrō II as the Wife (*Nyōbō*) Oryū, actually the Spirit of a Willow Tree (*Yanagi no sei*) (R), Ichikawa Danjūrō VIII as the Woodcutter (*Kikori*) Magosaku (C), and Nakamura Nakasuke II as the Villain (*Warumono*) Iwamatsu (L)

Utagawa Kunisada (1786–1865); Block carver: Ōta Tashichi (Komakichi) (act. ca. 1834–1882); Publisher: Kiya Sōjirō (act. 1851–1904); Japan, Edo period, 1854, 3rd month. Woodblock print; ink and color on paper; 35.3 × 25 cm (right); 35.4 × 25.1 cm (left). The Pearl and Seymour Moskowitz Collection, Arthur M. Sackler Gallery, National Museum of Asian Art, Smithsonian Institution, S2021.5.521a–b

This story begins during an imperial hunt, when one of the hunting falcons has become tangled in the branches of a willow tree. To save the prized falcon, an order is issued for the tree to be cut down. However, a kindly man named Heitarō appears and frees the falcon without damaging the tree. In a plotline familiar from many supernatural folktales in Japan, shortly after Heitarō's compassionate act, he meets a mysterious and beautiful woman who becomes his wife and bears him a son. The woman is named Oryū and, not-so-coincidentally, the second character of her name is the same as the character for "willow," *yanagi*.

Years later, the emperor becomes ill. The willow tree is blamed as the cause of his sickness after a fortune teller reveals the willow's roots are entwined around the skull of one of the emperor's ancestors. Once more, the willow tree is set to be cut down, and the woodcutter Magosaku (played here by Ichikawa Danjūrō VIII [1823–1854] in the center) begins to saw. Oryū, on the right, immediately collapses but manages to say farewell to her husband and son before disappearing. Of course, Oryū was the spirit of the grateful willow tree all along. According to some versions of this story, after the willow was cut down, its mighty trunk was used as the ridgepole for the Sanjūsangendō, or Hall of the Thirty-Three Bays, in Kyoto. The hall is 120 meters long, giving an idea of the willow tree's incredible size. Although the original building burned down less than one hundred years after its construction in 1164, and the original ridgepole no longer survives, there are still willow trees on the precincts today.

This diptych shows a performance of *The Earliest Story of the Plum and Willow (Ume yanagi sakigake zōshi)*, which opened on the 13th day of the 3rd month, 1854, at the Ichimura theater, Edo.[7] Nakamura Tomijūrō II (1786–1855) was a well-known *onnagata*, or specialist of female roles. Kabuki had initially been developed as an all-female form of theater, before government authorities forbade women and then young boys from performing in a bid to halt the unlicensed sex trade. As shaving the front part of the head was a marker of a man's entry into adulthood, *onnagata* opted to wear a stylish "purple cap" (*murasaki-bōshi*) to cover this disfigurement. *Onnagata* can be identified in woodblock prints by this patch of cloth worn high over the forehead. Oryū's supernatural status is indicated by the tall orange-blue flame at left, and the surprised reactions and splayed fingers of the two male figures are emphasized by the shapes of the spread fans mounted on the folding screen behind them. The willow pattern on Oryū's robe aligns seamlessly with the falling leaves swirling around her—another clue to her true identity.

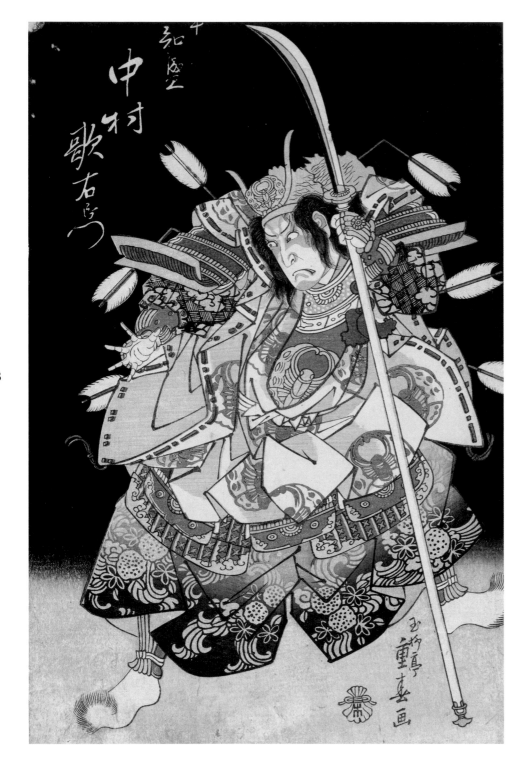

5 Nakamura Utaemon III as Taira no Tomomori

Ryūsai Shigeharu (1803–1853); Publisher: Wataya Kihei (ca. 1809–1885); Japan, Edo period, 1831. Woodblock print; ink and color on paper; 37.2 × 24.7 cm. The Anne van Biema Collection, Arthur M. Sackler Gallery, National Museum of Asian Art, Smithsonian Institution, S2004.3.279

Wrapped in layers of clothing over his bulky armor, the actor Nakamura Utaemon III (1778–1838) presents a haunting figure as a fictionalized version of the historical warrior Taira no Tomomori (1152–1185).[8] The depicted scene is from a performance of the well-known kabuki play *Yoshitsune and the Thousand Cherry Trees (Yoshitsune senbon zakura)* at the Kado theater in Osaka in the 5th month of 1831. The play is a liberal interpretation of the events between the Minamoto and Taira clans in the twelfth century, which are relayed in the epic war chronicle *The Tale of the Heike (Heike monogatari)*. In the historical account, the Taira general Tomomori was faced with total defeat during a sea battle at Dan-no-ura, which would be the final showdown between the two families. Tomomori lashed himself to an anchor and threw himself overboard, committing a dramatic suicide rather than facing the humiliation of enemy capture.

In the play, Tomomori relates that he did not die but used this moment to escape. He then disguises himself as his own ghost to torment his rival general, Minamoto no Yoshitsune (1159–1189), attacking his ship amid a tumultuous storm. Yoshitsune's faithful companion, the warrior-monk Musashibō Benkei (1155–1189), defeats Tomomori using both his physical and spiritual powers. As he grips his long *naginata* spear, Tomomori is assailed by arrows that become embedded in his armor and body. His plan a failure, Tomomori dies and becomes a "real" ghost. The print features the graduated black background common to many ghost prints, where the lighter lower section leads the eye upward and creates an ethereal atmosphere that suits the subject. Here, the printer has reversed this polarity on Tomomori's robes, applying darker blue ink to the lower edges at the same line where the background color transitions. This creates a sense of tension that echoes this part of the play's narrative, when Tomomori is suspended between the worlds of life and death.

By wearing the blue *kumadori* makeup customary for ghost roles in kabuki, Tomomori's presentation has a self-referential quality: a man pretending to be a ghost is played by an actor in that role. However, for viewers familiar with the fates of Yoshitsune and Benkei, there is an additional layer of tragic reference. After Yoshitsune's victory over Tomomori, he was betrayed by his own half-brother, Minamoto no Yoritomo (1147–1199). Yoshitsune and Benkei were forced to retreat north, with Yoritomo's soldiers in pursuit. The loyal Benkei—whose favored weapon was a *naginata*—stood his ground so Yoshitsune could escape and commit an honorable suicide. Too afraid to face the legendary warrior in close combat, Yoritomo's men rained arrows upon him from afar. When they finally dared to approach, they realized he had remained on his feet, even in death. The "Standing Death of Benkei" (*"Benkei no tachi ōjō"*) is legendary, and a monument has stood for centuries at the site of his sacrifice. This striking visual parallel between Tomomori's fictional death and Benkei's actual one would have been apparent to contemporary viewers—a grim foreshadowing blurring the boundaries between truth and pretense.

39

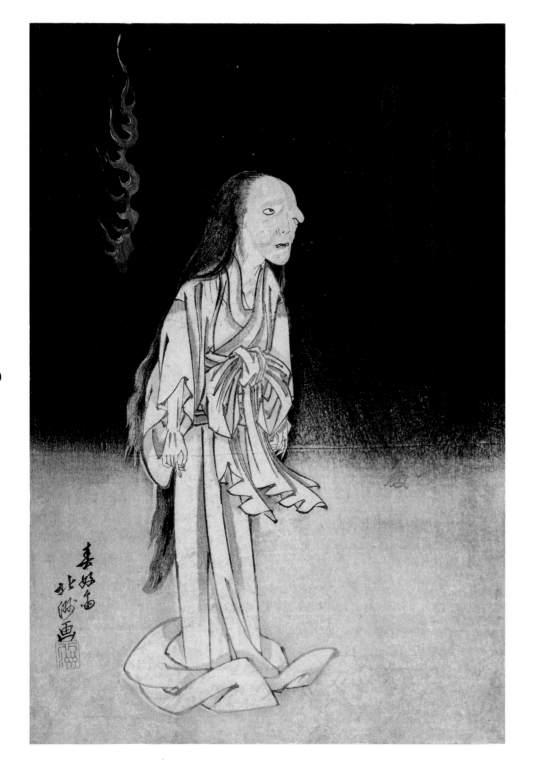

6 Onoe Kikugorō III as Oiwa

Shunkōsai Hokushū (act. ca. 1802–1832); Block carver: Horikō Kasuke (act. 19th century); Japan, Edo period, 1826, 1st month. Woodblock print; ink and color on paper; 36.7 × 24.8 cm. The Pearl and Seymour Moskowitz Collection, Arthur M. Sackler Gallery, National Museum of Asian Art, Smithsonian Institution, S2021.5.268

The first performance of Oiwa in the play *Ghost Story of Yotsuya on the Tōkaidō (Tōkaidō Yotsuya kaidan)* in Edo in the summer of 1825 caused such a sensation that just a few months later, the play was already being performed on the other side of the country in Osaka. The story revolves around Oiwa's poor treatment by her husband, a plot to disfigure her face through poison that results in her death, and Oiwa's return as a ghost to torment those involved in the scheme (for a full account of the story, see pages 20–21). Kabuki actors often traveled between the cities of Edo and Osaka, with Edo-based actors performing much-publicized tours for limited production runs.[9] The role of the disfigured, vengeful ghost woman Oiwa had been written for Onoe Kikugorō III (1784–1849), and this print commemorates his performance in the Osaka version of the play, *Irohagana Yotsuya kaidan*, which opened at the Kado theater in the 1st month of 1826.

This print was also produced in Osaka, which had a devoted audience for actor prints who often commissioned artists to produce limited edition, deluxe printed works.[10] Smaller than the standard *ōban* print size issued in Edo, it features inscriptions in silver, and the delicately oxidized pigment on the blue-orange spirit flame gives a realistic sense of a flare tinged with smoke. The design was such a success that it was printed in three known states; this example is likely a second state impression, with a graduated black background and silver inscription.[11] The text was written by Kikugorō himself and was signed with his poetry name, Baikō:

> The technique of playing ghosts, developed by my father six years ago, has been well received, and despite it being spring and past the appropriate season, it is difficult to refuse the many people who continue to request it.[12]

It was followed by a poem:

> It doesn't stay, just melts away, fortunately: spring snow[13]

Just as snow will quickly melt in the warmth of the spring, Kikugorō seems to be reassuring the audience (and us) that no matter how terrifying his performance of Oiwa is, her ghost will disappear once the play is over.

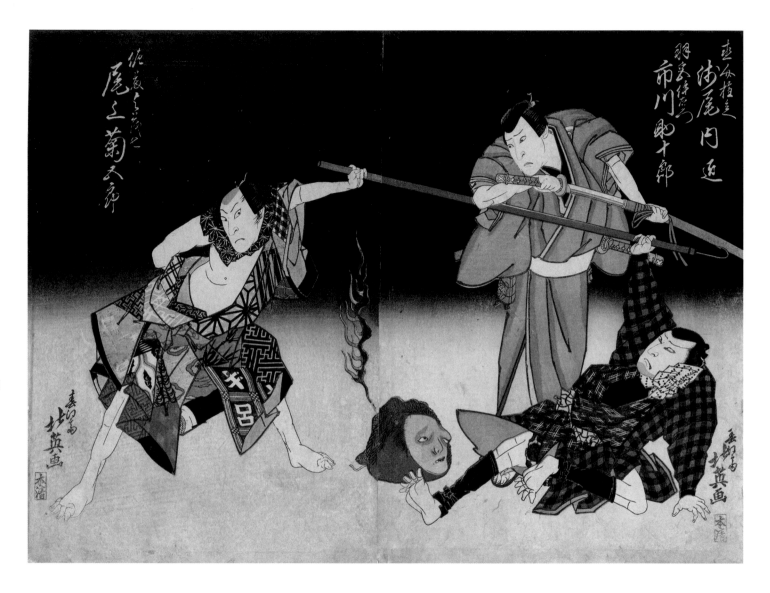

42

7 Asao Takumi I as Naosuke Gonbei, Ichikawa Sukejūrō I as Hamiya Iemon (R), and Onoe Kikugorō III as Satō Yomoshichi (L), with Oiwa's disembodied head in the center

Shunbaisai Hokuei (act. 1824–1837); Publisher: Honya Seishichi (Honsei) (act. ca. 1803–1893); Japan, Edo period, 1831, 3rd month. Woodblock print; ink and color on paper; 37.6 × 25.7 cm (right); 37.6 × 24.9 cm (left). The Pearl and Seymour Moskowitz Collection, Arthur M. Sackler Gallery, National Museum of Asian Art, Smithsonian Institution, S2021.5.266a–b

In this disturbing diptych, Oiwa's disembodied head lies on the ground by her wicked husband, Iemon. Drawing his sword, Iemon stands upright between his associate, Naosuke Gonbei, on the right and Oiwa's brother-in-law, Satō Yomoshichi, on the left. There are many variations of the *Yotsuya kaidan* story, with some scenes performed less often than others or certain techniques developed only for particular productions, and woodblock prints reflect this variety. In this rarely performed scene, Oiwa's dismembered head has rolled out of a container—the blue spirit flame (*shinka*) rising from the top making it clear the head is supernaturally animated. There are multiple angles of conflict here—not only the tension between Iemon and Oiwa but also between Gonbei and Yomoshichi. Since the beginning of the play, Gonbei has been lusting after Oiwa's sister, Osode, who is married to Yomoshichi. Iemon convinces Oiwa to remain with him so he can seek vengeance against her father's murderer, and Osode agrees to divorce Yomoshichi and marry Gonbei for the same reason. (The sisters are unaware that the murderer is actually Iemon.) Gonbei's villainous nature is indicated by the red makeup lining his eyes and his cowardly posture as he falls back from Oiwa's reproachful glare. In contrast, Yomoshichi's powerful stance and stylish clothing make him an appealing figure, and it is he who kills Iemon in the final act, with the help of supernatural assistance by Oiwa. In each performance of this play, the same actor plays both Yomoshichi and Oiwa, providing a multilayered tension between the characters. Onoe Kikugorō III was particularly renowned for his ability to perform multiple roles in the same production through rapid costume and makeup changes, which thrilled the audience. A dummy Oiwa head allowed both characters to appear onstage at the same time during this sequence.

This print depicts a performance of *Yotsuya kaidan* that opened at the Wakadayū theater in Osaka in the 3rd month of 1831. In general, the Osaka style of kabuki is characterized as *wagoto*, or "gentle style," in comparison to the *aragoto*, or "rough stuff," manner in which Edo-style kabuki was performed. As a visual analogue, Osaka actor prints are comparatively less crowded with cartouches and compositional elements, and the artists paid more attention to depicting the actual physiognomies and emotional states of the actors rather than their stylized and overblown Edo equivalents. Devoid of extraneous elements, the deep black background makes this a relatively refined design, despite the gruesomeness of the scene.

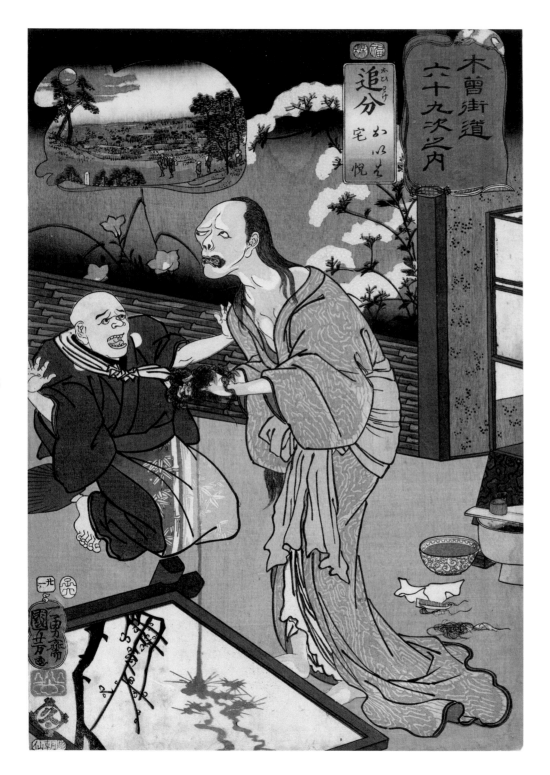

44

8 *Oiwake: Oiwa and Takuetsu*, no. 21 from the series *Sixty-nine Stations of the Kisokaidō Road (Kisokaidō rokujūkyū tsugi no uchi)*

Utagawa Kuniyoshi (1798–1861); Block carver: Hori Chōsen (act. mid-19th century); Printer: Surikō Kozenki (act. mid-19th century); Publisher: Takadaya Takezō (act. ca. 1851–1861); Japan, Edo period, 1852, 6th month. Woodblock print; ink and color on paper; 35.3 × 24.3 cm. The Pearl and Seymour Moskowitz Collection, Arthur M. Sackler Gallery, National Museum of Asian Art, Smithsonian Institution, S2021.5.577

The Kisokaidō road (also known as the Nakasendō) was one of the five main highways that traversed Japan in the Edo period (1603–1868), connecting Edo and Kyoto via a mountainous inland route of approximately 330 miles. Sixty-nine post stations along the route offered places to rest, eat, and shop, and each location became associated with different views or local goods as the domestic tourism industry developed over the course of the eighteenth and nineteenth centuries. For this series, the artist Utagawa Kuniyoshi was commissioned to produce designs to match each of the stations, creating images whose subjects are often clever puns on the place names. The series was a massive undertaking, produced through the collaboration of twelve different publishers, and several different block carvers and printers are also indicated by their seals on the various designs.[14] Kuniyoshi was a specialist of martial, supernatural, and macabre imagery, and the series exemplifies his visual and verbal creativity.

For this composition, Kuniyoshi has paired the famous "hair-combing" (*kamisuki*) scene from the *Yotsuya kaidan* with the post station Oiwake, located in the present-day town of Karuizawa, Nagano prefecture. The literal meaning of "Oiwake" is "forked road," but the same sounds can also mean "Oiwa's hair" (*Oiwa-ke*). The scenery of Oiwake station is shown in a cartouche in the upper left in the shape of a rat, with the full moon replacing the rat's eye. In Act V, Iemon complains the rats infesting his retreat have been sent by Oiwa, who was born in the year of the rat. Unlike the dark, cavernous backgrounds common to ghost prints made in Osaka, Kuniyoshi's version shows more details of the interior of Oiwa's residence. A comb and a bowl filled with water beside clumps of hair illustrate the section of the play where Oiwa attempts to make herself presentable before confronting her treacherous husband. Married women of this period often blackened their teeth for cosmetic effect, but Oiwa had not done so since giving birth. She attempts to do so now, but her numb fingers can only smear the blackening paste around her mouth, which makes her both more gruesome and more pitiable. She squeezes a clump of her hair, dripping blood onto the white paper of a standing screen decorated with plum blossoms. It is relatively unusual for a block carver's name to be included on a woodblock print, and it is even less common for that of a printer. However, the effect used here by the printer Surikō Kozenki is worthy of recognition. Red pigment has been blown through a straw to create this realistic splatter effect where the blood hits the paper.

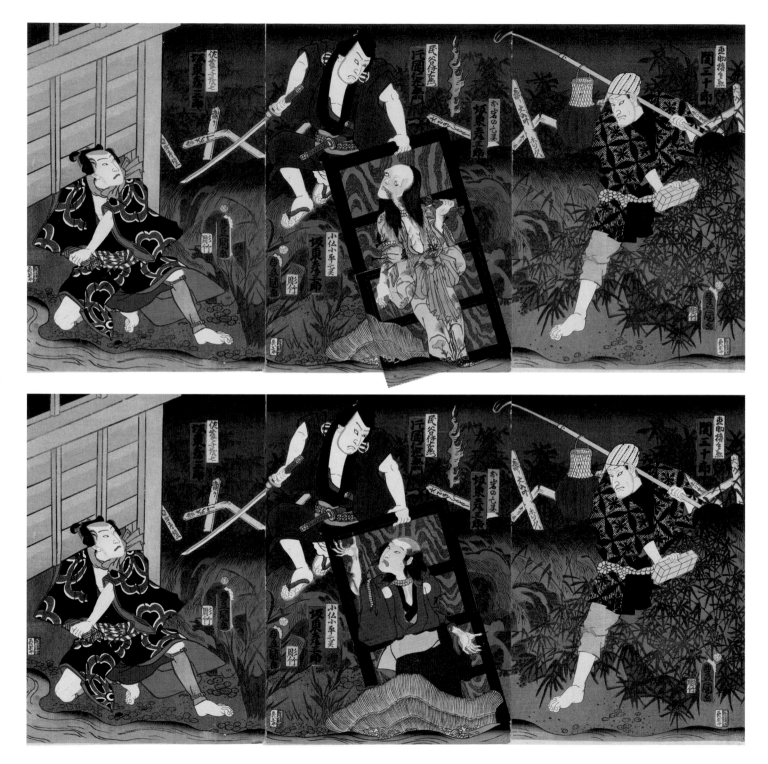

9 Seki Sanjūrō III as Naosuke Gonbei (R), Kataoka Nizaemon VIII as Tamiya Iemon (C) and Bandō Hikosaburō V as both the Ghost of Oiwa (*Oiwa no bōrei*) and the Ghost of Kobotoke Kohei (*Kobotoke Kohei bōrei*) (C), and Bandō Hikosaburō V as Satō Yomoshichi (L)

Utagawa Kunisada (1786–1865); Block carver: Yokokawa Takejirō (Hori Take) (act. 19th century); Publisher: Ebisuya Shōshichi (Kinshōdō) (act. ca. 1846–1883); Japan, Edo period, 1861, 7th month. Woodblock print; ink and color on paper; 37.5 × 25.4 cm (right); 37.5 × 25.7 cm (center); 37.6 × 25.7 cm (left). The Pearl and Seymour Moskowitz Collection, Arthur M. Sackler Gallery, National Museum of Asian Art, Smithsonian Institution, S2021.5.504a–c

This rare print is a *shikake-e*, or "trick picture," in which a piece of paper has been pasted along one edge and attached to the print. When the pasted paper is lifted, a new scene or detail is revealed. In this case, the initial image shows Oiwa, nailed to a raindoor and pulled to the surface by Iemon's fishing hook. When the paper is lifted, Oiwa is replaced with the corpse of the manservant Kohei, whose long fingernails have kept growing even after his death. This remarkable print technique is in imitation of the lauded stage technique of the "raindoor flip" (*toitagaeshi*) (see pages 24–27 in this volume). The red, rectangular cartouches beside each figure identify the actors playing each role, which determines this print was published at the time of a production of the *Tōkaidō Yotsuya kaidan* that debuted at the Nakamura theater, Edo, on the 11th day of the 7th month, 1861.[15]

The raindoor flip appears in Act III and requires sophisticated stage technology and daring performance. The stage for this scene is set with a large artificial embankment and a tank of water along the front of the stage, which allows Iemon to fish from the bank and eventually discover the bodies of his victims, Oiwa and Kohei. Obscured with debris, the raindoor is moved into place before a hidden compartment in the embankment, where the actor playing Oiwa (here, Bandō Hikosaburō V [1832–1877]) would place their head and arms through purpose-built holes that aligned with a dummy torso and legs on the other side of the door. When the raindoor is revealed to the audience, the actor's arms and head complete the illusion as Oiwa wails and laments at Iemon. The door is submerged again and flipped, with a dummy body of Kohei now facing the audience. Hidden within the embankment, the actor performs a quick costume change by removing the disfiguring facial prosthetics that define Oiwa and transforming into Kohei's corpse before placing his arms and head through the hole to emerge once more in this new guise.

However, Bandō Hikosaburō V's job was incomplete, as he also plays the character of Satō Yomoshichi (far left) in this scene, who appears a few minutes after the door is submerged for the final time. He had initially appeared in this role at the beginning of the scene to squabble with Iemon, before changing into Oiwa under the embankment. After performing the raindoor flip, the actor slips out from under the embankment and changes from Kohei back to Yomoshichi to emerge stage right. The crowd (and print audience) is very much aware that the same actor plays all these roles, which adds to the thrill of the performance. The seemingly supernatural talents of the actors and the technical level of the stagecraft is almost on the level of Oiwa's own powers to manipulate and transform.

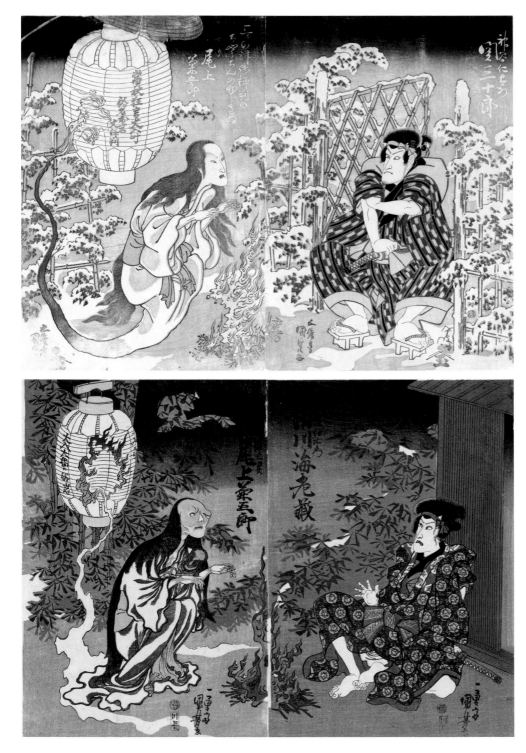

10-1
Seki Sanjūrō II as Kamiya Niemon and Onoe Kikugorō III from Kamigata (*Kudari*) as the Lantern Ghost, Applauded throughout the Three Cities (*Sanganotsu gohyōban no chōchin no yūrei*)

Utagawa Kunisada (1786–1865); Publisher: Moritaya Hanzō (act. ca. 1825–1835); Japan, Edo period, 1831, 2nd month. Woodblock print; ink and color on paper; 36.8 × 25.3 cm (right); 36.8 × 25.6 cm (left). The Pearl and Seymour Moskowitz Collection, Arthur M. Sackler Gallery, National Museum of Asian Art, Smithsonian Institution, S2021.5.505a–b

10-2
Ichikawa Ebizō V as Tamiya Iemon & Onoe Kikugorō III as the Ghost of Oiwa

Utagawa Kuniyoshi (1798–1861); Publisher: Kawaguchiya Chōzō (act. 1830–1840); Japan, Edo period, 1836, 7th month. Woodblock print; ink and color on paper; 38.1 × 26 cm (right); 38 × 26 cm (left). The Pearl and Seymour Moskowitz Collection, Arthur M. Sackler Gallery, National Museum of Asian Art, Smithsonian Institution, S2021.5.566a–b

The final location in the play *Tōkaidō Yotsuya kaidan* is the Snake Mountain Hermitage, an isolated religious retreat where Iemon flees after the deaths of his victims, Oiwa, Kohei, Oume, and Kihei. We first see the hermitage in a dream sequence, when Iemon imagines an alternate reality in which he has been restored to samurai status and Oiwa's death is just an unfortunate memory. In a bright, summery scene that contrasts with the gloomy destitution in the rest of the play, Iemon spies a beautiful country woman, played by the same actor who plays Oiwa. The audience watches in horrified amusement as Iemon seduces her, seemingly oblivious of her true identity despite his own observations about her remarkable resemblance to his former wife. After their tryst, Oiwa reveals herself, transforms, and attacks him.

Act V continues on Snake Mountain, where several months have passed while Iemon convalesces from his fevered visions, not safe from Oiwa even in his dreams. In both diptychs, a buildup of snow is visible on the bamboo, and Iemon wears a thin headband known as a *yamai hachimaki*, used in kabuki to signify physical and mental illness. Outside the hut, Oiwa approaches carrying their infant son. When Iemon begins muttering Buddhist prayers, Oiwa hands him their child, and Iemon promptly drops him. When the child hits the ground, he is transformed into a stone sculpture of the boddhisatva Jizō.[16] Kuniyoshi's diptych foreshadows this moment by depicting Oiwa cradling a sculpture. In the earlier dream sequence, Oiwa cites a poem from the *One Hundred Poets, One Poem Each (Hyakunin isshu)* to compare herself to stone, since the "*iwa*" character in her name means "boulder."[17] The visceral connection between the stone sculpture and Oiwa is visually emphasized by the heavy use of blue pigment to depict them both.

Both diptychs show the most well-known effect in *Yotsuya kaidan*, the so-called *chōchin nuke*, or "burst from a lantern," technique (see pages 21–23 in this volume), which first debuted in the production illustrated by cat. 10-1. Beside the name of Onoe Kikugorō III, who is playing Oiwa, Kunisada's version contains the inscription "Applauded throughout the Three Cities," referring to the major metropolises of Edo, Kyoto, and Osaka and to Kikugorō's continued acclaim six years after the play first opened. Kunisada was famous for his depictions of actor likenesses (*yakusha nigao-e*), and his rendition shows a closer approximation of the actors' features that would have been appreciated by their devoted fans. Although he also depicts Kikugorō III as Oiwa, Kuniyoshi was known for his violent and supernatural designs, and Oiwa's countenance here is more monstrous than flattering in appearance.

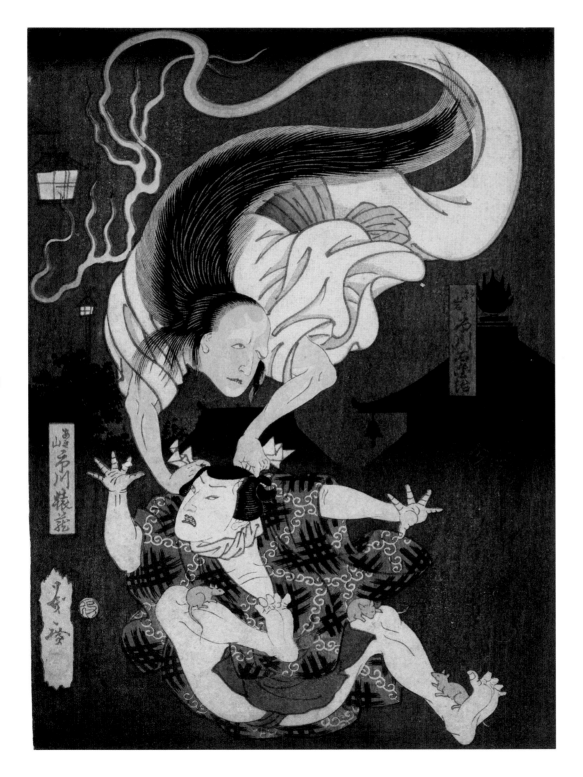

50

11 Ichikawa Udanji as Oiwa, Ichikawa Enzō as Akiyama

Shūgansai Shigehiro (act. ca. 1860s–1878), Japan, Edo period, ca. 1862–1878. Woodblock print; ink and color on paper; 24.2 × 17.6 cm. The Pearl and Seymour Moskowitz Collection, Arthur M. Sackler Gallery, National Museum of Asian Art, Smithsonian Institution, S2021.5.139

The climax of the play *Yotsuya kaidan*, Act V, takes place at a Buddhist hermitage on Snake Mountain, where Oiwa wreaks her revenge on her wicked husband, Iemon, and his associates for all the wrongs they have committed against her. The location is significant, as even though Iemon and his men have taken refuge on Buddhist grounds, the sanctity of their hideout is not enough to hold Oiwa at bay, signifying the total and terrifying breakdown of the normal world order. While Iemon is convalescing at the hermitage, he has been subject to repeated attacks by a swarm of rats. Oiwa was born in the year of the rat, making the creatures a fitting avatar for punishing her tormentors.

Although Iemon is the ultimate target of her vengeance, Oiwa also kills his henchman Akiyama Chōbei, depicted here. Chōbei had first been attacked by rats in his own home, after taking custody of a precious document for Iemon. He comes to Snake Mountain to return it, but Oiwa strangles him to death with a *tenugui* hand towel that she wraps around his neck. This is performed in a terrifying special effects sequence: the actor playing Oiwa enters a wheel hidden behind the altar, with only an aperture for him to emerge from visible to the audience. When the wheel is turned, the actor moves in an unsettling circular motion, above normal human height. Oiwa appears above Akiyama's head and strangles him. Once he has been killed, the direction of the wheel is reversed, enabling Oiwa to pull his body backwards into the compartment behind the wheel and out of sight of the audience and the other characters. Throughout this sequence, Iemon has his back turned, so he is unaware of Chōbei's fate. Although the designer has removed all the stage furniture for the composition of this print, the background provides the silhouette of a Buddhist precinct—indicating the location—and this mesmerizing scene would have been immediately recognizable to theatergoing fans.

The artist, Shūgansai Shigehiro, is mostly known for designing woodblock-printed images to accompany news stories for the *Osaka Daily Newspaper (Ōsaka Nichinichi Shinbun)* later in the Meiji era (1868–1912). This relatively early work reflects the prevalence of deluxe actor prints of the *chūban* format produced by private sponsorship for Osaka kabuki fan clubs, which often used specialist pigments and embossing. However, the round *kiwame* censorship seal in the lower left indicates this print may also have been sold in Edo. There is a barely visible inscription on the right, perhaps a poem, that may give insight into the circumstances of the print's production, should other more legible impressions be found.[18]

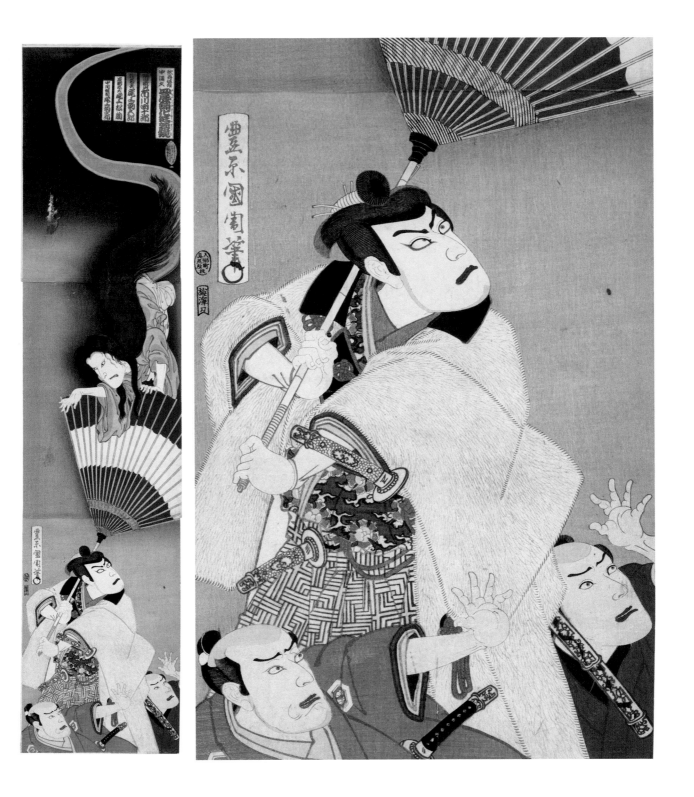

12 Onoe Kikugorō V as Okiku and Ichikawa Danjūrō IX as Aoyama Tessan, Onoe Kikujirō V and Onoe Matsusuke V as retainers

Toyohara Kunichika (1835–1900); Block carver: Umezawa Minokichi (act. ca. 1880–1922); Publisher: Fukuda Kumajirō (act. ca. 1874–1898); Japan, Meiji era, 1892. Woodblock print; ink and color on paper; 108.6 × 24.4 cm. Robert O. Muller Collection, Arthur M. Sackler Gallery, National Museum of Asian Art, Smithsonian Institution, S2003.8.2750

This scene is from a performance of *The Mansion of Plates and the Cursed Makeup Mirror (Sarayashiki keshō no sugatami)* that featured two star actors—Ichikawa Danjūrō IX (1838–1903) as the samurai Aoyama Tessan and Onoe Kikugorō V (1844–1903) in a female role as his victim, the maid Okiku. Tessan wants to have sex with Okiku, but when she refuses, he accuses her of stealing a priceless heirloom—one of a set of ten Dutch blue-and-white plates. When Tessan offers his forgiveness in exchange for sex, Okiku throws herself down a well instead and dies. Each night, her ghostly voice can be heard counting out the number of plates, but unable to get to ten, she lets out a terrifying wail that drives Tessan insane.

In this image, the snake-like form of Okiku's ghost descends from above, while the villainous Tessan and two of his male retainers are crowded together at the bottom. As if Okiku's supernatural status is not obvious to the viewer from her bodily contortions alone, her blue makeup, gray clothing, and the spirit flame (*shinka*) hovering in the upper sheet of the triptych make it clear she is a ghost. In contrast to Okiku's appearance, Tessan's superior social status is evidenced by his sumptuous clothing and the two swords he is permitted to wear as a samurai. Tessan uses both hands to grip his umbrella, which has turned inside out. This provides the viewer with a visual cue for the gusts of wind that accompany the appearance of a ghost, achieved onstage through the use of a trick umbrella. The vertical triptych format amplifies the drama, and the diagonal line formed by the umbrella shaft connects the two groups of figures, leading the eye upward from Tessan and his lackeys to the long, sinuous form of Okiku's body. The visible wood grain in the upper part of the print creates a swirl of distorted air, drawing the eye up even further.

Danjūrō IX was a major figure in Meiji-era kabuki, attempting a reform movement for more historically accurate performances, which made him a believable choice for a samurai figure. Kikugorō V was from a lineage of actors famous for their performances of supernatural roles, and he continued that tradition admirably. Despite their different styles, together, the two actors were engaged in reviving kabuki and elevating it to the status of a national theater. This period even became known as the "Dan-Kiku" era, in a portmanteau of their names. The extraordinary measure of producing this deluxe vertical triptych may have been to commemorate their dynamic collaboration onstage.

13-1
Ichikawa Kodanji IV as the Ghost (*Rei*) of Kozakura Tōgō and as the Tea Server (*Chadō*) Inba, Actually the Ghost of Tōgō (R), Bandō Hikosaburō IV as Orikoshi Tairyō, Iwai Kumesaburō III as the Secret Mistress (*Myō*) Katsuragi, and Ichikawa Kodanji IV as Koshimoto Sakuragi, Actually the Ghost of Tōgō (L)

Utagawa Kuniyoshi (1798–1861); Publisher: Kazusaya Iwazō (ca. 1842–1855); Japan, Edo period, 1851, 7th month. Woodblock print; ink and color on paper; 36.4 × 24.7 cm (right); 36.4 × 25.2 cm (left). The Pearl and Seymour Moskowitz Collection, Arthur M. Sackler Gallery, National Museum of Asian Art, Smithsonian Institution, S2021.5.553a–b

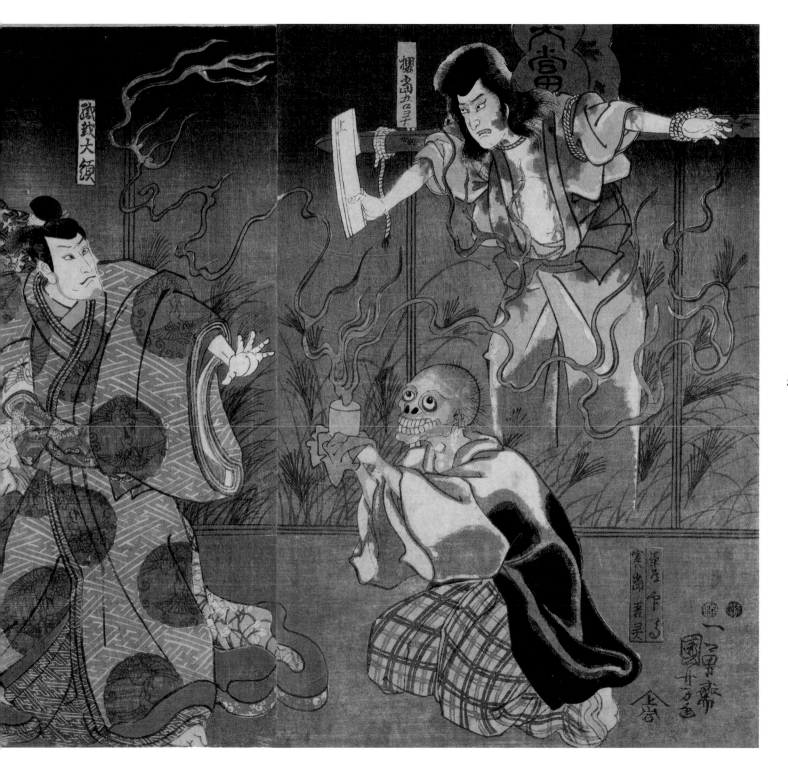

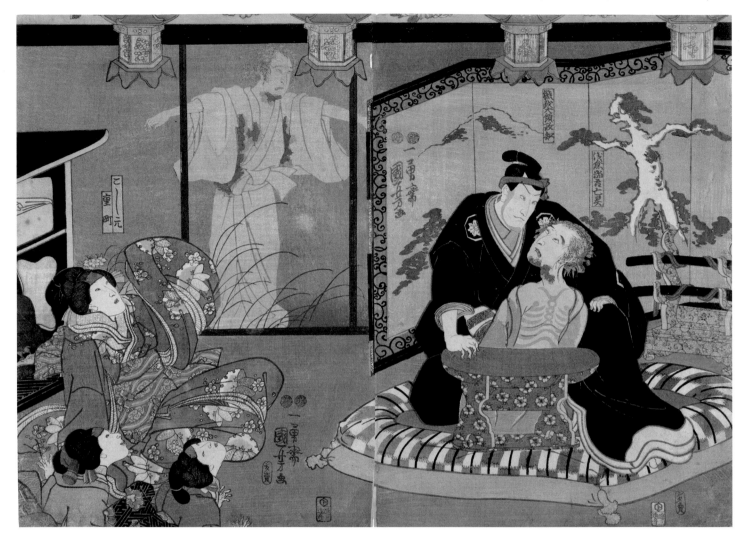

13-2 Scene from the play *"Higashiyama sakura no sōshi,"* at the Nakamura Theater, Edo

Utagawa Kuniyoshi (1798–1861); Publisher: Enshūya Hikobei (act. 1847–1852); Japan, Edo period, 1851, 8th month. Woodblock print; ink and color on paper; 35.8 × 25.4 cm (right); 35.8 × 25.2 cm (left). The Pearl and Seymour Moskowitz Collection, Arthur M. Sackler Gallery, National Museum of Asian Art, Smithsonian Institution, S2021.5.585a–b

Both diptychs by Utagawa Kuniyoshi depict scenes from the play *Higashiyama sakura no sōshi*, or *A Storybook of Cherry Blossoms in the Eastern Hills of Kyoto*, which debuted at the Nakamura theater in Edo in the 7th month of 1851.[19] Written by Segawa Jōko III (1806–1881), the play was a hit with the public and ran for one hundred consecutive days.[20] Kuniyoshi designed several works based on this play at the time of its production, issued by various publishers, who seem to have been quick to cash in on this lucrative subject. The artist returned to the theme in subsequent years, as his recognized brand of creative grotesquerie is particularly well-suited to the graphic retelling of that story.

The play is unusual in that the protagonist, Asakura Tōgo (also known as Kozakura Sōgo), is a member of the peasant class rather than a dashing masterless samurai (*rōnin*). After the residents of his village and the surrounding areas are taxed into starvation by the evil Lord Orikoshi Masatomo, Tōgo travels to Edo and delivers a petition for relief directly to the shogun, knowing that he and his family will be put to death for the insubordination of speaking out against their lord. Tōgo's wife and children are tortured and crucified in front of him before he is finally executed. The scene depicted so memorably by Kuniyoshi in these two diptychs shows Tōgo's ghost enacting revenge against Orikoshi for his cruelty. Not only does his ghost appear as a bleeding specter, but it also manages to possess Orikoshi's household servants and even manipulates the landscape painted on the folding screen that surrounds Orikoshi's sickbed—the white tree resembling Tōgo's crucified body. In cat. 13-1, Tōgo is still holding the missive to the shogun, revealing his tenacity even in the afterlife. In cat. 13-2, his ghost materializes from behind Orikoshi's red lacquer armrest, suggesting that even in sleep, the wicked lord will never again know peace.

The play is based on a farmers' revolt that occurred in Shimōsa province (now occupying territory in modern-day Chiba and Ibaraki prefectures) during the 1640s. At the time the play was first performed over two hundred years later, Japan was again shaken by famine. This was attributed to poor government, and with peasant uprisings occurring once more, the events depicted in the play would have felt immediate and contemporary. However, throughout much of the Edo period, it was officially forbidden to depict events and descendants of living personages who had lived after 1585 so as not to offend elite members of society. One way that artists, authors, and playwrights circumvented this prohibition was to set the events several centuries back in time or to tweak the names of the characters to differentiate them from historical personages. The name of the historical Lord Hotta Masanobu (1631–1680) was changed to Lord Horikoshi or Orikoshi and Sakura Sōgo to Asakura Tōgo. However, audiences would have seen through this flimsy ruse, and *Higashiyama sakura no sōshi* was also unusual in that the actors did not wear historicizing costumes but dressed in contemporary fashions. Nonetheless, some publishers were careful in how they marketed these prints so they would not draw undue attention from the government. The sheets of cat. 13-2 are marked with a long oval seal reading *shita-uri*, or "under sale," which seems to have meant such prints were sold "under the counter" and were not advertised prominently in the publisher's store.[21]

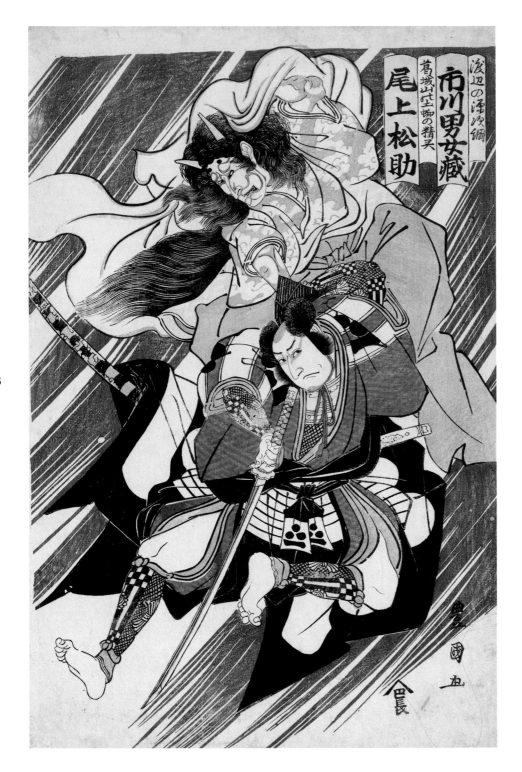

58

14 Ichikawa Omezō I as Watanabe no Genji Tsuna and Onoe Matsusuke I as the Spirit of the Earth Spider of Mount Katsuragi (*Katsuragisan no tsuchigumo no seikon*)

Utagawa Toyokuni I (1769–1825); Publisher: Nishimuraya Chō (act. ca. 1798–1810); Japan, Edo period, 1804. Woodblock print; ink and color on paper; 39.5 × 25.7 cm. The Pearl and Seymour Moskowitz Collection, Arthur M. Sackler Gallery, National Museum of Asian Art, Smithsonian Institution, S2021.5.606

The well-known legend of the *tsuchigumo*, or "earth spider," is based on an eleventh-century story of Minamoto no Yorimitsu (948–1021), who is more commonly known as "Raikō"—an alternate reading of the characters in his given name. A noh play of this tale existed for several centuries (see cat. 30) before a kabuki version, *The Spider's Web and the Stringed Catalpa Bow (Kumo no ito asuza no yumihari)*, first debuted in 1765 at the Ichimura theater in Edo. In the story, the supernatural creature known as the earth spider casts a spell over Raikō's mansion so that he and his associates are incapacitated or confused. A succession of characters arrives at the residence and attempts to gain access to Raikō, though they are all rebuffed. Finally, the earth spider manifests as Raikō's lover, Usugumo, but the men see through her disguise, and the spider's true form is revealed. After this confrontation, the *tsuchigumo* flees to its lair on Mount Katsuragi (on the border of present-day Osaka and Wakayama prefectures) for the final battle.

In the play, the *tsuchigumo* and all its different transformations are played by the same actor. In this case, it is Onoe Matsusuke I (1744–1815), who pioneered several ghostly and supernatural roles in the early nineteenth century, developed in collaboration with the playwright Tsuruya Nanboku IV (1755–1829) (see pages 18–19 in this volume). Transforming through the different roles required significant skill, not only to portray different genders, ages, and characters distinctly and plausibly but also to be able to perform the quick makeup and costume changes required for each part as well as their often acrobatic gestures. For example, after each manifestation is bested by Raikō's men, the earth spider throws webbing made of rice paper (*chisuji no ito*) at her opponents to simulate a spider's webbing.

At the climax, the opulence of Raikō's mansion falls away as the stage rotates to be replaced by the gloomy dank cave of the *tsuchigumo*'s lair, and Raikō and his men are attacked by a wave of spider warriors. For this final battle, Matsusuke wears a mask associated with female demons and the wide, red pants (*hakama*) worn by shrine attendants. The athleticism required for actors of supernatural roles is on display in this image; Matsusuke leaps behind Raikō, played here by Ichikawa Omezō I (1781–1833), connecting the actors in a diagonal composition that increases the dynamic tension. In this print, the sheets of rain, depicted in black ink, have been applied in jagged swathes that resemble the strokes of a wide hake brush. The rain sheets also resemble the *tsuchigumo*'s hair, as though she is one with the storm.

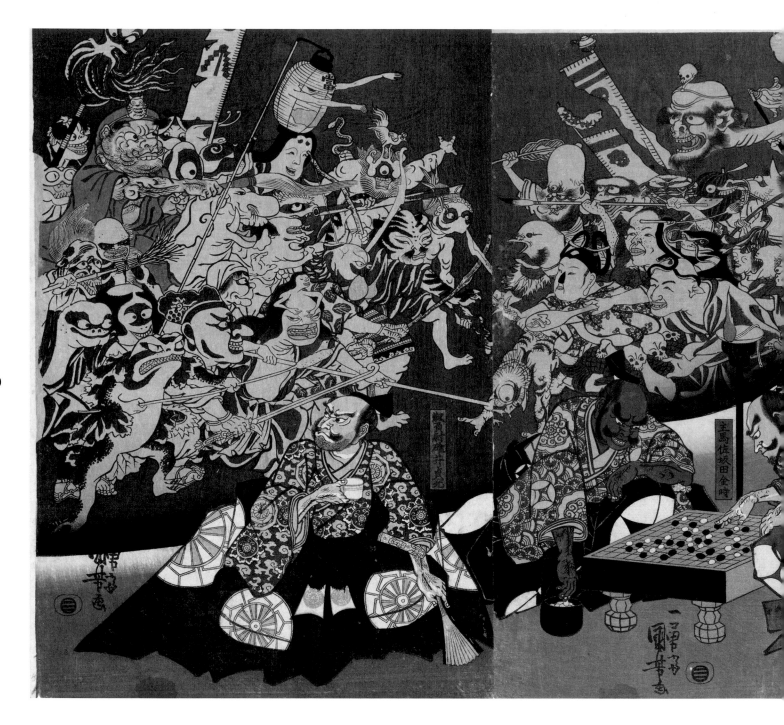

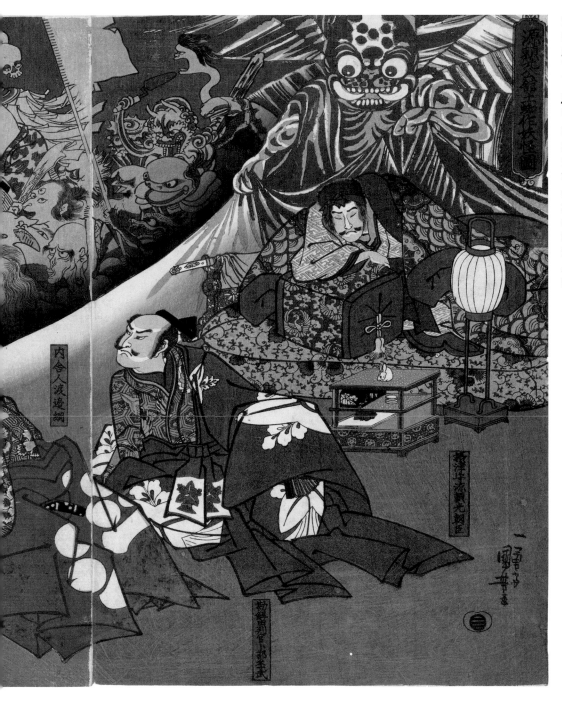

15-1 *The Earth Spider Generates Monsters at the Mansion of Lord Minamoto Yorimitsu (Minamoto Yorimitsu [Raikō] kō no yakata ni tsuchigumo yōkai o nasu zu)*

Utagawa Kuniyoshi (1798–1861); Publisher: Ibaya Senzaburō (act. ca. 1845–1847); Japan, Edo period, 1843. Woodblock print; ink and color on paper; 37.2 × 25.5 cm (right); 36.9 × 24.8 cm (center); 37.2 × 25.5 cm (left). The Pearl and Seymour Moskowitz Collection, Arthur M. Sackler Gallery, National Museum of Asian Art, Smithsonian Institution, S2021.5.591a–c

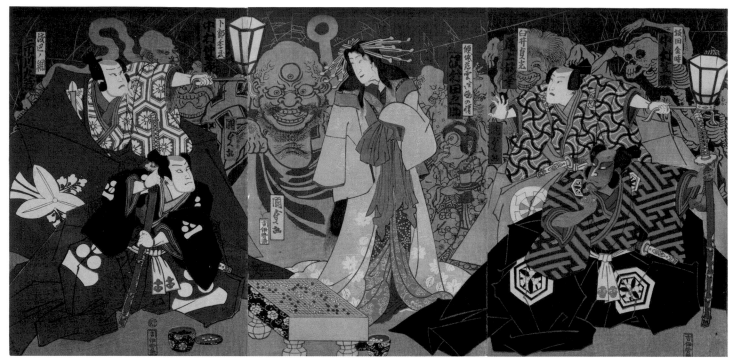

15-2 Nakamura Shikan IV as Sakata Kintoki and Onoe Baikō (Kakunosuke) as Usui Sadamitsu (R); Sawamura Tanosuke III as Usugumo, Actually the Spirit of a Spider (*Jitsu wa kumo no sei*) (C); Nakamura Chūtarō as Urabe no Suetake and Ichikawa Kuzō III as Watanabe no Tsuna (L)

Utagawa Toyokuni IV (1823–1880); Publisher: Iseya Kanekichi (act. ca. 1837–1875); Japan, Edo period, 1864, 10th month. Woodblock print; ink and color on paper; 35.8 × 24.7 cm (right); 35.9 × 24.7 cm (center); 35.9 × 24.7 cm (left). The Pearl and Seymour Moskowitz Collection, Arthur M. Sackler Gallery, National Museum of Asian Art, Smithsonian Institution, S2021.5.610a–c

A proficient military strategist, Minamoto no Yorimitsu, or Raikō, has the reputation of the "demon slayer" of Heian-period (794–1185) Kyoto, vanquishing the monsters that plagued the capital. Although he was a real historical figure, legend and folklore have been mixed into his character in the cultural imagination to create a hero of epic proportions. For example, Raikō was so renowned that the fearsome warrior Sakata no Kintoki, who had been raised by a mountain witch, decided to join him as one of his four companions.[22] Kintoki is depicted in both these triptychs as having red skin—a sign of his superhuman strength. One of the legendary monsters encountered by Raikō and his men is the *tsuchigumo*, the earth spider, who casts a spell over the group that leaves them distracted and listless (see also cats. 14, 30). It is only through Raikō's force of will that he is able to summon the strength to strike the spider, shattering the illusion. This story is likely based on the historical Raikō's battles with mountain bandits, who are referred to as *tsuchigumo* because, like spiders, they also lived in caves.[23]

Although the story had been illustrated in ukiyo-e for several decades already, one of the most startling presentations is by Utagawa Kuniyoshi (cat. 15-1). Unlike many previous versions done by Kuniyoshi and other artists in which Raikō is shown in dynamic action slashing at the *tsuchigumo*, Kuniyoshi has depicted him sleeping, surrounded by a parade of demons. This print was viewed by the Tokugawa authorities as a form of social protest, with the sleeping Raikō thought to satirize the ineffective shogun Ieyoshi (1793–1853) and the monsters in the background representing the victims of his government's reforms.[24] Both Kuniyoshi and his publisher were investigated, and the remaining woodblocks and unsold prints were ordered to be destroyed. Nonetheless, the image "went viral," and many pirated editions were produced. The inclusion of a "parade of one hundred night demons" (*hyakki yagyō*) in the background became a visual device used in subsequent print and stage variations of this story.

For example, Toyokuni IV's later interpretation has included an assortment of grotesque figures behind actors in a production of *The Spider's Web in the Early Evening (Kubekiyoi kumo no itosuji)* in 1864 at the Morita theater, Edo (cat. 15-2). In the stage version, the *tsuchigumo* transforms into several different people, including a child attendant, a medicine seller, and a blind musician, giving the actor the opportunity to thrill the audience by performing a sequence of costume changes. The *onnagata*, or female role-player Sawamura Tanosuke III (1845–1878), is depicted as the *tsuchigumo*, here in its final human disguise of Raikō's lover, Usugumo, a sex worker of the highest rank. On the stage, a large spider descends from the ceiling of Raikō's bedchamber and transforms into Usugumo when confronted by Raikō's bodyguards. Aside from the spiderweb pattern on her robe, another clue to her identity is her name, as "*gumo*" can mean both "spider" and "cloud."

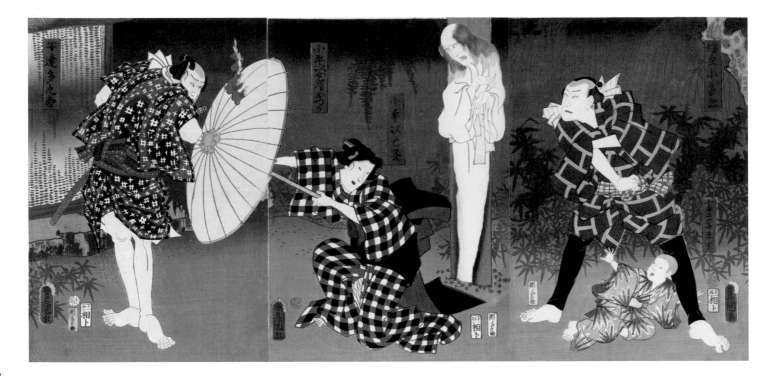

64

16 Ichikawa Kodanji IV as the youth Kohei and Nakamura Eizō as Koheiji's infant son Heikichi (R), Ichikawa Kodanji IV as the Ghost of Koheiji and Iwai Kumesaburō III as Koheiji's wife Otsuka (C), and Seki Sanjūrō III as Adachi Takurō (L)

Utagawa Kunisada (1786–1865); Block carver: Sugawa Sennosuke (act. late 19th century); Publisher: Sagamiya Tōkichi (act. ca. 1855–1866); Japan, Edo period, 1859, 7th month. Woodblock print; ink and color on paper; 36 × 25.3 cm (right); 36.2 × 24.8 cm (center); 36 × 25.1 cm (left). The Pearl and Seymour Moskowitz Collection, Arthur M. Sackler Gallery, National Museum of Asian Art, Smithsonian Institution, S2021.5.510a–c

Male ghosts are less common in Edo-period kabuki plays of domestic revenge but are not unknown. The same playwright who created the female ghosts of Oiwa and Kasane, Tsuruya Nanboku IV, also popularized the story of Kohada Koheiji in his 1808 play *A Colorful Storybook (Iroiri otogi zōshi)*. In Nanboku's characteristic manner, he combined extant fictionalized versions based on real-life events—in this case capitalizing off the success of an illustrated novel by Santō Kyōden (1761–1816), *The Bizarre Tale of Revenge at Asaka Marsh (Fukushū kidan Asaka no numa)*, published just a few years earlier in 1803.[25] This story is a particularly fascinating example of adaptation into a kabuki ghost play, as the character of Koheiji is based on a real person of the same name, a kabuki actor who had possessed a special skill in portraying ghosts, or *yūrei*. The historical Koheiji's dead body had been found in Asaka marsh (present-day Koriyama city, Fukushima prefecture), which Nanboku used for the title of his play to emphasize its historical grounding. This blending of real life and fiction was a dynamic combination and no doubt contributed to the play's success for several decades.

Regarded as an actor with little skill, Koheiji is reduced to touring with a troupe in the provinces, where audiences are less discerning than in the major cities. His wife, Otsuka, pictured here in the center, is having an affair with a *taiko* drum player from the Morita theater named Adachi Takurō; he cuts a dashing figure here on the left wearing an *obi* sash of an imported Southeast Asian textile. Aside from the weaknesses in her own moral character, Otsuka has a history of poor decisions regarding her romantic choices. Her previous husband had murdered the legendary kabuki actor Ichikawa Danjūrō I (1660–1704), who was in fact stabbed to death in his dressing room on March 24, 1704.[26] Due to his strange and sickly demeanor, Koheiji's theater manager suggests he try his hand at playing ghost roles, and Koheiji builds on this natural suitability by studying corpses. As he begins receiving acclaim for these performances, Otsuka's lover, Takurō, travels to meet him. Koheiji naively thinks this is a visit from a colleague; however, Takurō takes him on a fishing trip and drowns him in a swamp. When Takurō returns home to Edo, he excitedly tells Otsuka he has completed their plan and Koheiji is dead. Otsuka is confused, telling him that Koheiji had returned home shortly before. However, he has vanished. Koheiji's acting training means he knows exactly how to behave now that he has become a real ghost. Several months pass, and once Takurō and Otsuka relax their guard and settle into family life together, Koheiji's spirit takes his revenge to torment the adulterous couple until they are both driven mad.

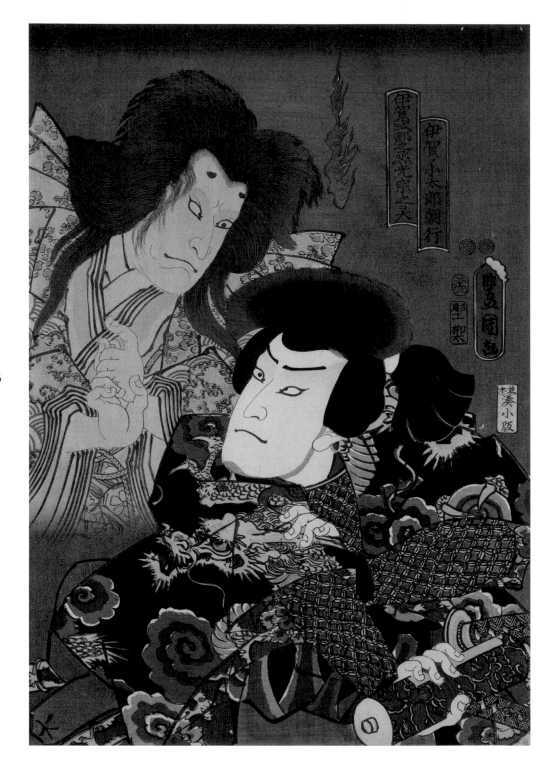

17 Nakamura Fukusuke I as Iga no Kotarō Tomoyuki (R) and Nakamura Utaemon IV as the ghost of Iga Shikibunojō Mitsumune

Utagawa Kunisada (1786–1865); Block carver: Ryūta; Publisher: Minatoya Kohei (Kinsendō) (act. ca. 1841–1862); Japan, Edo period, 1852, 6th month. Woodblock print; ink and color on paper; 36.2 × 25.1 cm. The Pearl and Seymour Moskowitz Collection, Arthur M. Sackler Gallery, National Museum of Asian Art, Smithsonian Institution, S2021.5.485

The eerie sight of Iga Shikibunojō Mitsumune's ghost looming over the shoulder of the younger man is made even more haunting by the knowledge that the actor playing the ghost, Nakamura Utaemon IV (1798–1852), had died two months prior to this print's publication. His spectral status is clear from the muted colors used to render both his ghostly form and the *shinka* flame alongside his head. Black eye makeup is used for ghosts to make the actor's eyes appear larger; in this case, it amplifies Utaemon's exaggerated facial gesture of concentration made by crossing only one of his eyes, a talent that is highly valued among kabuki actors. He is performing a ritual hand movement used by magicians to cast spells. These gestures are also used in Buddhist iconography and would perhaps have been seen as another reminder that Utaemon had already entered the afterlife. As Utaemon was a major celebrity, his death would have been common knowledge among theater fans.

The scene is from the play *Record of Honorable and Benevolent Rulers (Meiyo jinsei roku)*, which opened at the Ichimura theater in Edo in the 7th month of 1852. It is a dramatized version of a very successful serialized novel by Kyokutei Bakin (1767–1848), *The Story of Aoto Fujitsuna (Aoto Fujitsuna moryō-an)*, published between 1811 and 1812 with illustrations by Katsushika Hokusai (1760–1849).[27] The novel is partially based on a real-life historical figure, a magistrate named Ōoka Tadasuke (1677–1752) who was known for his fair judgments.[28] But how could this play be performed if a star actor had died before the production began? In fact, Utaemon's part was played by a voice imitator, known as a *kowairozukai*. Although this tradition has died out in the age of voice and video recording, the talent for imitating famous kabuki actors' voices was greatly appreciated as a form of entertainment in the Edo period. There were professional imitators who could step in for actors who were ill or otherwise unable to perform or who could offer a glimpse of the theater to establishments outside the officially licensed theaters. There were also commercial publications aimed at general readers in the genre of *kowairo*, or "voice mimicry," instructional guides on how to imitate the voices of well-known kabuki actors. Furnished with such a book (and some practice), household members could entertain one another by recreating scenes they may have seen at the theater or in woodblock prints. In this case, the *kowairozukai* had an additional effect, with Utaemon's voice seemingly speaking out from beyond the grave. The light dusting of glittering mica along the top of the print adds to the eerie otherworldliness of this performance.

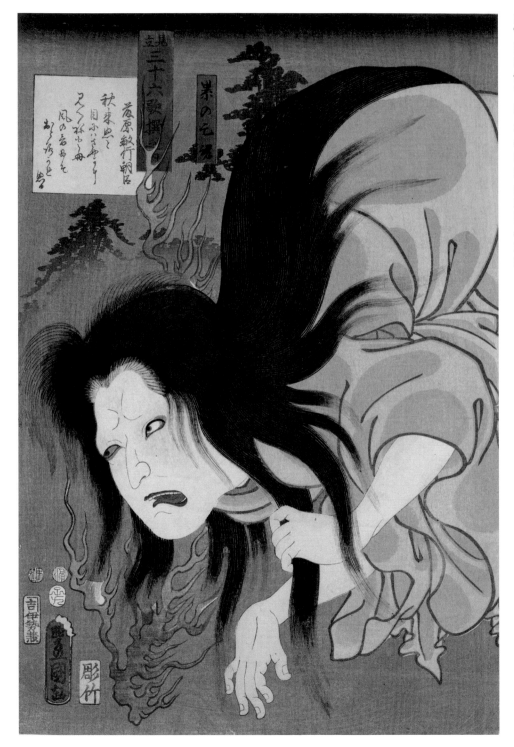

18 Poem by Fujiwara no Toshiyuki Ason: Ichikawa Kodanji IV as the Ghost of Kasane (*Kasane no bōkon*), from the series *Comparisons for Thirty-six Selected Poems (Mitate sanjūrokkasen no uchi)*

Utagawa Kunisada (1786–1865); Block carver: Yokokawa Takejirō (Hori Take) (act. 19th century); Publisher: Iseya Kanekichi (ca. 1837–1875); Japan, Edo period, 1852, 9th month. Woodblock print; ink and color on paper; 36.1 × 24.2 cm. The Pearl and Seymour Moskowitz Collection, Arthur M. Sackler Gallery, National Museum of Asian Art, Smithsonian Institution, S2021.5.494

Although less immediately recognizable than Oiwa and Okiku, Kasane is another recurring figure in the pantheon of female ghosts that emerged in Edo-period kabuki theater. She was born in the village of Hanyū in modern-day Ibaraki prefecture, and her ghost was exorcized in 1692 by the monk Yūten Shōnin (1636–1718). Given the name Rui by her parents, she was born with the same physical abnormalities as her brother, Suke, who had been murdered before her birth. The villagers believe she is a reincarnation of her brother, and so they instead call her "Kasane," an alternate reading of the character for "Rui" that means "to pile on." After her parents' deaths, Kasane is murdered by a suitor who had only pretended to be in love with her so he could acquire her land. Kasane's ghost returns to possess her former husband's new wives and eventually his daughter. However, Kasane's rage cannot be contained, and she also strikes out at all the villagers who stood idly by and watched her be murdered. It is only the holy power of Yūten that can finally pacify her spirit, and when she recites a sutra with him, it is revealed she has indeed been Suke all along.

Many different theatrical versions and adaptations are loosely based on these events, and as is typical with kabuki, the plots became more complex over time. However, the story always centers around deformity, rebirth, and revenge. Although the historical Kasane was deformed, in many adaptations she is performed as a beautiful woman who falls in love with a handsome samurai named Yoemon. Unbeknownst to Kasane, Yoemon had an affair with her mother, and the lovers had killed Kasane's father when they were discovered. He was brutally murdered, with Yoemon stabbing his leg and the mother gouging out her husband's eye. In the play, there is an intense dance sequence, where at first the lovers Yoemon and Kasane are planning a romantic love-suicide by a river. However, Yoemon is attacked by the spirit of Kasane's father, and Yoemon's eye and leg begin to hurt in the same places where Kasane's father had been wounded. The actor playing Kasane quickly applies makeup and a facial prosthetic while her face is hidden from the audience to resemble the distorted features from the legend.

This is the moment depicted in the image here, where the actor descends from the top of the stage. She is possessed by the spirit of Suke but is passionately gripping her hair as she approaches her lover. Kasane has been paired with a poem by Fujiwara no Toshiyuki (d. 901 or 907):

> To my eyes it is
> not clear that autumn has come
> but the chill whisper
> of the invisible wind
> startles me to awareness[29]

As in the poem, the sound of the wind signals the arrival of a ghost, even if it cannot be seen—just as Suke's resentment lies right under the surface of Kasane's beautiful face.

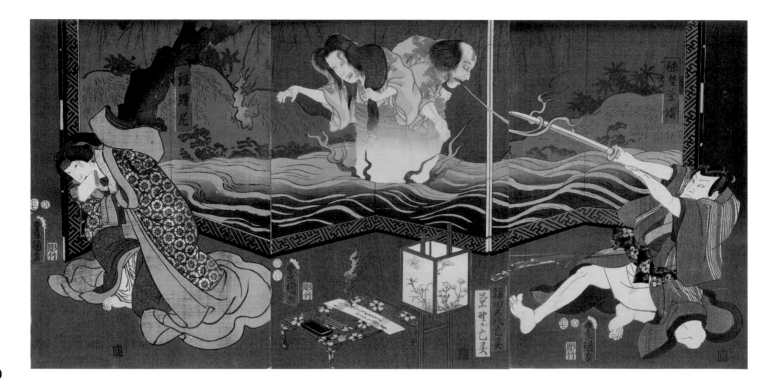

70

19 Ichikawa Kodanji IV as Mari no Kanemitsu (R), Ichikawa Kodanji IV as both the Ghost of Kamada Matahachi (*Kamada Matahachi bōrei*) and the Ghost of Kikuno (*Kikuno ga bōrei*) (C), and Iwai Kumesaburō III as the Nun Kyōdai (*Kyōdai-ni*) (L)

Utagawa Kunisada (1786–1865); Block carver: Yokokawa Takejirō (Hori Take) (act. 19th century); Publisher: Hayashiya Shōgorō (act. ca. 1845–1863); Japan, Edo period, 1855, 7th month. Woodblock print; ink and color on paper; 36.1 × 24.8 cm (right); 36 × 25.3 cm (center); 36.2 × 24.8 cm (left). The Pearl and Seymour Moskowitz Collection, Arthur M. Sackler Gallery, National Museum of Asian Art, Smithsonian Institution, S2021.5.495a–c

Two flanking characters recoil in horror from the back-to-back apparitions in the center sheet, bound together in a woven basket and seemingly emerging from a painted folding screen. This triptych depicts a scene from a performance of the play *True Record of the Famous Song for Handballs (Nani takashi temariuta jitsuroku)* at the Nakamura theater, Edo, in the 7th month of 1855. The actor Ichikawa Kodanji IV (1812–1866) was a specialist at *hayagawari*, or quick costume changes, and he played six separate roles in this play. Three of those characters are shown here, as Kodanji played the villainous Mari no Kanemitsu, on the right drawing his sword, in addition to both ghost characters.

Kanemitsu murders the pair—named Kamada Matahachi and Kikuno—after they discover his affair with the nun Kyōdai, here on the left. Kyōdai's husband had been a noble lord, and although she becomes a nun after her husband's death, she also continues her affair with his brother, Kanemitsu. The perception that Kanemitsu has taken advantage of his brother's wife—someone he should have protected as if she were family—would have destroyed his reputation, and so their affair is kept a secret. However, the lord's concubine Kikuno and his loyal retainer Matahachi discover the liaison and confront them. The stark contrast between the scheming Kanemitsu and the devoted Matahachi would have been more apparent to Edo-period viewers, as Matahachi was a popular character in contemporary culture, known as a brave fighter and famous for defeating monsters and wild animals. When confronted by Matahachi, Kanemitsu turns the accusation of adultery around and accuses Matahachi and Kikuno of having an affair behind his brother's back. Meting out his own punishment, he ties them together and throws them into a river, where they drown.

The falsely accused ghosts get their revenge by tormenting Kanemitsu and Kyōdai, appearing to them in a dream. In a distorted mimicry of the place of their deaths, they materialize from a painted river on a folding screen. Kyōdai is terrified and comes forward to tell the truth about what happened and to clear Matahachi's and Kikuno's names. The story undoubtedly raises issues of family responsibility and loyalty. It is also significant that the sinful accusers are of the elite samurai class, whereas those suffering from their selfishness and injustice are of subordinate status. This would have unquestionably appealed to the primary audience of kabuki, the urban commoner class, who often suffered at the hands of the samurai-led government.

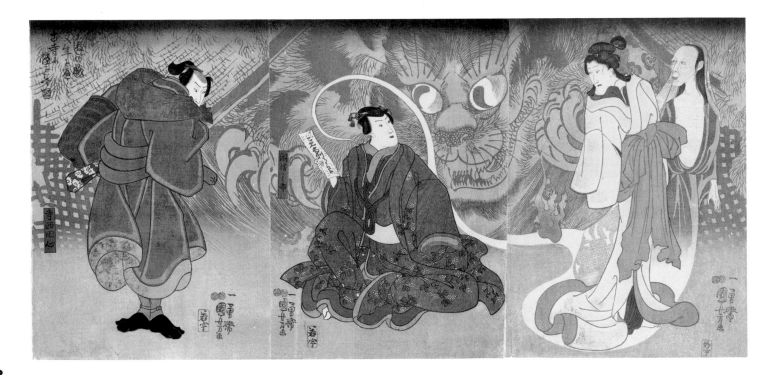

72

20 Scene from a Ghost Story: The Okazaki Cat Demon (Mukashi banashi no tawamure nekomata wo hete koji ni kai wo nasu zu)

Utagawa Kuniyoshi (1798–1861); Publisher: Wakau (act. ca. 1842–1850); Japan, Edo period, 1847, 7th month. Woodblock print; ink and color on paper; 35.5 × 25.5 cm (each sheet, approx.). The Pearl and Seymour Moskowitz Collection, Arthur M. Sackler Gallery, National Museum of Asian Art, Smithsonian Institution, S2021.5.562a–c

Printed entirely in gray, the enormous ghostly apparition of a monster cat, known in Japanese as a *kaibyō*, rips apart the walls of the abandoned temple where the hero, Inabanosuke (center), has taken refuge. The talisman he grips in his right hand is inscribed with a Buddhist verse that protects him from the ghostly figure to his left. This is the old woman who lives at the Muryōji temple in Okazaki—actually the monster cat in disguise—who has killed a local woman named Okura and possessed her body. The character on the left is Teranishi Kanshin, holding a sedge basket under one arm. This is a type of woven hat (*komusōgasa*) that was worn by traveling monks and swordsmen who wished to travel incognito.

The scene is part of the play *A Solo Journey Along the Fifty-three Stations (Hitori tabi gojūsan tsugi)*, which debuted in the 6th month of 1827 at the Kawarasakiza theater in Edo. Written by ghost play legend Tsuruya Nanboku IV just two years after the huge success of *Tōkaidō Yotsuya kaidan*, the play is based on the comic novel *Tōkaidōchū Hizakurige*, which is known in English as *Shank's Mare*. This is a humorous tale of misadventure authored by Jippensha Ikku (1765–1831) that was serialized over twenty years and is about two country bumpkins and their journey along the Tōkaidō road. Nanboku exploited his audience's familiarity with the title but gave the novel's two main characters only minor roles and focused on supernatural side stories instead. The scene of the monster cat was such a hit that the entire play is often abbreviated simply to "The Cat of Okazaki." It has continued to enthrall, and in the twentieth century, many plots from supernatural kabuki plays were reinterpreted for cinema by directors working in the *kaiki*, or "strange tales," genre. The *kaibyō* was a very popular example, with films such as the 1958 *Black Cat Mansion (Bōrei kaibyō yashiki)* and the 1968 *Black Cat (Kuroneko)* featuring wronged or abandoned women who transform into monstrous cats.

The production depicted here is from the special program *The Lifetime of Onoe Kikugorō (Onoe Kikugorō ichidai banashi)* held at the Ichimura theater in 1847. This presentation commemorated the thirty-third memorial service for Kikugorō III's adoptive father, Onoe Matsusuke I. Matsusuke was a specialist of ghost roles who had been succeeded admirably by his son Kikugorō. Kikugorō had become renowned for his acrobatic skills, his ability to perform *hayagawari* quick changes, and his portrayal of supernatural characters, including the transforming cat woman shown here. In addition to memorializing his father, this magnificent production also marked Kikugorō's own retirement, and he left the stage to open a store selling pounded rice cakes (*mochi*). However, the allure of the theater was too strong, and he returned to the stage less than a year later, performing until his death in 1849.

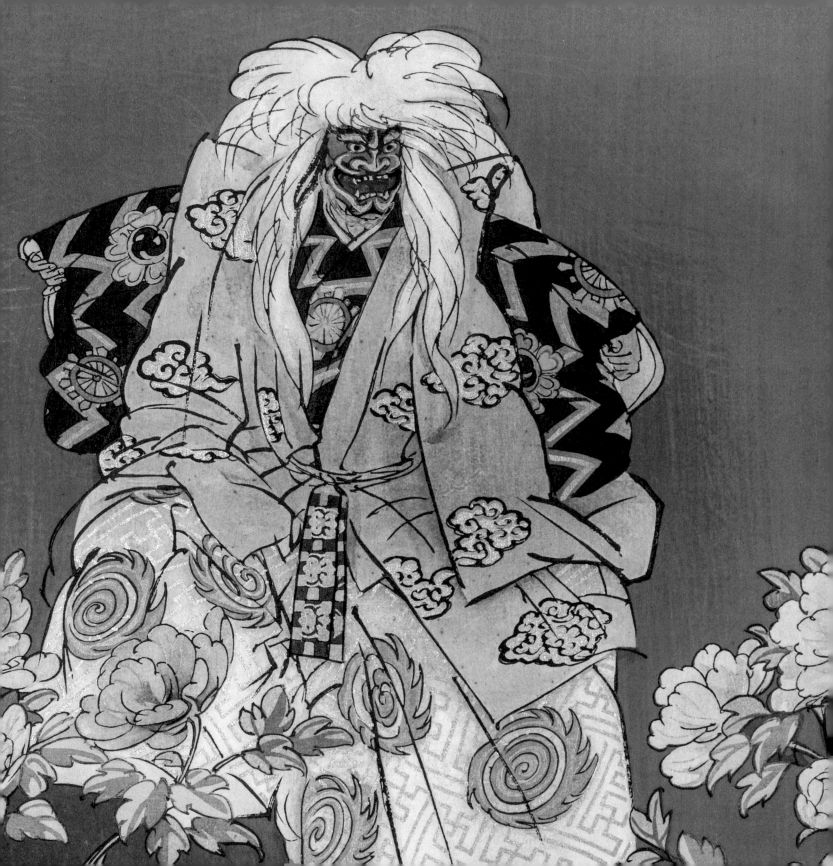

The Noh Theater Through the Eyes of Tsukioka Kōgyo

Frank Feltens

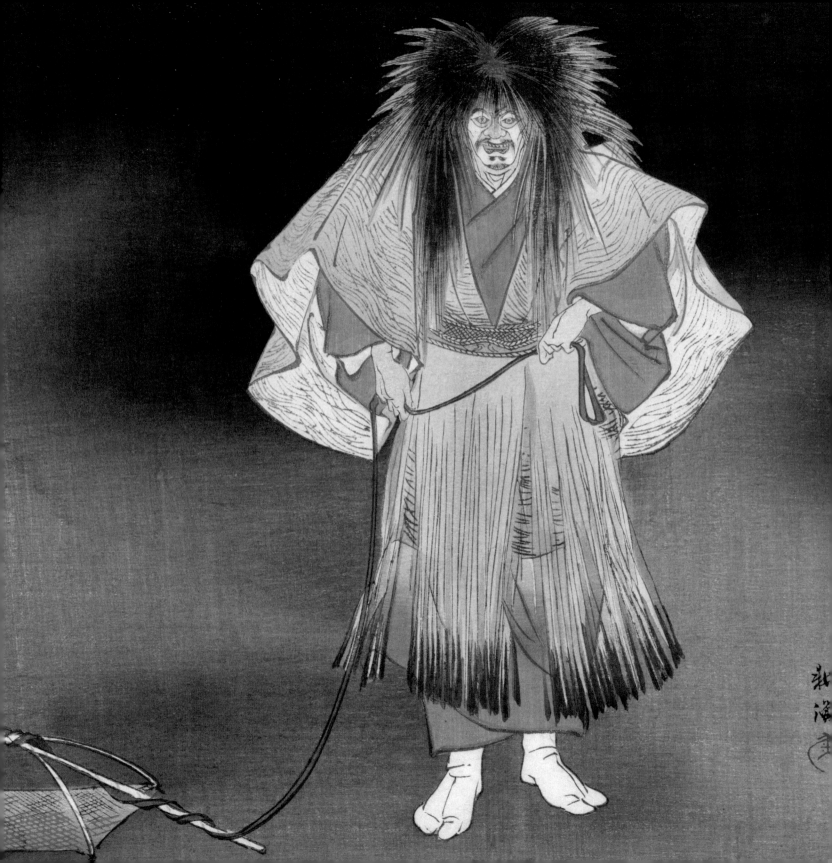

Spectral Modern: Tsukioka Kōgyo and Ghosts on the Noh Stage

The ghost of a fisherman stares back at the viewer, his wild hair framing the mask of an emaciated face casting a sinister gaze, at once strained and accusatory, his hand clasping a rope connected to a stylized fishing net (fig. 1, cat. 21). The costume is rendered in the blue tones of the sea that swallowed and killed the protagonist, while the surrounding sky is tinted a foreboding, vaporous black. It appears as if the ghost is trapped at the bottom of the ocean in eternal darkness. Contrasting with such disquieting stillness in *Akogi* is the light of *Dōjōji*, a print in which an actor dancing in a bright costume dons the white mask of a shunned female lover (fig. 2, cat. 26-1). The edge of a large temple bell is visible just above the character, hinting at her imminent transformation into a vengeful spirit who will spew fire against the bell to fry her lover hiding underneath. These are but two glimpses into the world of Tsukioka Kōgyo's (1869–1927) prints of the noh theater. Arguably the greatest and most specialized artist to capture and interpret this medieval form of theater, he created a body of work that differs drastically from other artists in both aesthetic and quantity.

Kōgyo was born just one year after the Meiji Restoration in 1868, which reinstated the Japanese emperor's political power, established a constitutional monarchy, and ushered in a time of change in virtually all areas of Japanese society and culture. Against the backdrop of that turbulent time, Kōgyo turned to the traditional medium of woodblock printing to help revive and recast noh, a centuries-old art of performance. Like many of his contemporaries, he seems to have been motivated by a blend of nostalgia, cultural preservation, and artistic impulse. His adopted father, the famous artist Tsukioka Yoshitoshi (1839–1892), drew inspiration from the theater in his own works. In the process of capturing the ethereal, otherworldly tenor of noh in his prints, Kōgyo turned to a specific visual language that reflected at once a traditional understanding of the noh theater, a distinctive blend of the different aesthetics of prints and paintings, and a novel awareness of medieval treatises that became known to a wider public for the first time in the early twentieth century. The combination of these elements resulted in daunting pictures of spirits on the stage.

Fig. 1 (left) Detail from cat. 21 **Fig. 2** (right) See cat. 26-1; Previous pages, detail from cat. 35

From ritual to theater

Noh is an art of hints in which abstract gestures, stylized stage props, and allusive language chanted in a muffled, guttural tone merge into a unity of expression and withholding. Much of the intimations of a play are left to the viewer to untangle and interpret. It is a performative art that involves chanting, singing, and dancing, often accompanied by a chorus and musical instruments, such as a flute and different-sized drums. Any music, however, is sparse, serving only to underline critical moments or to build up tension during a play. Traditionally, the entire cast of a noh play is male. The protagonist (*shite*), most often a spirit of a deceased person or a specter associated with a place, dons a carved wooden mask along with elaborate wigs and costumes that enable him not simply to act a part but effectively to assume the very soul of a character. The actor becomes someone—or something—other than himself. The protagonist interacts with actors performing other roles (*tsure*), sometimes masked, sometimes not. There are more than two hundred plays whose libretti are known, many of them dating to the formative stages of the noh theater in the fourteenth and fifteenth centuries.[1]

The origins of the noh theater are obscure, but scholars assume that urforms date back to early ritual practices that evolved during the fourteenth century into a codified means of performative entertainment. Essentially, two types of performance preceded and impacted the formation of noh: *dengaku*, or "field entertainment," and *sarugaku*, or "monkey entertainment."[2] As the name suggests, the former originated as a group of ceremonial songs and dances associated with agriculture that evolved into a popular spectacle employing animal and demon masks. *Sarugaku*, on the other hand, originally featured an array of acrobatic practices that by the fourteenth century morphed into a more restrained aesthetic with an emphasis on increasingly refined forms of expression and nuanced plots. *Sarugaku* eventually developed into what is now considered noh, and, especially under the playwright Zeami (ca. 1363–ca. 1443), it became a highly codified theater catering to elite warrior and aristocratic clientele.[3] Plots written by Zeami and later playwrights served a mix of purposes, including entertainment, social interaction, and the dissemination of information.

Many of the plays penned during the fourteenth and fifteenth centuries capture plotlines inspired by actual events of the past that resonated with audiences of the present.[4] The ghosts of deceased figures from history and other spirits, such as those of flowers and places, feature prominently in many noh plotlines. For example, the play *Atsumori*, written by Zeami, dramatizes the life of the warrior Taira no Atsumori (1169–1184), a key figure in the Genpei War (1180–85) and one of the characters of the civil war's major epics, *The Tale of the Heike*. Even though Atsumori had been dead for more than two hundred years by the time Zeami wrote the story, the inclusion of his spirit in noh reflected a lasting affinity toward stories of the war among elite patrons. The longevity of plays like *Atsumori* illustrates how audiences of warriors, members of a group that had solidified its political power through the Genpei War, cherished enactments of that storied past. By the same token, the

performativity and relative ease of understanding of noh plays vis-à-vis the complex and antiquated language of epics like *The Tale of the Heike*, a work of literature that was sung rather than read, helped embed specific stories in the cultural fabric. The same is true for other stories relating to complicated literary works, such as *The Tale of Genji*, that were difficult to read and comprehend throughout the centuries after their production. In short, the noh theater drew from historical memory while helping create and sustain that memory. It was digest and amplifier at the same time.

Noh continued to be performed throughout the centuries after its inception during the medieval period, but its elite status prevented most commoners from practicing or watching performances outside of public rituals at temples and shrines.[5] With an exponential increase in literacy and rising interest in both historic and contemporary culture during the early modern period from 1603 to 1868, a great number of commoners with sufficient means were able to study chanting (*utai*) and dancing (*shimai*) with noh actors. But very few, if any, were able to see full-fledged, masked noh productions or learn how to perform in them.[6] Illustrations of noh plays in prints and paintings provide a window onto the art form while also making clear how, despite its scarcity in the urban milieu, noh was an impactful cultural phenomenon.

Noh in print

Printed images of noh subjects help trace the evolution of the theater from the early modern period into modern times. Prints from the eighteenth century, for example, reveal a different public interest than those from the nineteenth. Simply put, noh shifted from an esoteric, rarified discipline to a much more public-facing art.

Many seminal early modern artists of ukiyo-e prints created images inspired by noh plays. The work of Suzuki Harunobu (1724–1770) makes clear how noh subjects were not illustrated exactly according to the text but were incorporated into broader cultural allusions. For example, a print by Harunobu pays homage to the play *Hakurakuten* by embedding the protagonist in a referential context that is entirely unrelated to the play itself (fig. 3). In the play, the famed Chinese poet Bo Juyi (J. Hakurakuten; 772–846) arrives on the shores of Japan to test the poetic acumen of the Japanese people. The Sumiyoshi deity, also considered

Fig. 3 (right) Suzuki Harunobu (1724–1770), *Parody of the noh play Hakurakuten*, 1769–70. Gift of Alan, Donald, and David Winslow from the estate of William R. Castle, Freer Gallery of Art Study Collection, FSC-GR-24

a god of poetry, rushes to the scene in the guise of a fisherman and so impresses Bo Juyi with his lyrical skills that the Chinese poet returns home chagrined, reluctantly admiring the elegiac dexterity of even the humblest of Japanese. In Harunobu's print, the Sumiyoshi deity is replaced by a sex worker who competes with Bo Juyi not with written words, like those in the books that Bo Juyi carries in his boat, but with songs from Edo's upscale brothels, as symbolized by the painting she holds up and the lute near her feet. The design of pine trees on her kimono alludes to Sumiyoshi shrine, a place famous for its evergreens, hinting that she may be the god of poetry in disguise. As in other prints, Harunobu plays with the concept of *mitate*, a kind of double (or triple) entendre that conveys layered meanings by recasting unrelated themes.

This form of noh, in which commonly known aspects of a play were reconfigured into other contexts, appeared often during the early modern period. So well-known were stories like *Hakurakuten* that neither reading the libretti nor seeing performances of it were necessary to understand puns on the plot. Printed books like *Illustrated Wish for Riches* (*Ehon tsūhō shi*) of 1730, which offered a guide to themes of good fortune, helped disseminate noh subjects and linked them to auspicious symbolism. A blend of superstition, playfulness, and relative prosperity across classes throughout the early modern period cultivated a ceaseless demand for propitious images. Artists of all backgrounds tapped into that lucrative market by turning to noh. Pictures of the play *Takasago*, which featured two deities in the guises of an old woman and an old man and was often performed around the New Year, were made and sold as harbingers of good fortune. In the process, a complex play was converted into a cultural symbol. The case of *Takasago* is highlighted by its many depictions by people as diverse as the ukiyo-e artist Harunobu, the early modern literatus Yosa Buson (1716–1784), and the prolific polymath Kawanabe Kyōsai (1831–1889), active at the juncture of the modern age (fig. 4).

More allusive images were made as well. Two paintings by Katsushika Hokusai (1760–1849) and his pupil Hishikawa Sōri (act. ca. 1797–1813) contain concealed references to the play *Hagoromo*, in which a fisherman steals the cloak of a heavenly being and refuses to return it unless she performs a dance for him (figs. 5 and 6). Here, too, the artists have hidden allusions to the play to engage the viewer in a game of hide-and-seek. In Sōri's image, the fisherman is wearing an unusual cloak that seems to be made of exotic bird

Fig. 4 (above) Detail: Kawanabe Kyōsai (1831–1889), *Drawing of the noh play Takasago*, from an album, ca. 1880s. Purchase—Charles Lang Freer Endowment, Freer Gallery of Art, F1975.29.14

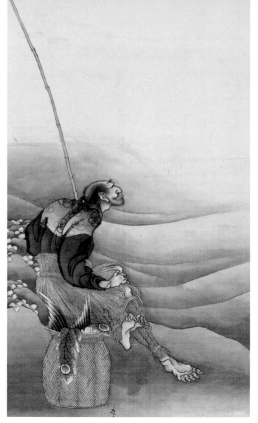

feathers. In Hokusai's image, the fisherman sits on a basket that should be filled with fish but instead is overflowing with peacock-like feathers and wings, implying that the fisherman is resting on the stolen celestial cloak, his face suggesting contentment with his booty. Neither Hokusai nor Sōri had the societal rank and sway to attend many, if any, noh performances outside of religious ceremonies. But each had enough secondhand cultural knowledge to adapt a charming, popular narrative into an evocative image whose source of reference was not immediately apparent to every viewer.

So powerful was the role of noh in shaping cultural memory that sometimes it is difficult to tell if the image was inspired by the play or by the story that inspired the play in the first place, or both at the same time. In other words, the elitism and remoteness of early modern noh offered an opportunity to both poke fun at these layers of referentiality and embed them into artworks. Moving into Kōgyo's time, from the latter half of the nineteenth to the early part of the twentieth century, the story of noh continues to change. As we will see, virtually everything about the works that precede Kōgyo is different from his own.

81

Kōgyo's noh

During Kōgyo's time, noh achieved a more diversified presence in terms of sponsorship, audience, and aesthetic paradigms. The level of detail paired with the spectral subcurrent in works like Kōgyo's rendering of the play *Sesshōseki* would have been impossible without an intimate grasp of the art form's plots, subtexts, and imagery (fig. 7). But Kōgyo did not arrive at this preternatural aesthetic immediately. In many ways, his trajectory as a consummate creator of noh pictures reflects the push and pull between tradition and modernity experienced by Japanese culture during the second half of the nineteenth century and after.

Fig. 5 (top) Detail: Katsushika Hokusai (1760–1849), *Fisherman*, 1849. Gift of Charles Lang Freer, Freer Gallery of Art, F1904.181 **Fig. 6** (bottom) Detail: Hishikawa Sōri (act. ca. 1797–1813), *Fisherman*, 1770–1820. Gift of Charles Lang Freer, Freer Gallery of Art, F1900.58

With the abolition of the Tokugawa shogunate in 1868 and the ensuing breakdown of the feudal system, noh lost much of its elite patron base.[7] Unlike the kabuki theater, which relied on box office sales and an enthusiastic fan base among the urban population, noh traditionally occupied a narrower niche of warrior and aristocratic support. With the loss of this base, its funding matrix disappeared so quickly that some renowned actors left the theater and trained in new professions, like farming, to make ends meet.[8] Noh was in need of reinvigoration.

Visits to the United States and Europe by the Iwakura embassy, an impactful mission that went abroad between 1871 and 1873, planted the seed for a reconsideration of the country's traditional performing arts. Entertained with operas and concerts while abroad, members of this mission witnessed the use of cultural entertainment as a way to court foreign emissaries and to represent a country's refinement. The Iwakura delegates returned to Japan with ambitions to recast the country's own "operatic" performance—noh—into a representative

82

form of cultural entertainment and a tool to achieve bilateral diplomacy. Foreign politicians, advocates of Japanese culture, and literary figures further nurtured calls to reinvigorate noh. United States President Ulysses S. Grant (1822–1885), art historian Ernest Fenollosa (1853–1908), and poet Ezra Pound (1885–1972) were advocates of the art form. Associations were founded to raise funds and awareness for noh among the public, and a new theater was built in 1881. This moment marked a change in noh's fortunes that heralded not simply its survival but an unprecedented shift to a more diversified viewership and patronage. Alongside a new public appeal, patronage from the country's elites—the imperial family and leaders in politics and business—was needed. It was exactly the diplomatic potential of noh combined with its newfound public presence that triggered Kōgyo's interest in theater. He wrote:

I first developed my interest in making pictures of nō when I first saw a nō performance. It was 1883. The Russian crown prince (currently the emperor) made a visit to Japan, and he was to travel to Tokyo, among other things to attend a performance of the play Shakkyō to be performed by Umewaka Minoru (1828–1909). On his way the crown prince was attacked in what is called the Otsu Incident (outside of Kyoto) and his trip to Tokyo was cancelled. But I still had the chance to see the performance of Shakkyō. I had no idea what Shakkyō was, nor did I know anything about nō. [. . .] As I saw more and more performances, I learned about the colors and their distribution for nō pictures. I learned first the patterns of the costumes, and came to realize that the color schemes (of the costumes) were essential to pictures of nō. Since I wanted to paint elegant people, I was attracted to doing pictures of nō.[9]

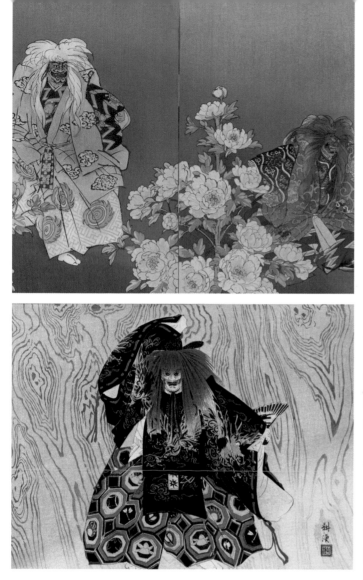

Unlike other commoners like him during the early modern period and before, with the reinvigoration and reinvention of noh in the late nineteenth century, Kōgyo was able to see full-fledged performances. Before his time, access and personal practice were limited to dances and chants—an exposure to noh that was episodic rather than complete. Although Kōgyo discloses his familiarity with these elements, *Shakkyō* was the first entire noh play he was able to see. He did so in 1883, and he was infatuated by the play's rapid plot and its vivid costumes, including one depicting a mythical lion (fig. 8, cat. 35). It comes as no surprise that all of Kōgyo's renderings of *Shakkyō* center on the play's climax, the energetic lion dance.

The hundreds of noh prints he created popularized the theater and helped its modern evolution. Kōgyo's first series of noh prints, *Pictures of Noh* (*Nōgaku zue*), consists of works depicting 261 plays and was published in five volumes between 1897 and 1902. Though it would take another decade and a half for noh to become the core of Kōgyo's artistry, the power of spiritual entities apparently did not release him from its grip. The opening image in the first volume of *Pictures of Noh* is from the play *Kamo* (fig. 9). Like many noh plays, the plot contains heavy undertones of Buddhist virtue, capturing a combination of mythical stories related to the Kamo shrine in Kyoto. Even though one of the protagonist's manifestations is that of a celestial maiden, Kōgyo instead selected the red-haired god of thunder, Wakeikazuchi, for his print. The deity appears only briefly during the main dance of the celestial maiden, but his entrance is powerful and thunderous—a rupture in the play akin to the lion's dance in *Shakkyō*. Kōgyo evidently wanted to start with a splash. This impression is amplified by the dramatic wood grain pattern behind the deity, which also serves as a testimonial to the woodblock-printed nature of the image itself.

Fig. 7 (left) Tsukioka Kōgyo (1869–1927), *Sesshōseki*, from the series *Nōgaku hyakuban*, ca. 1922–25. Gift of the Embassy of Japan, Washington, D.C., Freer Gallery of Art Study Collection, FSC-GR-402 **Fig. 8** (top) See cat. 35 **Fig. 9** (bottom) Tsukioka Kōgyo (1869–1927), *Kamo*, from the series *Nōgaku zue*, 1897–1901, Smithsonian Libraries

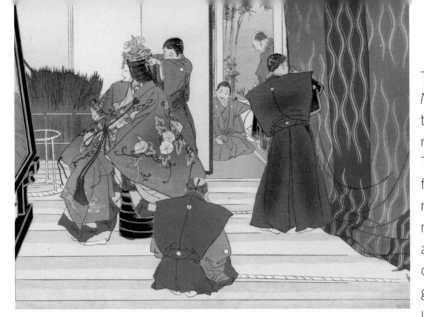

The production and publication of *Pictures of Noh* coincided with the peak period of the theater's resurrection and its reshaping from ritual performance to aesthetic entertainment. The different volumes of the series fulfill several functions, both educational and aesthetic. For novices of the noh theater, the depiction of key moments in a play and brief outlines of the actors' roles and the plot turn the prints into a type of digest, enabling viewers to gain a fundamental grasp without reading the libretto in a hard-to-understand medieval language. For more seasoned connoisseurs, the prints serve as visualizations of favorite plays, dwelling on the intricacies of masks, costumes, and props. Many prints also contain other elements that enhance the experience of each play.

Several images in *Pictures of Noh* have little of the uncanny effect that Kōgyo's haunting *Akogi* print conveys. Rather than trying to seize a more metaphysical essence of noh, these pictures prioritize instructional information over philosophical interpretation. One work in particular stands out. A rendering of the play *Asagao* offers a glimpse at the actor putting on his costume while a stagehand peeks out at the stage behind the curtain (fig. 10). Such backstage exposure is unprecedented in noh imagery and effectively deletes its spiritual nature. Kōgyo has stripped the protagonist of the ethereality he assumes in the play and represents him simply as a person in costume whose onstage presence is at least in part the product of a behind-the-scenes frenzy. The spectral nature of traditional noh is demystified into an elaborate form of theater. Like other plays in the noh repertoire, *Asagao* features an encounter with the spirit of a flower—a morning glory, or *asagao*—that recounts an ancient story related to the place the person is visiting. In other words, following a major aspect of the noh theater, the plot captures the encounter between the living and the world of spirits. Kōgyo, however, has complicated the traditional intersection between this world and the world beyond by casting an almost scientific, analytical gaze at the back-of-house aspect of noh that previously remained hidden.

The theatrical nature of noh is never negated since each print distinguishes the skin tone of the actor vis-à-vis the mask, making clear a human being animates the costume. But as Kōgyo's artistry evolved and he produced more noh prints, his representation of specific plots became increasingly nuanced and often playful. For example, two prints of the warrior plays *Atsumori* and *Tadanori*, which depict two characters from the twelfth-century war epos *The Tale of the Heike*, show the respective protagonists amid each play's climactic moment (figs. 11 and 12). In each print, Kōgyō has inserted elements that visualize the plot but are not found onstage.

The story of *Atsumori* features a young warrior of the Taira clan who is slain by the older Kumagai no Jirō Naozane (1141–1207) at Ichinotani, one of the key battles of the Genpei civil war. As Kumagai discovers his opponent was just a boy and not, as he thought, a seasoned warrior, he is struck by unbearable grief. Kōgyo illustrates the battle at the beaches of Ichinotani with a swarm of plovers. He has also added a passage from *The Tale of the Heike* on the peeled-back page that reveals the plovers flying above the sea. The ghost of the dead warrior is shown in a pose of readiness, prepared to bravely face the opponent who would ultimately cause his demise. In *Tadanori*, an old cherry tree houses the spirit of the warrior and poet Taira no Tadanori (1144–1184). As a traveling monk sleeps underneath the tree, the specter of Tadanori appears to him in a dream, bemoaning that a poem in the anthology *Collection of a Thousand Ages* (*Senzaishū*) is wrongfully listed as anonymous when it was Tadanori who composed it. Linking the realms of life and death, wakefulness and sleep, the play suggests the missing attribution is the cause of Tadanori's restless soul. Capturing the evanescence symbolized by the cherry tree, Kōgyo has rendered it in full bloom to accompany Tadanori at the moment he recites the poem.

85

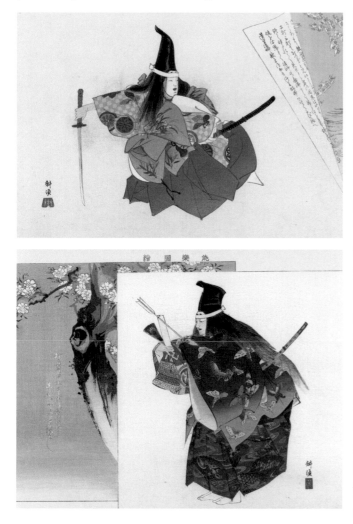

Kōgyo's Meiji-era noh prints reflect his attempts to cultivate a new audience for the theater by educating a broader public. His works pair approximations of watching noh live with revelations from behind the scenes and illustrations of key moments and tropes. Kōgyo seized upon the latter approach as his work developed, amplifying and reshuffling it so that spirits and their representations onstage were treated as theater and enhanced by symbols. In Kōgyo's later series, *One Hundred Noh Plays* (*Nōgaku hyakuban*), published from 1922 to 1926, he embedded the actor in a world that approximates both the character's internality and a more abstruse symbolization of a play's essence.

Fig. 10 (left) Tsukioka Kōgyo (1869–1927), *Asagao*, from the series *Nōgaku zue*, May 1, 1902. Robert O. Muller Collection, Arthur M. Sackler Gallery, S2003.8.2907 Fig. 11 (top) Tsukioka Kōgyo (1869–1927), *Atsumori*, from the series *Nōgaku zue*, 1897. Robert O. Muller Collection, Arthur M. Sackler Gallery, S2003.8.2953 Fig. 12 (bottom) Tsukioka Kōgyo (1869–1927), *Tadanori*, from the series *Nōgaku zue*, July 15, 1898. Robert O. Muller Collection, Arthur M. Sackler Gallery, S2003.8.2888

Spectral minds

The prelude to Kōgyo's visual and aesthetic methods in *One Hundred Noh Plays* can be found in works like *Akogi*. The ethereal atmosphere conjured by the ghost of a fisherman surrounded by a dark miasma in the 1899 print from *Pictures of Noh* established a precedent for the entirety of *One Hundred Noh Plays* twenty years later. In another rendering of a similar play, *Ukai*, that depicts the tormented ghost of a fisherman whose livelihood of killing sentient beings causes his rebirth in purgatory, the darkness around the figure is only alleviated by the light of his torch (fig. 13, cat. 25-2). The blackness in both prints feels metaphoric, evoking the doomed souls of dead fishermen who wander aimlessly unless they are saved by celestial intervention from a bodhisattva or through prayer.

In the sum of its parts, *One Hundred Noh Plays* offers a layered artistic interpretation of the theater. Many prints in the series retain a distinctive stage-like character; actors are shown with props, and occasionally architectural features of the stage are included (figs. 14 and 15). Some works feature waterfalls and other elements that are sung about in the plot but are not physically shown onstage (figs. 16 and 17). Yet others try to capture the aura of an actor and the ambiance of a play in addition to conjuring an abstracted sense of the play's spirit, as in Kōgyo's rendering of *Ukai*. Not all prints in *One Hundred Noh Plays* are as gloomy and brooding as the ones discussed earlier. In some, bright colors abound and imbue the print with chromaticity reminiscent of the bright brocade robes of a noh actor or the visualized fragrance of the sea, as in *Matsukaze* (fig. 18, cat. 28-3). But most images in the series retain an aura of suggestion in which things are implied instead of said. The same is true of the prints that comprise *Pictures of Noh*.

Some familiarity with each play seems to be required to fully grasp the deeper essence that Kōgyo sought to convey. The theme of allusion is also carried on in the absence of any labeling or text. Unlike the references in noh, no image in *One Hundred Noh Plays* identifies the play by name or lists protagonists and plot summaries. At the same time, an unaccustomed viewer might still find the prints insightful in their attempt to interpret a play rather than simply convey details. In this way, Kōgyo offers different layers of engagement and information in the same series.

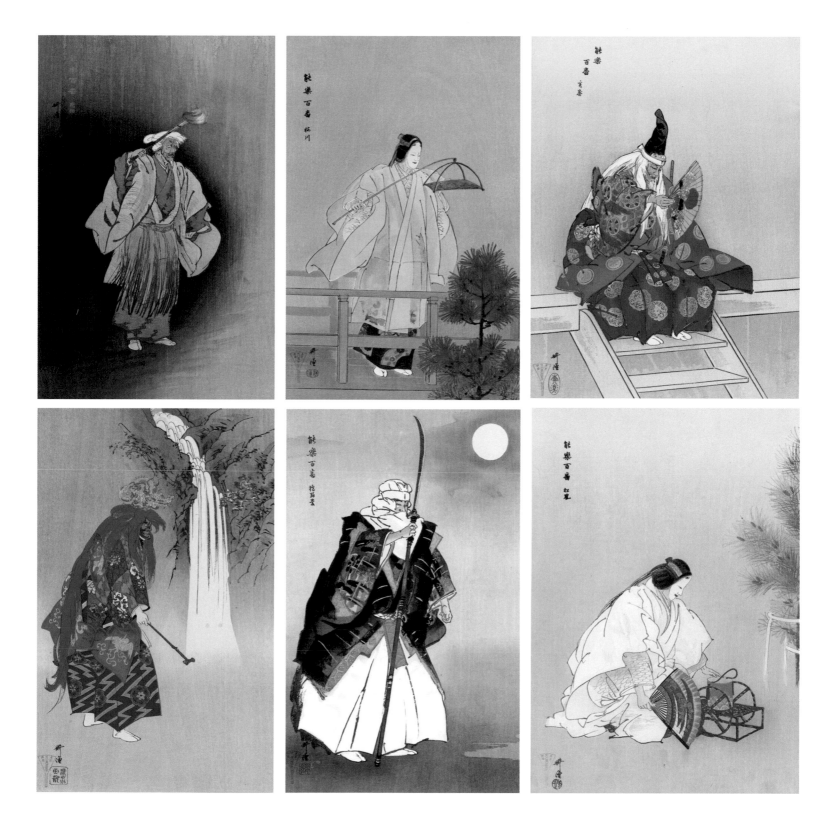

Yūgen and interiority

Kōgyo's diverse treatment of plays no doubt reflects his personal preferences along with his deep knowledge of specific plotlines. Atmosphere is more difficult to convey than physical props, and trying to capture that abstract mood challenges the artist. The marked shift from an objective representation of noh to a subjective interpretation of a play's ambiance remains a mystery among Kōgyo's evolution as an artist. How did he arrive at the premonitory, phantasmal timbre found in many prints from *One Hundred Noh Plays*?

During Kōgyo's time, a shift occurred that transformed noh. In 1908, a copy of Zeami's *Teachings on Style and the Flower* (*Kadensho*) was found at a used bookstore in Tokyo.[10] In the medieval and early modern ages, such secret teachings were passed on either verbally or through extremely coveted manuscripts. Most noh actors had no access to them. Zeami's treatise had previously been known to only a small number of performers, and noh instruction focused little on the metaphysical aspects described in the medieval text. Its discovery and subsequent publication in 1909 made the esoteric treatise available to anyone, ushering in a transformation of noh from an art form that relied mainly on the physical training of its actors to one that involved a much more theoretical approach to performance. One particular aesthetic principle espoused by Zeami fascinated actors and audiences alike: *yūgen*.

The concept of *yūgen* was all but unknown among most noh practitioners prior to the publication of *Teachings on Style and the Flower* in the early twentieth century. Famed modern noh actors like Umewaka Minoru devoured the treatise, becoming conscious of *yūgen* and making the abstract principle a central aspect of their performances. As an aesthetic idea, *yūgen* had been present in Japanese literature since at least the twelfth century before it was adapted by Zeami into the realm of theater.[11] Often described as a kind of mysterious beauty, *yūgen* captures the "interiority" of theatrical expression.[12] In other words, Zeami stipulated that an actor should first make sure to master song and dance—or what he considered the exterior aspects of performance—before internalizing these aspects and applying them to the character portrayed onstage. *Yūgen* arises from a blend of conscious and unconscious immersion in the role. The audience sees different parts of that process that are manifested in the emotional pathos and other nonintellectual aspects of a performance—effect and interpretation are prioritized over accuracy. All of this is achieved through the atmosphere of a play.

In many ways, an outcome of this process is replicated in *One Hundred Noh Plays*. The subjective interiority of *yūgen* combined with the objective exteriority of song, dance, costumes, and props is perfectly applicable to the spectral presence in many of Kōgyo's prints. The betweenness characterizing ghosts of historical people and the spirits of places and things recalls the liminality of Kōgyo's later works, where the space between life and death, animate and inanimate objects, is intentionally blurred. The looming shadows surrounding characters in prints like *Sesshōseki* capture the inherent numinousness of the play's plotline and

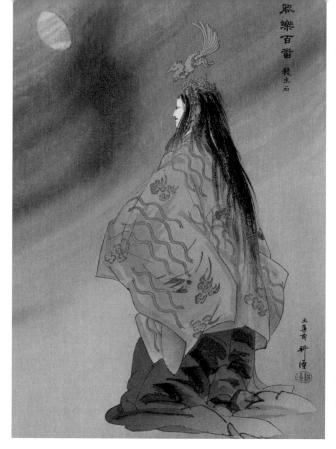

protagonist (fig. 19, cat. 31-2). In the play, a priest encounters the so-called killing stone (*sesshōseki*) that will quench every life around it. A fox spirit that inhabits the stone reveals herself to the priest. Kōgyo's print shows the fox spirit in sumptuous clothing, gazing at the moon that is slowly emerging behind dark clouds. The image teases out the interiority of the fox spirit, whose true nature is only revealed by moonlight. The same is true in a daunting image of the play *Dōjōji* (fig. 20, cat. 26-2). Images of the play usually feature the striking scene of a woman who is consumed by unreciprocated love for a priest and who eventually turns into a dragon-like demon. Although Kōgyo depicted that part of the play in a print referenced earlier in the text, the work here has none of that stage-like quality. Instead, the print captures the second manifestation of the main character, the so-called *nochijite*, or later protagonist: the woman turned into a demon. But instead of highlighting the quick series of actions that make this play one of the most popular in the noh repertoire, Kōgyo manifests the brooding, terrifyingly dark pain that caused the woman's transformation.

The interiority that defines many of Kōgyo's works in *One Hundred Noh Plays* seems to have been as much a result of expert printing techniques as it was a part of his creative process. Kōgyo created a preparatory drawing for his prints depicting the play *Kokaji*, indicating to the printer the hue of the background and the general mood he sought to convey (figs. 21 and 22, cats. 22-3 and 22-1). But the final print is far from a faithful reproduction of Kōgyo's drawing.

Fig. 19 (top) Tsukioka Kōgyo (1869–1927), *Sesshōseki*, from the series *Nōgaku hyakuban*, ca. 1922–25. Gift of the Embassy of Japan, Washington, D.C., Freer Gallery of Art Study Collection, FSC-GR-359 **Fig. 20** (bottom) See cat. 26-2

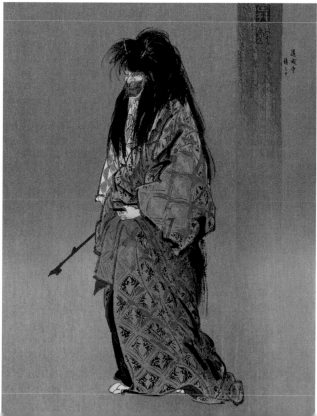

90

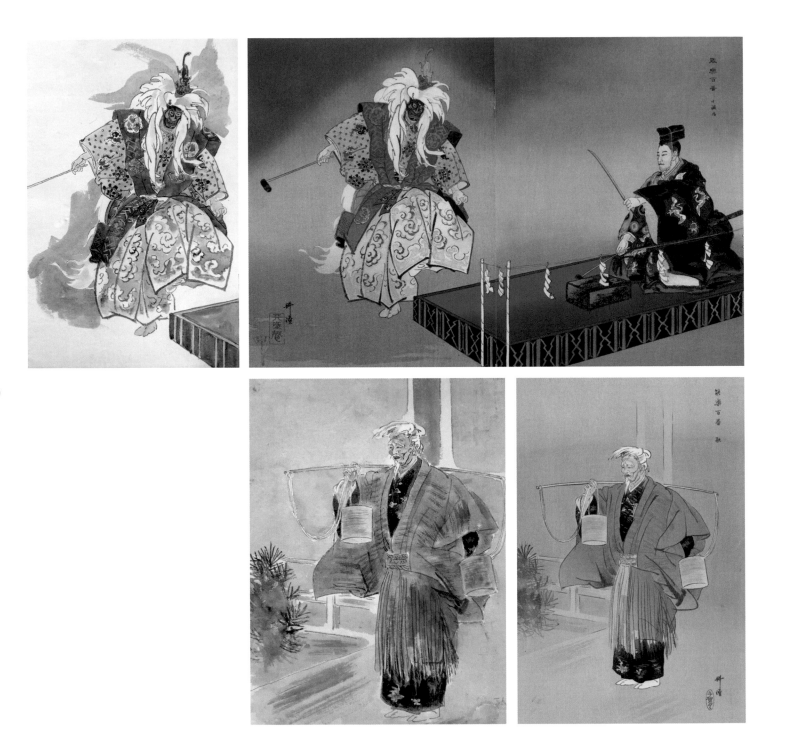

While the figure is a mirror image of the design, the dark background—the atmosphere—is much more complex. Similarly, the subtle gradations in the final print of the play *Tōru* project a more pensive timbre than originally conveyed in the drawing (figs. 23 and 24, cats. 29-2 and 29-1). They serve to capture the emotionality of minister Minamoto Tōru's ghost, who sentimentally recounts his former life in his now-dilapidated mansion. It becomes evident that, much like many print artists throughout the early modern and modern periods, Kōgyo worked closely with his publisher, Matsuki Heikichi (mid-19th c.–early 20th c.) of the Daikokuya press, and printers in the studio to bring out the desired effect through the production process.

Conclusion

The dualism of light and dark, of interiority and exteriority, embraced in Kōgyo's *One Hundred Noh Plays* was described by several other intellectual figures during Kōgyo's time, creating an often unintentional bridge between their intellectual output. The philosopher Nishida Kitarō (1870–1945), for example, distinguished between light consciousness—higher reason—and dark consciousness—instinctual, pure manifestations— that unintentionally echo Kōgyo's aesthetic approach.[13] Similarly, the novelist Tanizaki Jun'ichirō (1886–1965) emphasizes in-betweenness in his *In Praise of Shadows*, a highly subjective work acclaiming the subdued quality of traditional Japanese architecture.[14] At the same time, the psychological intensity of Kōgyo's prints

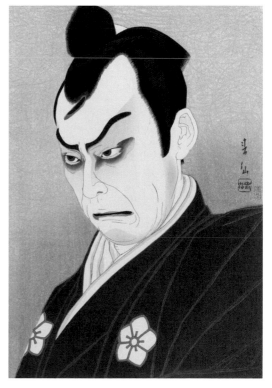

correlates with actor portraits and other theater-inspired imagery during the 1920s (fig. 25). These images equally convey both the exterior façade and the interior intensity of the role.

Noh and its representation in prints helped form Kōgyo's aesthetic as an artist. Steeped in his education by Tsukioka Yoshitoshi and in his own experience of noh, Kōgyo rendered plays that convey a cerebral depth. Rather than self-explanatory representations, they leave us guessing. He hinted at both the visible and the atmospheric, the former through costumes and the latter through the ambiance in which he placed the protagonist. All the while, his tone is often brooding and dark, and his prints conceal more than they reveal.

Fig. 21 (left page, top to bottom, left to right) See cat. 22-3 **Fig. 22** See cat. 22-1
Fig. 23 See cat. 29-2 **Fig. 24** See cat. 29-1 **Fig. 25** (this page) Natori Shunsen (1886–1960),
Nakamura Kichiemon in the Role of Takechi Mitsuhide, 1925. Robert O. Muller Collection,
Arthur M. Sackler Gallery, S2003.8.1547

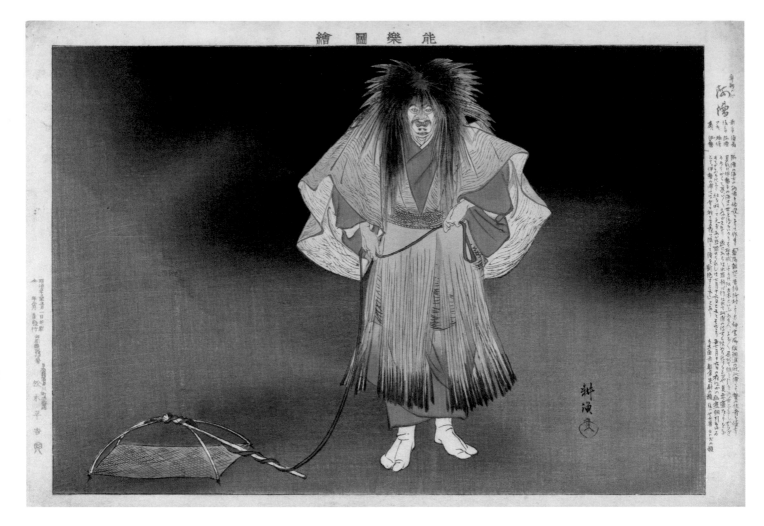

21 *Akogi,* from the series *Nōgaku zue*

Tsukioka Kōgyo (1869–1927), Japan, Meiji era, March 1, 1899. Woodblock print; ink and color on paper; 22.9 × 33.2 cm. Robert O. Muller Collection, Arthur M. Sackler Gallery, National Museum of Asian Art, Smithsonian Institution, S2003.8.2898

Like many noh plays, the plot of *Akogi* begins with an itinerant monk who chances upon a site laden with the memory of a past event. The play is set during the fading light of fall, imbuing scenes with an eerie ambiance. A group of monks has landed at the beach of Akogi-ga-ura in today's Mie prefecture during a pilgrimage to the shrines at Ise. They meet an old angler by the sea who laments his fate of killing sentient beings for a living. The suffering caused by his destiny is voiced immediately in the first line: "My clothes never dry, drenched not by the waves but by my tears." A monk finally asks about the name of the beach, and the old man begins to recount the story of a fisherman named Akogi.

As the tale moves on, the monks learn that Akogi fished in sacred waters, committing the cardinal sin of killing in a holy place where fish are offered to the deities of Ise. For this sin, Akogi was wrapped in a straw blanket weighted with rocks and drowned in the sea. His spirit descended to hell, where it still exists in purgatory. As in other plays, the monks are asked to offer prayers to alleviate Akogi's suffering.

It soon becomes clear that the fisherman is the spirit of Akogi. During his sermon, the ghost of Akogi appears, and the plot develops slowly but harrowingly. The play takes a disturbing turn as Akogi recounts in detail his torments in hell. The actor's voice is slow and pained, conveying his agony through haunting enunciation that makes this one of the most distressing plays in the noh repertoire. Finally, the spirit is swallowed again by the waves, shouting these final lines: "Save me, traveler! Save me, traveler! I am drowning again in the waves! I am drowning again in the waves!"

In his print, Kōgyo chose to focus on the ghost of Akogi in the final section of the play. Engulfed in the darkness of the stormy clouds and the sea, the haggard, petrifying appearance of the fisherman staring back at the viewer is as arresting as it is brooding. As with other prints in *Pictures of Noh* (*Nōgaku zue*), a summary of the plot is included along with a list of the roles in the play.

93

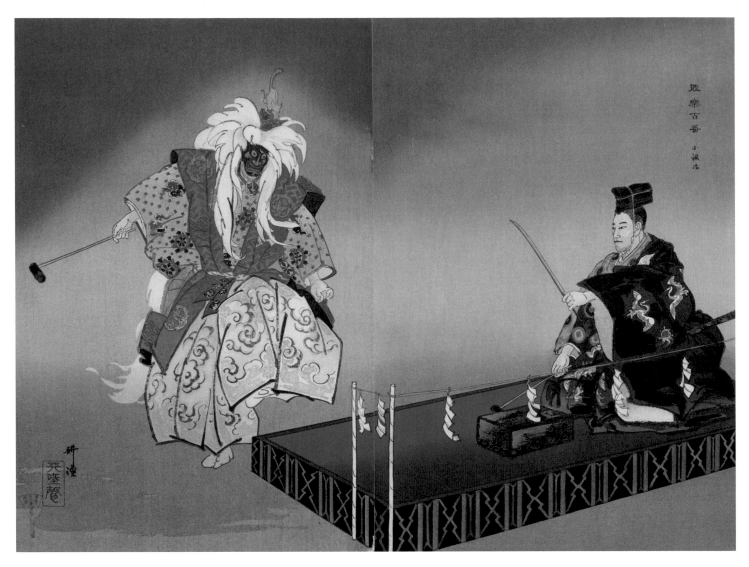

22-1 *Kokaji*, from the series *Nōgaku hyakuban*

Tsukioka Kōgyo (1869–1927); Publisher: Matsuki Heikichi; Japan, Taishō era, ca. 1922–27. Woodblock print; ink and color on paper; 37.6 × 51.4 cm. Robert O. Muller Collection, Arthur M. Sackler Gallery, National Museum of Asian Art, Smithsonian Institution, S2003.8.2879

22-2 *Kokaji,* **from the series** *Nōgaku hyakuban*

Tsukioka Kōgyo (1869–1927); Publisher: Matsuki Heikichi; Japan, Taishō era, ca. 1922–27. Woodblock print; ink and color on paper; 37.6 × 51.4 cm. Gift of the Embassy of Japan, Washington, D.C., Freer Gallery of Art Study Collection, National Museum of Asian Art, Smithsonian Institution, FSC-GR-321 and FSC-GR-322

Multiple impressions of an image appear here and on several of the following pages.
We encourage you to look at them closely to see the subtle differences in each one.

96

22-3 *Kokaji,* from the series *Nōgaku hyakuban*

Tsukioka Kōgyo (1869–1927), Japan, Taishō era, ca. 1922–27. Preparatory drawing; ink and color on paper; 32.1 × 27.2 cm. Darrel C. Karl Collection

The play *Kokaji* is one of the most dynamic works in the noh repertoire. The narrative unfolds at a rapid pace, almost as if to capture the speed and energy of one of the play's main characters, the Inari deity. The plot opens with a messenger announcing the assignment he has received from the emperor. The emperor has commanded him to seek out the swordsmith Sanjō no Kokaji Munechika and ask him to forge a sword. The matter is pressing since the emperor is responding to a premonition he received that same night and must respond to it quickly. Kokaji is honored and wants to accept the work, but there is one small wrinkle: he does not have a partner with whom to forge the sword. The messenger is unconvinced by the craftsman's excuse, but Kokaji explains that great swords are only fashioned by two smiths.

The messenger keeps pressing, assuring Kokaji that this sword will be forged upon a celestial prophecy, so with such divine support, there is no need to worry. Left with an impossible task, Kokaji goes to Inari shrine in Kyoto and prays for help to his guardian deity, Inari. Suddenly, a boy appears who seems to know Kokaji's name and his plight. After some back and forth, the boy urges Kokaji to prepare to forge the sword that night. He then vanishes. A short while later, as Kokaji is preparing his workshop and praying to the gods, the Inari deity dashes onto the stage accompanied by a fast rhythm. The smith and the deity join forces and hammer out the blade of the sword, fulfilling Kokaji's promise to the emperor. At the end of the play, it is revealed that the divine blade carries the swordsmith's signature on the front and the insignia of the deity on the back.

Kōgyo's print depicts the very moment when the Inari deity circles the stage to the wild rhythm of drums.
The raised foot and animated posture capture the tension of this climactic moment. Following his first encounter with noh through the play *Shakkyō*, an equally energy-charged plot, Kōgyo revealed a lasting penchant for fast-paced storylines with arresting climaxes. In fact, some of Kōgyo's most striking prints in *One Hundred Noh Plays* represent plays akin to *Kokaji, Shakkyō, Tsuchigumo*, and other untamed narratives. Equally, plays with darker plots, like *Akogi* and *Shunkan*, are expressed with depth in arresting prints.

A preparatory drawing for the left part of the *Kokaji* diptych offers a glimpse into Kōgyo's creative process. The attention to posture, proportion, and general details in drawing and print disclose the artist's use of photographs as references for some of his works. Even though it is not known whether Kōgyo employed that technique for his noh prints, the impact of photography's naturalism on the traditional arts of Japan is palpable. Not without reason do many of Kōgyo's noh prints emulate the brushwork found in paintings. This merger of naturalism and subjective interpretation imbues the works with creative and psychological profundity.

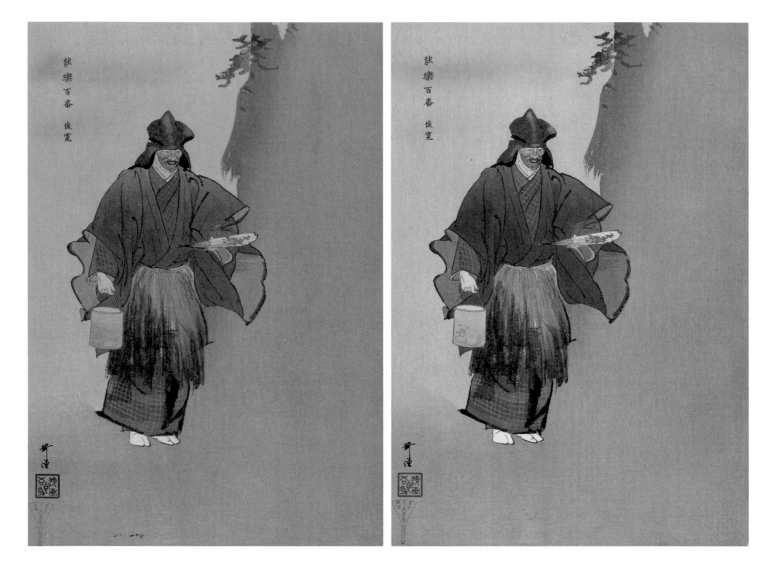

23-1 and 23-2 *Shunkan,* from the series *Nōgaku hyakuban*

Tsukioka Kōgyo (1869–1927); Publisher: Matsuki Heikichi; Japan, Taishō era, ca. 1922–27. Woodblock print; ink and color on paper; 37.8 × 25.7 cm. Robert O. Muller Collection, Arthur M. Sackler Gallery, National Museum of Asian Art, Smithsonian Institution, S2003.8.2852; Gift of the Embassy of Japan, Washington, D.C., Freer Gallery of Art Study Collection, National Museum of Asian Art, Smithsonian Institution, FSC-GR-405

The play *Shunkan* deals with a political plot and the fate befalling the conspirators. In the late Heian period (794–1185), the high-ranking priest Shunkan (1143–1179) colluded against the powerful Taira clan that held sway over the court in Kyoto. This was at a time of civil war when the Taira and Minamoto families vied for dominion over the Japanese polity. The plot is uncovered and quelled, and Shunkan and his fellow conspirators are exiled to an island off the southern tip of Kyushu. A short while after, a royal pardon is announced, and an emissary is dispatched to the island. When he arrives, it is revealed that Shunkan is the only one not receiving amnesty, and he falls into a deep depression. As his pardoned compatriots begin to leave, Shunkan clings to their boat in desperation, only to be cast off and left whimpering on the shore. The play concludes with the waning voices of those aboard the boat as Shunkan remains alone on the island.

The tragic story of Shunkan's exile and abandonment is recounted in the war epos *The Tale of the Heike* and has been rendered by several artists, including Kōgyo's adopted father, Tsukioka Yoshitoshi (1839–1892). Yoshitoshi's interpretation shows Shunkan clothed in rags, his hands stretched out in despair toward the stormy ocean. The receding boat is hidden in the distance, having abandoned him on the island to spend the remainder of his days alone. Whereas Yoshitoshi's image is clearly rooted in *The Tale of the Heike* text, Kōgyo's noh-based rendering offers a more somber, less dramatic take on the theme of desperation. The entire noh play focuses on the moment the pardon is delivered, revealing the psychological impact it has on Shunkan. Kōgyo seems intent to tease out this mental, subliminal effect. Throughout Japanese literature, exile has long been equated with extreme mental and physical hardship. Being expelled from the capital and cut off from the court was one of the most severe punishments—hence Shunkan's anguished urge to be forgiven. In the print, Shunkan is shown during the first part of the play approaching his fellow exiles with a gift of sake. This moment of camaraderie is dramatically shattered in the second part as his compatriots are taken back to the capital while Shunkan is left behind. The emaciated, tanned face rendered on the mask is meant to illustrate the hardships of Shunkan, stranded off southern Kyushu.

These two different impressions of the same print highlight the potency of the medium in its visual effect. The subdued palette in the Robert O. Muller Collection imprint (left) fosters a more somber tone than the saturated brightness of the print from the Embassy of Japan (right). In the latter, the artist has rendered Shunkan basking in the southern sunlight, while the former conveys a more devastating psychological effect.

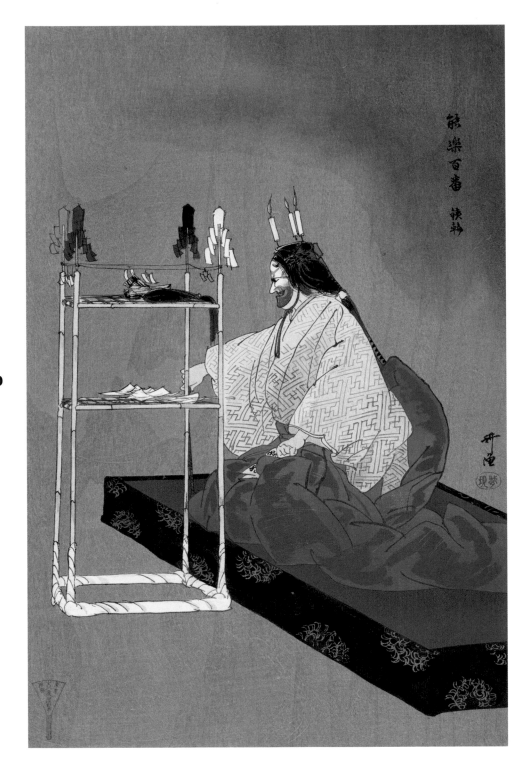

24 *Kanawa*, from the series *Nōgaku hyakuban*

Tsukioka Kōgyo (1869–1927); Publisher: Matsuki Heikichi; Japan, Taishō era, ca. 1922–27. Woodblock print; ink and color on paper; 37.8 × 25.7 cm. Gift of the Embassy of Japan, Washington, D.C., Freer Gallery of Art Study Collection, National Museum of Asian Art, Smithsonian Institution, FSC-GR-381

Kanawa, the "iron crown," is one of many noh plays featuring the vengeful spirit of a woman who was mistreated in her life. The play begins with a Shinto priest recounting a dream. In medieval Japan, when this play was written, premonitions delivered while sleeping carried potent meanings and were recorded and analyzed carefully. The priest states the message in his dream should be delivered to a woman he has not yet met. He resolves to wait by the shrine gate for her to arrive. Soon enough, a woman enters and describes her unforgiving feelings toward her former husband who divorced her. She discloses how her love for her husband grows each day, "like clothes I cannot shed." She prays at the shrine daily so that these sentiments shall not consume her. Her deepest wish is for the deities to punish her former husband.

The priest approaches her and tries to tell her of his dream. Her wish to become a demon and haunt her former husband has been granted. The priest advises her to return home and don a red kimono and red makeup along with an iron crown. Upon the crown she is to put three candles. As they speak, the woman appears to change. Frightened by her behavior, the priest runs off. The woman continues to transform as dark clouds gather above, while the wind howls and thunder crashes. The scene then changes to focus on her former husband, who is plagued by nightmares. He seeks out the counsel of the great *onmyō* master Abe no Seimei (921–1005), who creates a prayer shelf with effigies meant to absorb the man's torment. The woman has now fully turned into a demon and visits the shelf at night holding an iron rod—the precise moment captured in Kōgyo's print. At this instant of the play, the demon curses her former husband and promises to make those who harmed her suffer.

Although Kōgyo's rendering in *One Hundred Noh Plays* arrests the tension of the moment when the demon kneels before the shelf and contemplates the effigies, a version in his earlier series, *Pictures of Noh*, renders the next moment when the demon beats the effigies with her iron rod. The two prints contrast the interiority and eerie anticipation of the scene with the action of the climax. In the print belonging to *One Hundred Noh Plays*, Kōgyo masterfully employs the wood grain to capture the flickering of the iron crown's flames in the darkness.

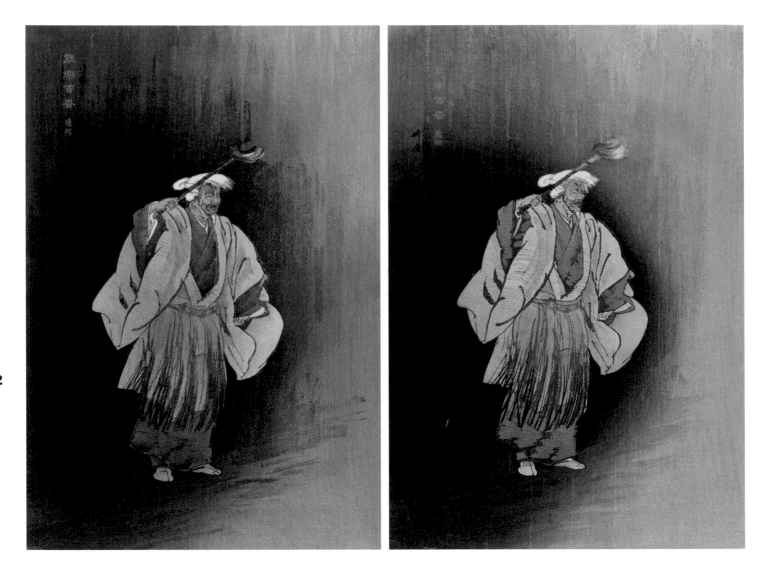

25-1 and 25-2 *Ukai,* from the series *Nōgaku hyakuban*

Tsukioka Kōgyo (1869–1927); Publisher: Matsuki Heikichi; Japan, Taishō era, 1922. Woodblock print; ink and color on paper; 37.8 × 25.7 cm. Robert O. Muller Collection, Arthur M. Sackler Gallery, National Museum of Asian Art, Smithsonian Institution, S2003.8.2796; Gift of the Embassy of Japan, Washington, D.C., Freer Gallery of Art Study Collection, National Museum of Asian Art, Smithsonian Institution, FSC-GR-352

Like *Akogi, Ukai* is a play in which the soul of a fisherman is banished to hell for killing sentient beings. In many ways, the contrast between noh's abstract refinement and the retelling of shame and suffering in purgatory makes these elegant treatments of hell an especially impactful part of the theater's repertoire. The play begins with the arrival of a group of monks in today's Yamanashi prefecture in Japan's eastern region, an area characterized by its remoteness at the time the play was written. The monks encounter an old cormorant fisherman and admonish him for his livelihood of killing living things. Kōgyo's print captures the moment of this meeting, when the old man emerges from the gloom of night carrying a flaming torch. The theme of darkness is carried forth as the man retells his story, saying, "Just like the darkness of the extinguished torch of a cormorant fisher, my destiny is shrouded in deep darkness."

Kōgyo has captured this undercurrent by placing the fisherman against a dark background with only a flame casting a dim, flickering light onto the figure. During the exchange, it is revealed that the old man is the ghost of a cormorant fisherman who had been killed for his sin of fishing in restricted waters. As in *Akogi,* the darkness becomes a metaphor for the spirit of the fisherman, who is trapped in hell. The black in the print reflects the night, the time during which cormorant fishing is done since fish are attracted by torchlight and are subsequently seized by cormorants, and it also reinforces the subtheme of damnation. The monks eventually offer prayers to benefit the tormented soul of the fisherman. Unlike the resolution of *Akogi,* in which the fisherman vanishes into his cold, watery grave at the end of the play, the cormorant fisher in *Ukai* is saved through the efficacy of the *Lotus Sutra* that the monks recite. The play, like others in noh, contains an emphatic laudation of Buddhist virtue and of the potency of certain scriptures that right previous wrongs.

Kōgyo's two impressions of the same print achieve different effects in capturing the theme of darkness. The print from the Robert O. Muller Collection is darker and gloomier, while the one from the Embassy of Japan adds an almost positive coloration, as if the fisherman is approaching a literal light at the end of the tunnel. In this way, the saturation and choice of colors in the printing process can achieve vastly different emphases through subtle shifts in tonality.

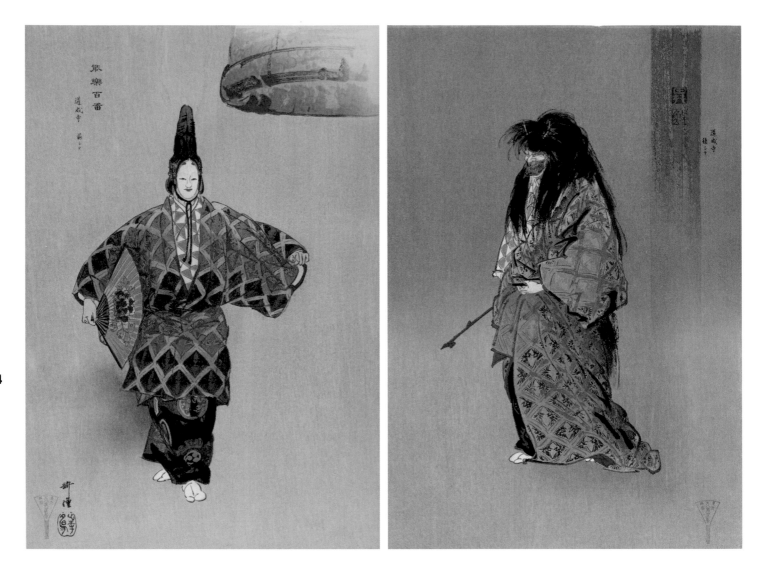

104

26-1 *Dōjōji, maejite*, from the series *Nōgaku hyakuban*

Tsukioka Kōgyo (1869–1927); Publisher: Matsuki Heikichi; Japan, Taishō era, 1925. Woodblock print; ink and color on paper; 37.8 × 25.6 cm. Robert O. Muller Collection, Arthur M. Sackler Gallery, National Museum of Asian Art, Smithsonian Institution, S2003.8.2850

26-2 *Dōjōji, nochijite*, from the series *Nōgaku hyakuban*

Tsukioka Kōgyo (1869–1927); Publisher: Matsuki Heikichi; Japan, Taishō era, ca. 1922–27. Woodblock print; ink and color on paper; 37.8 × 25.7 cm. Gift of the Embassy of Japan, Washington, D.C., Freer Gallery of Art Study Collection, National Museum of Asian Art, Smithsonian Institution, FSC-GR-346

Dōjōji is one of the most popular among the more than two hundred noh plays that are known, and it was later adapted for the kabuki theater as well (see cat. 2). It is performed often, and its renowned, fast-paced plot has made it an audience favorite. The central element of the story is a large temple bell that is suspended by a rope in the center of the stage. Larger and more elaborate than many other props in noh plays, the bell is made of a light wooden lattice frame covered in woven cloth. It is so iconic that it is considered the protagonist of *Dōjōji*. The play begins when the head priest of the temple Dōjōji, in the region around Nagoya, enters the stage to relay that monks are about to consecrate the new temple bell. The priest then alerts his helper that no woman is to be allowed on the premises during the rituals.

After this exchange, a *shirabyōshi* dancer enters, wearing the courtier's hat characteristic of this female-dominated performance art. In Kōgyo's print, she approaches the bell, hinting that a past sin is weighing on her and that observing the rite for the new bell might alleviate her from it. She asks for permission and is first refused. But after she dances and pleads further, a monk allows her in. Depicted in one of Kōgyo's prints, the first part of the play is cheerful and filled with dance and chanting. There is an anticipatory feeling in the air as the priest looks forward to the consecration rituals and the dancer hopes to be relieved of her past act.

The dancer secretly slips underneath the bell before it drops over her. After the monks hear the bell dropping, they rush to the head priest, who recounts a story associated with the temple. He tells the tale of a woman who fell madly in love with a mountain priest and visited him often. When she asked him to marry her, the priest remembered his vows and rushed to Dōjōji to hide. Saddened and furious at being abandoned, the woman turned into a poisonous snake and pursued her beloved to the temple. The priest hid underneath the temple bell, only to be incinerated by a snake whose tail caused the bell to melt upon him. The curse of that event still looms over the temple, and suddenly the dancer in *Dōjōji* emerges from underneath the bell in the form of a snake—the image illustrated in Kōgyo's second print of the play. It is at this moment that the play's speed accelerates, and the tension created by the action onstage and the fast-paced music is almost unbearable. At the end, the evil spirit is once more quelled by prayer and burns herself with her own flames.

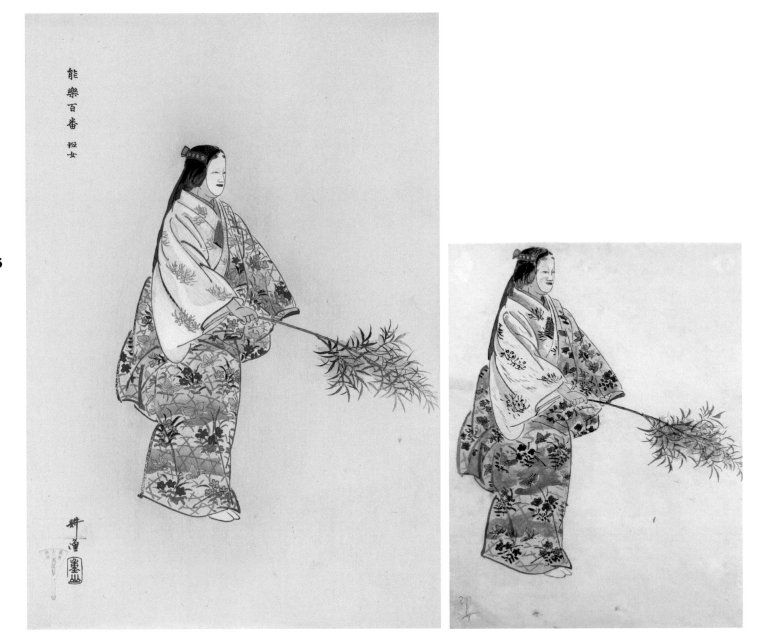

能樂百番
班女

27-1 *Hanjo,* from the series *Nōgaku hyakuban*

Tsukioka Kōgyo (1869–1927); Publisher: Matsuki Heikichi; Japan, Taishō era, ca. 1922–25. Woodblock print; ink and color on paper; 37.8 × 25.7 cm. Gift of the Embassy of Japan, Washington, D.C., Freer Gallery of Art Study Collection, National Museum of Asian Art, Smithsonian Institution, FSC-GR-404

27-2 *Hanjo,* from the series *Nōgaku hyakuban*

Tsukioka Kōgyo (1869–1927), Japan, Taishō era, ca. 1922–25. Preparatory drawing; ink and color on paper; 27 × 20.1 cm. Darrel C. Karl Collection

Hanjo recounts the story of an ill-fated love affair and its psychological impact on the woman involved. The play also highlights class differences and the imbalanced power dynamics between a man and a woman. At the beginning, a proprietress of an inn recounts the tale of Hanago (or Hanjo), a young woman in her employ, who fell in love with a customer of high rank. The two lovers exchanged fans as a vow of their affection. From that moment onward, Hanjo only had eyes for the fan and neglected her duties, infuriating her mistress. When Hanjo retreats to her room and refuses to come back out, she is dismissed from the inn. She wanders around, likening herself to a branch of bamboo floating on a river, carried by outside forces rather than her own free will. Kōgyo selected this moment for his print, depicting the protagonist carried upon a sprig of bamboo leaves. He accentuated the figure with faint touches of green pigment, as if to amplify the color of the bamboo and imbue the woman with an aura of beauty and depth.

The play continues when her former lover visits the inn and asks about Hanjo's whereabouts. He returns to his home in Kyoto to pray before a shrine when Hanjo suddenly appears at the same site. Her mental state has visibly deteriorated, and she grows ever more distraught as her former lover's servant ridicules her grief. The servant mockingly asks her to dance, and she grants his wish. Holding the fan she has received as a token of love while she dances, she grows increasingly manic and distraught, her abandonment consuming her. Eventually, her former lover recognizes both the fan and Hanjo. The two reunite, their joy returns, and the play concludes with a happy ending.

Even though the play does not feature a ghost or spirit, its treatment of the psychological effects of abandonment and unreciprocated love is handled similarly to other plays featuring female spirits. Hanjo does not turn into a demon, but her soul effectively demonizes her. Kōgyo subtly alluded to this state of mind by choosing a metaphorical moment for his print. The preparatory drawing (right) highlights the artist's attention to detail. The light green aura surrounding Hanjo in the print is not present in the drawing, suggesting that Kōgyo and his printer devised it during the later stages of the production process.

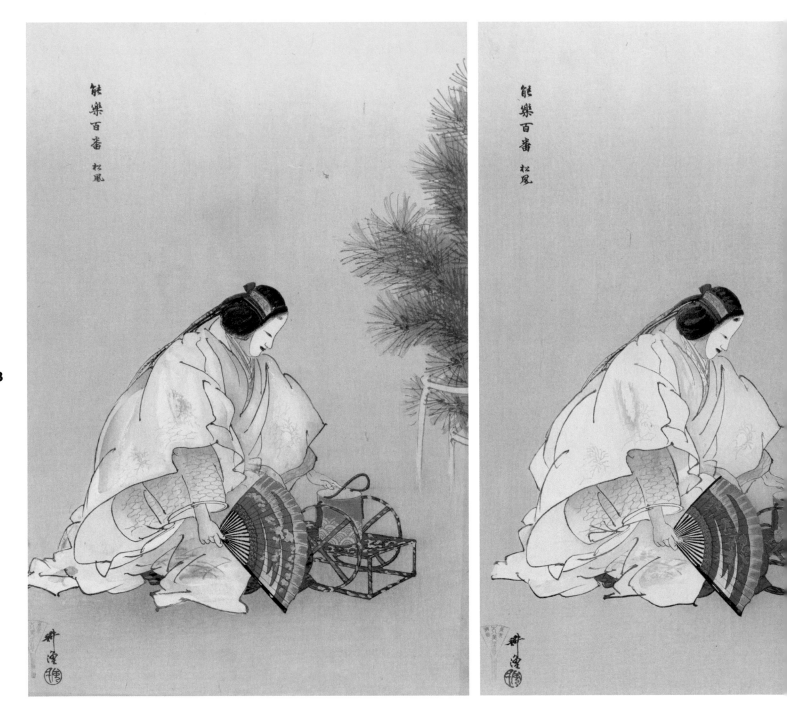

108

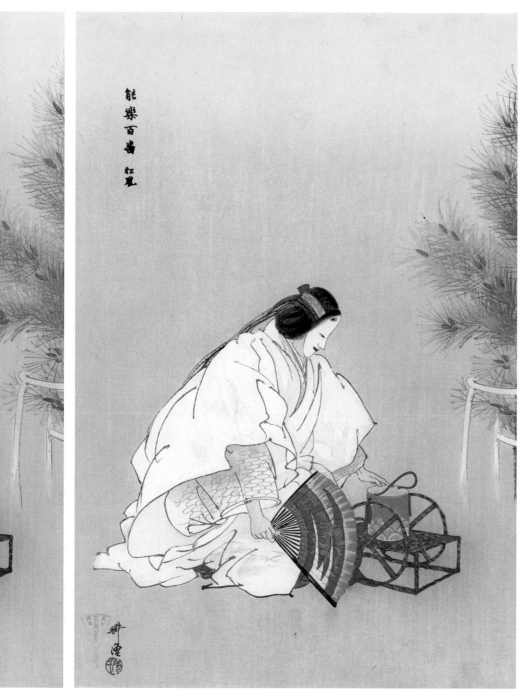

28-1, 28-2, and 28-3
Matsukaze, from the series
Nōgaku hyakuban

Tsukioka Kōgyo (1869–1927); Publisher:
Matsuki Heikichi; Japan, Taishō era, ca.
1922–25. Woodblock print; ink and color
on paper; 37.8 × 25.7 cm.
Robert O. Muller Collection, Arthur M.
Sackler Gallery, National Museum of
Asian Art, Smithsonian Institution,
S2003.8.2807 and S2003.8.2825;
Gift of the Embassy of Japan,
Washington, D.C., Freer Gallery of Art
Study Collection, National Museum of
Asian Art, Smithsonian Institution,
FSC-GR-425

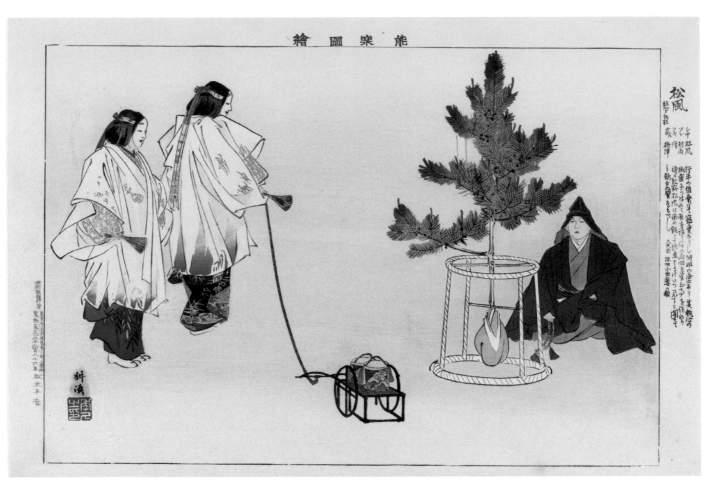

28-4 *Matsukaze,* **from the series** *Nōgaku zue*

Tsukioka Kōgyo (1869–1927); Publisher: Matsuki Heikichi; Japan, Meiji era, September 5, 1897. Woodblock print; ink and color on paper; 22.5 × 33.3 cm. Robert O. Muller Collection, Arthur M. Sackler Gallery, National Museum of Asian Art, Smithsonian Institution, S2003.8.2893

Fig. 1 (right) Tsukioka Yoshitoshi (1839–1892); Publisher: Kobayashi Tetsujirō; Carver: Noguchi Enkatsu; *Picture of the Exiled Councilor Yukihira Ason Amusing Himself with the Two Divers Murasame and Matsukaze at Suma Beach;* Japan, December 1886. Woodblock print; ink and color on paper; 37.47 × 25.24 cm (sheet, each, approx.). The Mary Griggs Burke Endowment Fund established by the Mary Livingston Griggs and Mary Griggs Burke Foundation, gifts of various donors, by exchange, and gift of Edmond Freis in memory of his parents, Rose and Leon Freis, Minneapolis Institute of Art, 2017.106.182a, b

This story of the two salt-making sisters, Matsukaze ("pining wind") and Murasame ("passing rain"), is another iconic part of the noh canon. Once the lovers of the exiled courtier Ariwara no Yukihira (818–893), the two women died in agony a short while after news of his death reached them. Because of their attachment to him, their spirits remain in limbo, unable to let go and achieve salvation. The pitfalls of worldly attachment—especially love—comprise a major theme in noh.

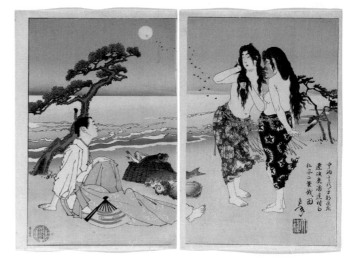

The play begins when an itinerant monk arrives at Suma Bay in today's Kobe. He chances upon a pine tree whose aura hints that it might be associated with a special event. He soon learns the pine memorializes the two sisters Matsukaze and Murasame, whose history has been associated with the place for centuries. Feeling pity for their plight, the monk recites a prayer before seeking shelter for the night. He comes across a lone hut inhabited by two salt-makers who soon appear, pulling their cart. Kōgyo's print from 1897 captures this encounter. A summary of the play located outside the right side of the picture frame—a customary addition for all prints in the artist's *Pictures of Noh* series—describes the pained hearts of the two sisters that prevent them from leaving this world behind.

Like many others in the series, the image captures a direct view of the stage, including the props. The salt wagon of the sisters is stylized, decorated lavishly in contrast with the gorgeous salt-white color of the women's robes. Kōgyo's mid-play view of the stage is strikingly different from a version made by his adopted father, Tsukioka Yoshitoshi, less than a decade early. Yoshitoshi's 1886 print eroticizes the story of Matsukaze and Murasame to an extraordinary degree. They are seen topless with their erstwhile lover at the beach, a far cry from Kōgyo's highly aestheticized version. The contrast offers a glimpse at the starkly different uses of classical narratives in Japanese literature and visual culture, through which a subject could be punned on and modified at will.

In the next part of the play, the sisters recount their isolated existence; they have "no friends but the moon." The moon's silver light evokes the glistening of salt, further adding to the color allusions that comprise the chromatic theme of the play. During their dialogue with the monk, the pair's true identity and plight are revealed. The monk again offers prayers to benefit these spirits who have remained wandering and longing for hundreds of years.

Kōgyo's later print from the 1920s displays one of the final moments of the play, focusing solely on the sister Matsukaze. The faint greenish blue surrounding her seems to create an aura of unquelled longing. In the last part of the play, Matsukaze is so consumed with this longing that she loses her mind and begins to mistake the pine tree for her lost lover, Yukihira. She is so devoured by her passion that even the monk's fervent prayers can no longer help her. At last, both sisters vanish, and only the wind can be heard in the pines.

29-1 *Tōru, from the series* Nōgaku hyakuban

Tsukioka Kōgyo (1869–1927); Publisher: Matsuki Heikichi; Japan, Taishō era, ca. 1922–25. Woodblock print; ink and color on paper; 37.8 × 25.4 cm. Robert O. Muller Collection, Arthur M. Sackler Gallery, National Museum of Asian Art, Smithsonian Institution, S2003.8.2851

29-2 *Tōru, from the series* Nōgaku hyakuban

Tsukioka Kōgyo (1869–1927), Japan, Taishō era, ca. 1922–25. Preparatory drawing; ink and color on paper; 29.4 x 22.6 cm. Darrel C. Karl Collection

Like *Matsukaze, Tōru* is another noh play in which salt brining is a main theme, albeit minus the subject of all-consuming love. The play begins when a traveling monk arrives in Kyoto under the light of a shining moon—its glistening an evocation of salt—in the fall, the season most associated with the celestial body in Japanese art and literature. The monk comes upon a large, abandoned mansion, where he suddenly encounters an old man. As the old man enters the stage, he muses about the moon's beauty and the cleansing power of its rays. Puzzled by the old man's cargo of brine, the monk asks him about it. The man recounts the story of the mansion's former owner, a ninth-century minister named Tōru, who was so struck by the beauty of the seashore that he designed his Kyoto garden to resemble it, even ordering his servants to bake salt.

After the old man finishes telling this centuries-old story, the scene transforms into a sightseeing detour. Having traveled to Kyoto from the eastern provinces, the monk asks the old man to tell him more about scenic places in Kyoto. Thus the play is both a celebration of the city's history as well as an advertisement for its sights. *Tōru* illustrates the diverse functions of medieval noh plays as historical tales, as connectors between this world and the netherworld, as travelogues, and as carriers of cultural memory.

The old man then vanishes, and the ghost of the minister Tōru appears to the monk in a dream to recount his own story. He talks about his love for the scenery at the beach of Shiogama (literally, "salt cauldron") in today's Miyagi prefecture in northeastern Japan, a sight he says is particularly charming in the moonlight. The minister sought to recreate that scenery at home in Kyoto. The ghost then performs a dance, praising the moon in his song. *Tōru* is an altogether more somber, slow-paced version of a ghost play.

Kōgyo's print and his preparatory drawing represent the old man entering the stage and appearing before the monk, who is not depicted. It is revealed in the play that the old man is indeed the ghost of the minister, so the figure takes on additional importance. Kōgyo translated the dark ink washes surrounding the figure in the drawing into a subtler representation in the print. He seems to have tried to capture some of the moonlit atmosphere that is emphasized again and again throughout the play.

114

能樂百番

土蜘

30-1, 30-2, and 30-3
Tsuchigumo, from the series *Nōgaku hyakuban*

Tsukioka Kōgyo (1869–1927); Publisher: Matsuki Heikichi; Japan, Taishō era, ca. 1922–25. Woodblock print; ink and color on paper; 37.8 × 25.4 cm. Robert O. Muller Collection, Arthur M. Sackler Gallery, National Museum of Asian Art, Smithsonian Institution, S2003.8.2845; Pearl and Seymour Moskowitz Collection, Arthur M. Sackler Gallery, National Museum of Asian Art, Smithsonian Institution, S2021.5.360; Gift of the Embassy of Japan, Washington, D.C., Freer Gallery of Art Study Collection, National Museum of Asian Art, Smithsonian Institution, FSC-GR-403

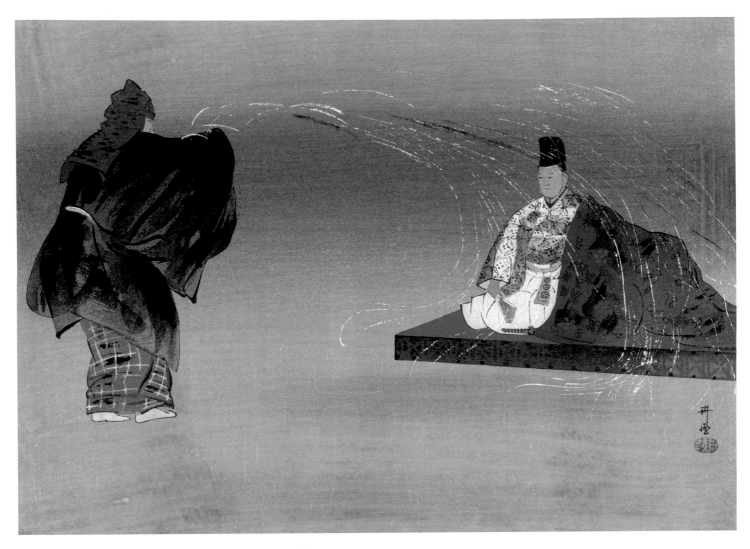

30-4 *Tsuchigumo,* **from the series** *Nōga taikan*

Tsukioka Kōgyo (1869–1927); Publisher: Matsuki Heikichi; Japan, Taishō era, ca. 1925–30. Woodblock print; ink and color on paper; 26 × 37.1 cm. Pearl and Seymour Moskowitz Collection, Arthur M. Sackler Gallery, National Museum of Asian Art, Smithsonian Institution, S2021.5.361

The warrior Minamoto no Yorimitsu (944–1021) is one of the most cherished heroes in Japanese visual arts and literature, and he is associated with several fantastical tales. One of those, the eerie story of *Tsuchigumo*, has become so beloved that it was adopted into the kabuki theater and has been depicted by countless artists (see cats. 14 and 15). The play begins with the revelation that the protagonist Yorimitsu (or Raikō) has been struck by illness. No matter what remedy his retainers bring him, the sickness seems to persist, suggesting a more sinister cause. In fact, Yorimitsu is so out of sorts, he ponders the meaning of life itself: "A person's life is like foam on the water, disappearing here and gathering there." Steeped in this fatalist mood, he strikes a conciliatory tone, saying that only he is to blame for his malaise—a hint that indeed something else is the cause for his suffering.

A strange monk soon reveals that an evil spider, the so-called "earth spider" (*tsuchigumo*), has cast a wicked spell over the warrior. It becomes clear that the monk himself is the earth spider in disguise, casting his poisonous net over Yorimitsu. As the spider-monk approaches the warrior's bed in the middle of the night, Yorimitsu slashes at him with his sword. The moment that the spider-monk casts his net upon Yorimitsu is shown in a print from Kōgyo's last series of noh images, completed by pupils after his death. The stagecraft of shooting the net from the spider-monk's hand is one of the most innovative techniques in noh, and the suddenness of the action makes it one of the most striking parts of the play.

Yorimitsu's loyal retainer, Hitorimusha, enters the stage, and the warrior tells him of his encounter. The pace of the play increases as Hitorimusha is granted permission to pursue the evildoer and slay him. Accompanied by warriors, Hitorimusha approaches the mound in which the earth spider resides and breaks it open. Just then, the spider appears and engages his enemies by shooting spiderwebs at them. Kōgyo captured that moment in prints from his *One Hundred Noh Plays* series. Though not depicted onstage, the mound is faintly visible behind the earth spider, whose wild hair and elaborately colored costume make for an imposing presence. The actor would continue to throw paper spiderwebs in this scene, building up a palpable tension and speed. Eventually, the warriors prevail, the spider is slain, and Yorimitsu is saved.

See opening pages (4–5) for an illustration of *Tsuchigumo* from the series *Nōgaku zue*.

118

31-1 *Sesshōseki,* from the series *Nōgaku zue*

Tsukioka Kōgyo (1869–1927); Publisher: Matsuki Heikichi; Japan, Meiji era, October 1, 1898. Woodblock print; ink and color on paper; 22.9 × 33.5 cm. Robert O. Muller Collection, Arthur M. Sackler Gallery, National Museum of Asian Art, Smithsonian Institution, S2003.8.2905

熊樂百番 殺生石

**31-2 *Sesshōseki,* from the series
*Nōgaku hyakuban***

Tsukioka Kōgyo (1869–1927); Publisher:
Matsuki Heikichi; Japan, Taishō era, 1922.
Woodblock print; ink and color on paper;
37.8 × 25.7 cm. Robert O. Muller Collection,
Arthur M. Sackler Gallery, National Museum of
Asian Art, Smithsonian Institution, S2003.8.2814

While returning from eastern Japan to Kyoto, a priest muses about the unpredictability and feebleness of life, setting the theme for the moral lesson of the play *Sesshōseki*. The protagonist is passing through an area in today's Tochigi prefecture when one of his attendants suddenly notices birds dropping dead in mid-flight around a strange stone—the killing stone (*sesshōseki*). Soon after, a woman appears and asks the priest not to approach the stone, explaining that the killing stone will end all life that touches or comes near it. The priest is both shocked and intrigued. He asks the woman why the stone affects living things in such a sinister way, and the woman answers that it harbors the chagrined spirit of a lady named Tamamo. A long time ago, the lady lived at the court in Kyoto, and her intelligence and beauty enthralled the emperor. Soon the emperor fell ill, and the famous *onmyō* master Kamo no Yasunori (917–977) revealed that she had been the cause. She was a fox spirit, and it soon becomes apparent that the woman recounting the story is in fact the spirit of Tamamo.

As is customary in many noh plays, the priest offers prayers to the spirit of the killing stone to console its restless soul. He begins by musing about the nature of Buddhahood itself. Although the teachings state that inanimate things do not have a spirit or soul, the killing stone proves otherwise, drawing in question the very foundations of the Buddhist paradigm. When the prayers conclude, the stone splits open, and the fox spirit emerges from it. This is the moment that Kōgyo rendered in his 1898 print from his series *Pictures of Noh*. Onstage, the stone is a prop behind which the actor hides before emerging after helpers move the two halves apart. The actor's mask is partly concealed beneath a sprawling wig, enhancing the character's menacing appearance. A musician behind the protagonist beats a drum whose sound imbues the scene with heightened tension.

Kōgyo's later print from *One Hundred Noh Plays* captures the spirit's earlier manifestation as the woman recounting Tamamo's story to the priest (see page 89, fig. 19). The dark, swirling clouds in the sky are visualizations of her song, through which she recounts a moonless, stormy night at the palace when Tamamo's body alone illuminated the darkness. As with many other prints of that series, Kōgyo has captured an eerie moment illustrating the spectrality of the main character.

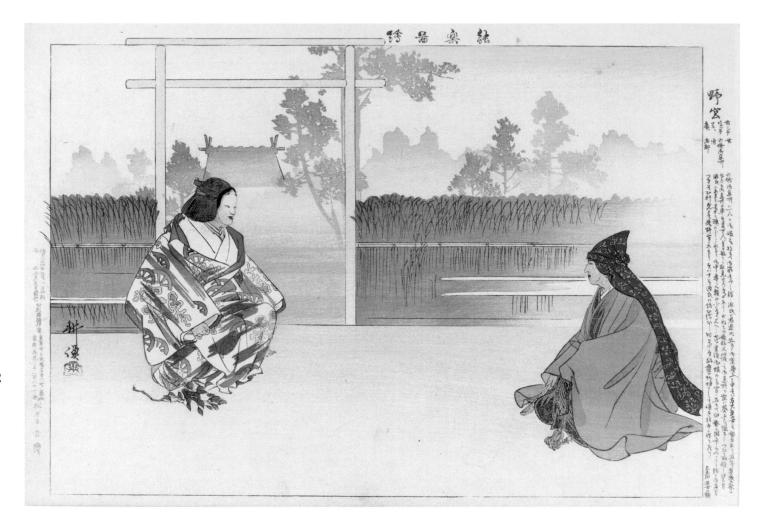

32 *Nonomiya*, from the series *Nōgaku zue*

Tsukioka Kōgyo (1869–1927); Publisher: Matsuki Heikichi; Japan, Meiji era, April 1, 1901. Woodblock print; ink and color on paper; 22.5 × 32.9 cm. Robert O. Muller Collection, Arthur M. Sackler Gallery, National Museum of Asian Art, Smithsonian Institution, S2003.8.2896

Several noh plays have been inspired by *The Tale of Genji*, a major piece of literature that traces the life of its protagonist, Genji, the so-called Shining Prince. The tale was written by the court lady Murasaki Shikibu (ca. 973–ca. 1014/1025) in the early eleventh century and is considered the world's first novel. The work had an enormous impact on Japanese arts and culture, but the dense, literary language of its text became increasingly difficult to understand in the centuries after its production. As a result, various digests were developed in the fashion of poetry manuals, listing key words and phrases. The corpus of noh plays based on *The Tale of Genji* helped keep it alive and evolving throughout its history.

The story in *Nonomiya* is one key episode of the tale surrounding the Lady Rokujō, one of Prince Genji's famous lovers. A traveling monk arrives in the Sagano area, just outside of Kyoto, in the fall, and he comes across the remnants of the Nonomiya shrine. There, he encounters a woman carrying a *sakaki* branch, a sprig from an evergreen tree considered sacred. The woman recounts an old story that appears to cause her pain. The monk, meanwhile, is struck by her elegance in such a rugged place—a hint that this woman is the worldly Lady Rokujō, who had secluded herself at the Nonomiya shrine along with her daughter before the latter was sent to the grand shrine at Ise as one of its vestals. Kōgyo's print captures the moment the woman enters the story. Contrasting with the matter-of-fact rendering of a scene onstage, as in many others in his series *Pictures of Noh*, here, Kōgyo visualized elements that are present only in the play's songs. One such element is the vista of the Nonomiya shrine, whose gate is described in *The Tale of Genji* as made of unpainted wood and linked by a wicker wood fence. The print transports the viewer away from the stage to the literary site, thus enabling a mental journey both into the play and into *The Tale of Genji* itself. The choice to render an early scene—the first encounter between the monk and Lady Rokujō's spirit—is repeated in other works from Kōgyo's series. The remainder of the play, during which Rokujō reminisces about her love for Genji and dances for the monk, is effectively rendered superfluous. This scene captures the timbre and gist of the narrative as a whole.

124

33-1 and 33-2 *Aoi no ue*, from the series *Nōgaku hyakuban*

Tsukioka Kōgyo (1869–1927); Publisher: Matsuki Heikichi; Japan, Taishō era, 1922. Woodblock print; ink and color on paper; 37.8 × 25.7 cm. Robert O. Muller Collection, Arthur M. Sackler Gallery, National Museum of Asian Art, Smithsonian Institution, S2003.8.2822; Gift of the Embassy of Japan, Washington, D.C., Freer Gallery of Art Study Collection, National Museum of Asian Art, Smithsonian Institution, FSC-GR-427

Another play based on *The Tale of Genji*, albeit with a more sinister tone than *Nonomiya*, *Aoi no ue*, or *Lady Aoi*, begins in an unusual manner when a *kosode* is silently placed on the stage. The short-sleeved garment is symbolic of the plight of Lady Aoi, who was famously haunted by the specter of a jealous lover of Genji. The play is unusual in other ways as well. Instead of recounting a story of times past, it transports the audience directly into the time and plot of *The Tale of Genji*.

A courtier and priestess enter. The courtier announces that the Lady Aoi, Genji's wife, has been possessed—a central and frightening plotline in *The Tale of Genji*. It is revealed that a priestess was called upon to divine the nature of the spirit possessing Aoi. As the priestess incants prayers, the spirit of Genji's lover, Lady Rokujō, appears. It becomes clear that Genji's attention has shifted away from Rokujō, and the spurned lover has in turn lashed out at Aoi. Genji's disinterest becomes evident during a festival in Kyoto when Rokujō's ox cart is pushed to the side for Genji's carriage to come through, despite her high-ranking birth. Unbeknownst to Genji, his lover suffers a major slight in full public view.

As Rokujō's disguised spirit recounts her sorrow before them, the priestess and courtier are aware of her true identity and ask her to reveal her name. Disclosing her identity, the specter talks herself into a frenzied rage. In an interlude that serves to ease the rapidly building tension, a monk is summoned to quell the vengeful spirit. The monk's prayers cause Rokujō's specter to take on her true resentful form: a horned, yellow-eyed demon. The play's speed and tension continue to increase. This is the part of the play Kōgyo selected for his print. Rokujō's demon gazes scornfully upon the *kosode* lying on the floor, her own costume patterned with a motif of scales akin to a snake or dragon. Eventually, the prayers work, and Rokujō's avenging spirit is pacified. Lady Aoi is healed, although her character never enters the stage and is only present in song.

125

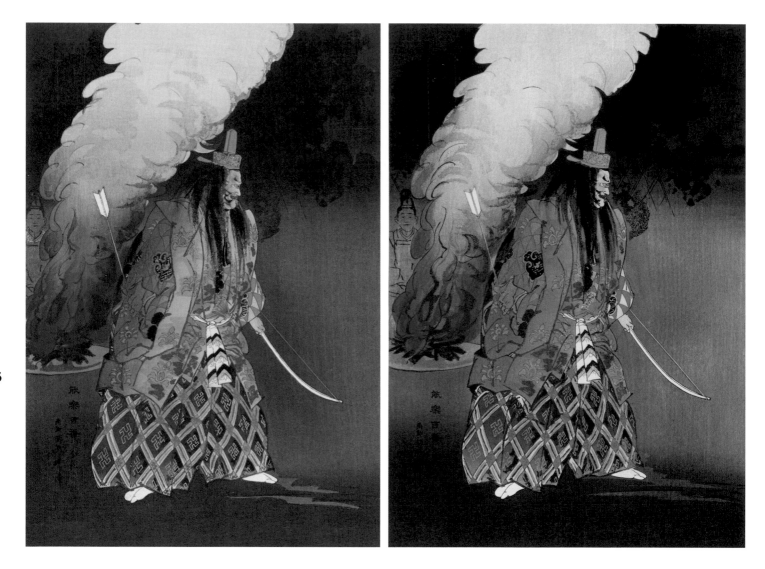

34-1 and 34-2 *Kinsatsu,* from the series *Nōgaku hyakuban*

Tsukioka Kōgyo (1869–1927); Publisher: Matsuki Heikichi; Japan, Taishō era, 1922. Woodblock print; ink and color on paper; 37.8 × 25.7 cm. Robert O. Muller Collection, Arthur M. Sackler Gallery, National Museum of Asian Art, Smithsonian Institution, S2003.8.2820; Gift of the Embassy of Japan, Washington, D.C., Freer Gallery of Art Study Collection, National Museum of Asian Art, Smithsonian Institution, FSC-GR-309

Kinsatsu belongs to a category of noh plays that are traditionally shown at the end of a day's worth of performances. Other plays, such as *Shakkyō,* are similarly used to wrap up a string of long performances that often fill most of the day. They are usually relatively brief, positive in spirit, and celebratory in message. The auspicious timbre and reassuring message of *Kinsatsu* aligns with such conventions.

The essence of the play is a celebration of the benevolent imperial rule of the emperor Kanmu (737–806), who is blessed by higher forces. The emperor dispatches an envoy to build a shrine in the southern Kyoto suburb of Fushimi. The gesture of sponsoring a shrine is symbolic of the emperor's virtuous reign. To further underscore his righteousness, the envoy discovers a golden tablet falling from the sky as soon as he arrives at the site of the prospective shrine. Divine blessing of the project is ensured. The envoy decides to rest beneath a pine tree with the hopes of receiving a celestial omen in his sleep. As soon as he drifts off, the deity Amatsu-futodama-no-mikoto appears and reveals it is he who sent the tablet. The shrine, coated in gold, is finished by divine intervention. At the concluding moment of the play, the deity shoots an arrow marking the advent of an era of peace and prosperity for the entire realm.

At first sight, the darkness and foreboding timbre of Kōgyo's print seem nothing like the positivity of the play's plot. The fire illuminating the deity does not appear onstage but instead reflects the nighttime vision of the envoy toward the end of the play, right before the deity shoots his arrow to augur a tranquil and just polity. In Kōgyo's time of increasingly nationalistic sentiment, such plays took on new meaning as a form of theatrical propaganda for the emperor and his rule.

35 *Shakkyō,* from the series *Nōgaku hyakuban*

Tsukioka Kōgyo (1869–1927); Publisher: Matsuki Heikichi; Japan, Taishō era, ca. 1922–27. Woodblock print; ink and color on paper; 37.9 × 51.4 cm. Robert O. Muller Collection, Arthur M. Sackler Gallery, National Museum of Asian Art, Smithsonian Institution, S2003.8.2884

The play *Shakkyō,* or Stone Bridge, begins with the Japanese priest Jakushō (ca. 962–1034) introducing himself to the audience. Jakushō was born into nobility and held various political appointments in Kyoto and elsewhere before taking vows to become a priest. In pursuit of religious studies, he eventually crossed the seas to Song-dynasty (960–1279) China. His life and success in China have been a subject of fascination among Japanese artists. Anecdotes about Jakushō have been rendered in paintings and dramatized in both noh and kabuki.

In *Shakkyō,* Jakushō is traveling in China and chances upon a storied stone bridge, where he encounters a boy. The boy suddenly stops Jakushō as he begins to cross the bridge, telling the priest that the land beyond the bridge is the realm of the bodhisattva Manjushri. He reveals that no mortal, not even virtuous priests, should cross without undergoing rigorous purification. The essence of this conversation is the fact that regular Buddhist training is not sufficient to attain enlightenment and enter the paradisiacal realm of the bodhisattva.

The play has no firm conclusion, but it climaxes in a dance performance. After the exchange and in tandem with a chorus, the boy describes the bridge as old as time, traversing a bottomless, hellish ravine beneath it. Soon after, two lions—the mounts of Manjushri—appear as the bodhisattva's messengers. The lions break into a mesmerizing dance to celebrate Buddhist virtue and a peaceful realm. Kōgyo's diptych of prints depicts this climactic final moment of the play. The scene is flush with red, reminiscent of an evening or morning glow, echoing the luminous light of the paradise that lies beyond the bridge.

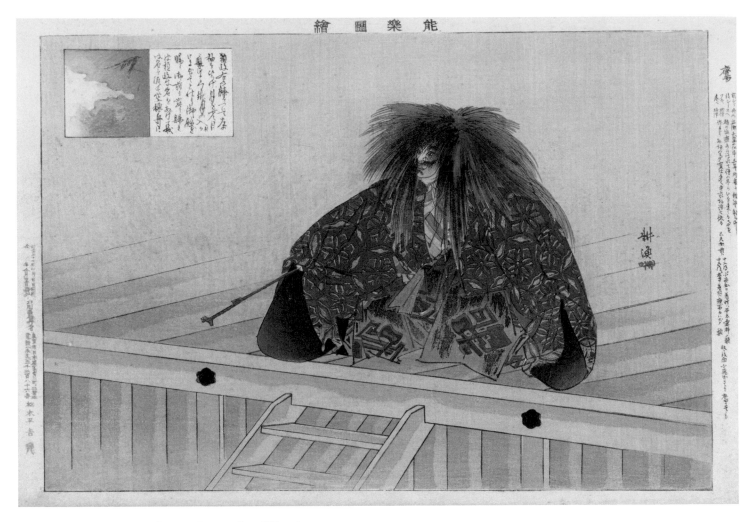

36-1 and 36-2 *Nue,* from the series *Nōgaku zue*

Tsukioka Kōgyo (1869–1927); Publisher: Matsuki Heikichi; Japan, Meiji era, September 1, 1898. Woodblock print; ink and color on paper; 22.9 × 33.2 cm. Robert O. Muller Collection, Arthur M. Sackler Gallery, National Museum of Asian Art, Smithsonian Institution, S2003.8.2948 and S2003.8.2949

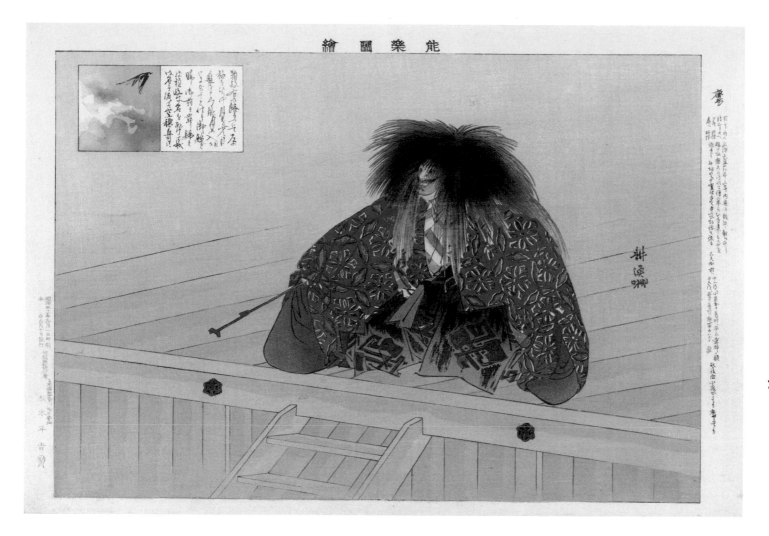

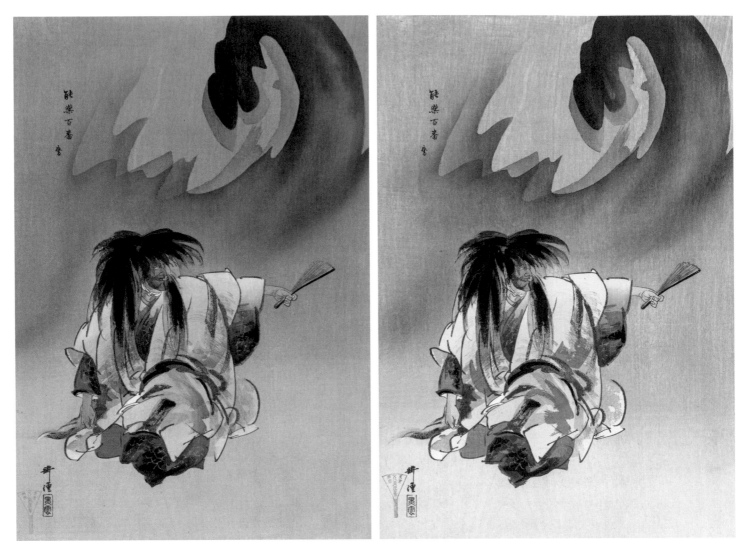

36-3 and 36-4 *Nue,* **from the series** *Nōgaku hyakuban*

Tsukioka Kōgyo (1869–1927); Publisher: Matsuki Heikichi; Japan, Taishō era, 1925. Woodblock print; ink and color on paper; 37.8 × 25.7 cm. Robert O. Muller Collection, Arthur M. Sackler Gallery, National Museum of Asian Art, Smithsonian Institution, S2003.8.2947; Gift of the Embassy of Japan, Washington, D.C., Freer Gallery of Art Study Collection, National Museum of Asian Art, Smithsonian Institution, FSC-GR-410

A traveling monk reaches the area of Ashiya in today's Hyōgo prefecture, a site by the inland sea that is laden with the history of exiles from Kyoto and that features in several noh plays. Everyone in the village declines to host the monk for the night, so he decides to sleep at a nearby temple despite a villager's warning that a specter occasionally visits the site.

Sure enough, at night the monk is met by a strange-looking boatsman who laments being trapped in a miserable existence, unable to break away from this world, "floating on tears." As the two converse, the monk grows suspicious of his nocturnal visitor and begins to doubt he is human. The boatsman reveals he is indeed the spirit of Nue, a mythical creature from Japanese folklore that was slain by the warrior Minamoto no Yorimasa (1106–1180). Unfazed, the monk inquires about the circumstances of Nue's death. The specter recounts how the emperor at the time was beset by a mysterious illness that could not be cured by any medicine. At the same time, a strange dark cloud rose behind the woods surrounding the imperial palace. Kōgyo's 1925 print captures Nue in front of the foreboding cloud, pairing a view of the actor onstage with the atmospheric aspect sung about in the story. The cloud was interpreted as a sign of evildoing and was linked to Nue, who was killed because he was thought to be the cause of the emperor's illness. The artist's earlier print, on the other hand, captures Nue as he faces the audience and recounts his story. In the upper left, a small *shikishi* with an image of dark clouds above water adds a reminder of the spirit's wet grave.

The monk offers to perform prayers on Nue's behalf, but the spirit despairs that no incantations can save **133** him. After Nue disappears into the darkness, the monk prays for him anyway but to no avail. As in the story of *Akogi*, prayers do not alleviate the sin of Nue's actions that cursed and sickened the emperor. The grave deed cannot remain unpunished, and at the end of the play, in spite of the monk's recitations of sutras and rituals, Nue sinks back into the darkness of the sea.

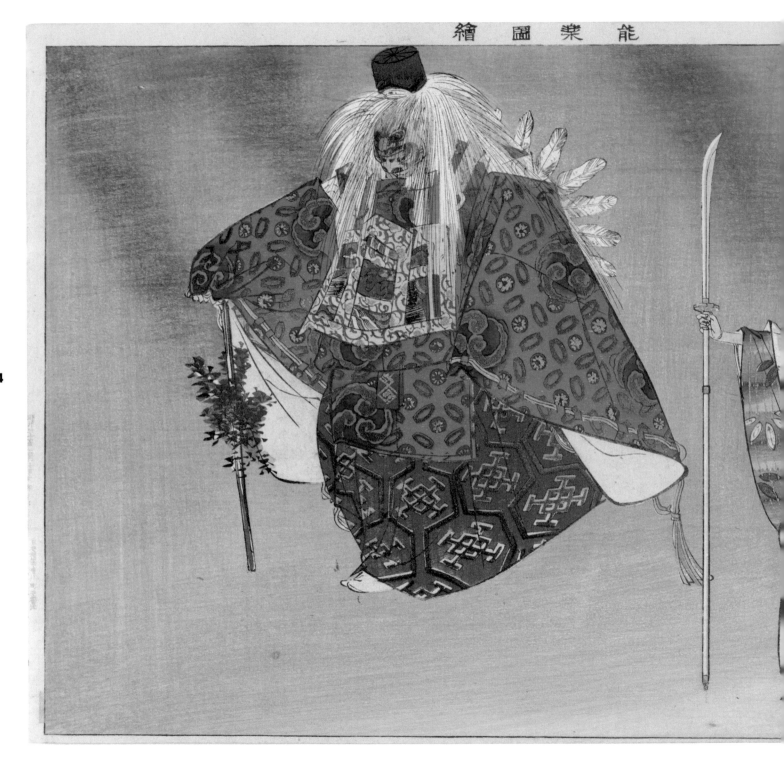

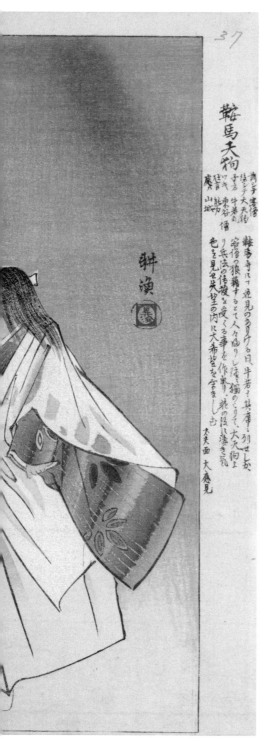

37-1 *Kurama tengu*, from the series *Nōgaku zue*

Tsukioka Kōgyo (1869–1927); Publisher: Matsuki Heikichi; Japan, Meiji era, 1898. Woodblock print; ink and color on paper; 22.9 × 33.5 cm. Robert O. Muller Collection, Arthur M. Sackler Gallery, National Museum of Asian Art, Smithsonian Institution, S2003.8.2890

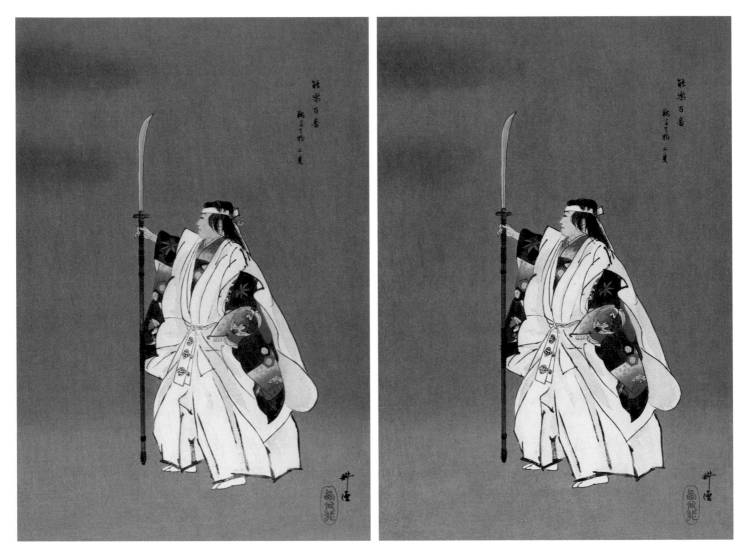

37-2 and 37-3 *Kurama tengu*, from the series *Nōgaku hyakuban*

Tsukioka Kōgyo (1869–1927); Publisher: Matsuki Heikichi; Japan, Taishō era, ca. 1922–25. Woodblock print; ink and color on paper; 37.8 × 25.7 cm. Robert O. Muller Collection, Arthur M. Sackler Gallery, National Museum of Asian Art, Smithsonian Institution, S2003.8.2811; Gift of the Embassy of Japan, Washington, D.C., Freer Gallery of Art Study Collection, National Museum of Asian Art, Smithsonian Institution, FSC-GR-347

The story of *Kurama tengu* mixes mystical mountain creatures, fictionalized history, and lessons of piety into one. The story begins when a mountain priest encounters a group of monks en route to enjoy cherry blossoms on Mount Kurama. Unlike the priests in most other plays, this one bears a secret: he is not actually human but a mythical mountain creature, half bird half person, called a *tengu*. Even though the *tengu* appears in the guise of a human, the monks are suspicious of the stranger and pepper him with questions. Stressing that he was not invited to the gathering, they try to find excuses to get rid of him. In the end, afraid to seem rude by chasing him away, the monks depart together, leaving only a boy attendant behind. The attendant, Minamoto no Yoshitsune (1159–1189), also known as Ushiwakamaru, stays with the mountain priest as to not seem impolite. Ushiwakamaru would eventually become one of the great military leaders of Japanese history, and his prowess was due to the training he received from the *tengu*. *Kurama tengu* is the fictionalized account of their first encounter.

Left by themselves, Ushiwakamaru and the mountain priest begin to talk. The mountain priest is flummoxed by the outrageous departure of the monks but is touched that Ushiwakamaru has politely stayed behind. The boy impresses on the mountain priest that only with others can the beauty of the blossoms really be cherished. In fact, he is also a loner. Having been born into the Minamoto clan, the aloof Taira clan often shunned him. Here, the play lays out the dynamic between the two major clans, whose competition for dominion over the realm in the late twelfth century culminated in the civil war that established shogunal rule in Japan.

The mountain priest soon reveals he is the leader of the *tengu* and offers to train Ushiwakamaru in the arts of fighting and war. The two soon begin the training, a scene captured in Kōgyo's 1898 print. The *tengu* and Ushiwakamaru stand side by side, the boy holding a halberd and the *tengu* resting royally on a rough walking stick. Kōgyo's later print focuses solely on Ushiwakamaru, emphasizing the subtext of Ushiwaka's destiny. The boy stares defiantly into the void ahead of him, surrounded by the nighttime setting of the play.

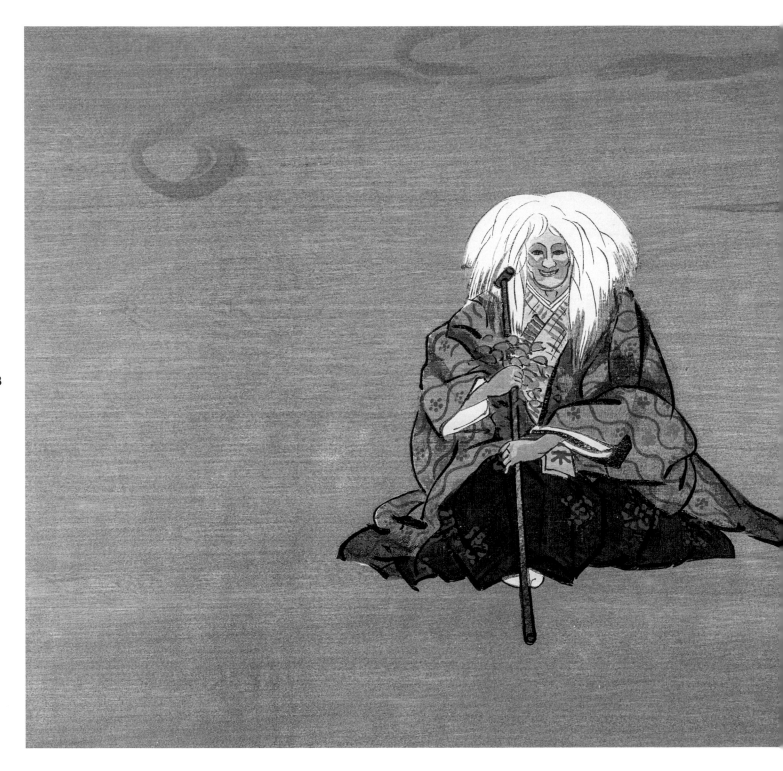

38-1 *Yamanba,* from the series *Nōga taikan*

Tsukioka Kōgyo (1869–1927); Publisher: Matsuki Heikichi; Japan, Taishō era, ca. 1925–27. Woodblock print; ink and color on paper; 25.6 × 38.3 cm. Robert O. Muller Collection, Arthur M. Sackler Gallery, National Museum of Asian Art, Smithsonian Institution, S2003.8.2921

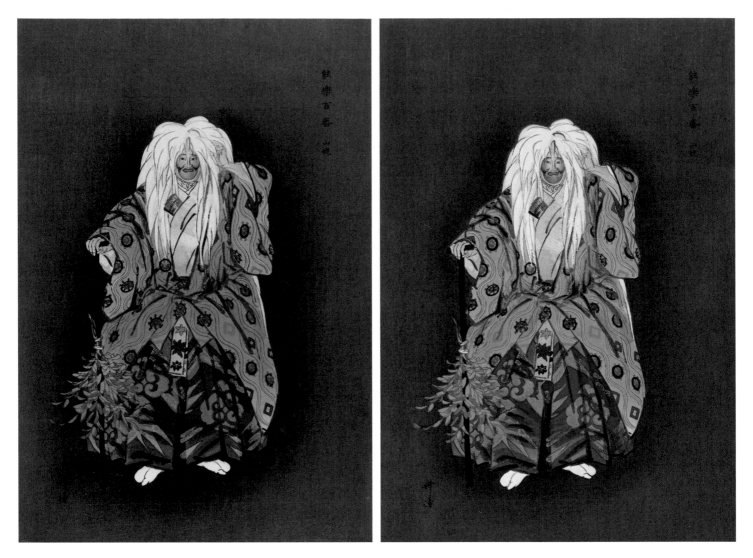

38-2 and 38-3 *Yamanba,* **from the series** *Nōgaku hyakuban*

Tsukioka Kōgyo (1869–1927); Publisher: Matsuki Heikichi; Japan, Taishō era, 1924. Woodblock print; ink and color on paper; 37.8 × 25.7 cm. Robert O. Muller Collection, Arthur M. Sackler Gallery, National Museum of Asian Art, Smithsonian Institution, S2003.8.2848; Gift of the Embassy of Japan, Washington, D.C., Freer Gallery of Art Study Collection, National Museum of Asian Art, Smithsonian Institution, FSC-GR-368

Yamanba is a complex and compelling play in which an actor meets the subject of her main role. At the beginning of the play, a group of retainers and servants introduce a dancer famous for her song and dance impersonating a storied mountain witch named Yamanba. The dancer is so renowned for that performance she is known by the name of the piece, "Hyakuma yamanba." The play starts in the middle of the dancer's pilgrimage with her servants from Kyoto to the temple Zenkōji in the mountains of today's Nagano prefecture. As their trip continues, the group comes upon Mount Agero, in today's Niigata prefecture, and prepares to cross, when night suddenly falls around them.

Just as the sky gets dark, a woman approaches them and offers accommodation, reminding the group of the remoteness of the area and urging them to stay with her. Puzzled by the sudden darkness, the dancer and her company follow the woman to her home. The woman soon asks the dancer to perform her signature piece. She also asks the group if they know what the mountain witch is really like, to which a retainer responds she is an evil hag.

The woman reveals she is Yamanba and feels slighted someone portraying her for so many years has never bothered to pay her respects. Yamanba asks for the dance to be performed by moonlight. Only if the dancer's song is as clear as the moon's radiance will the witch reveal her true form to the group. As the dancer prepares, Yamanba appears undisguised and urges her not to fear. Eventually, the witch dances and prays before disappearing forever.

141

Kōgyo's prints from the series *One Hundred Noh Plays* show Yamanba dancing during the final part of the play. The artist has repeated the frightening frontality he championed in his earlier print from 1924. Unlike his prints of other plays in which he selected different points of emphasis in his various print series, Kōgyo has captured *Yamanba* through the striking image of the witch glaring toward the audience, as if challenging us just as she challenged the dancer.

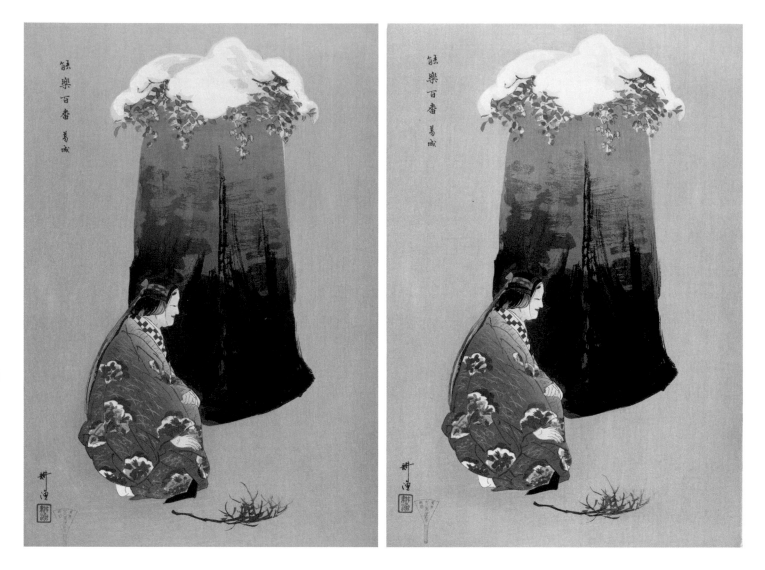

39-1 and 39-2 *Kazuraki,* from the series *Nōgaku hyakuban*

Tsukioka Kōgyo (1869–1927); Publisher: Matsuki Heikichi; Japan, Taishō era, ca. 1922–25. Woodblock print; ink and color on paper; 37.9 × 25.7 cm. Robert O. Muller Collection, Arthur M. Sackler Gallery, National Museum of Asian Art, Smithsonian Institution, S2003.8.2846; Gift of the Embassy of Japan, Washington, D.C., Freer Gallery of Art Study Collection, National Museum of Asian Art, Smithsonian Institution, FSC-GR-418

Although most noh plays whose main character is a specter focus on spirits of people and places, *Kazuraki* is a rare example in which the protagonist is the pained spirit of a deity. *Kazuraki* also reveals some of the Buddhist biases that are part of several noh plays. A group of mountain priests on pilgrimage arrives at Mount Kazuraki and are surprised by a snowstorm. Seeking shelter, they find the home of a woman who allows them in for the night.

The woman prepares a fire using firewood called *shimoto*, explaining to the puzzled monks that bundles of wood gathered on Mount Kazuraki are named for the vines used to tie them. The vines have a special significance for the woman's fate. When the mountain priests settle in for the night and begin performing nocturnal rites, the woman suddenly appears and asks them to pray for her as well. Surprised by her request, the priests inquire why. The woman reveals she is the spirit of the deity of Mount Kazuraki, who was punished by the great mountain priest En no Gyōja (634–706). Believing that women are inherently sinful and accusing the deity of neglecting his wishes, Gyōja bound her with the mountain's vines and left her in never-ending agony. After her true identity is revealed to the monks, she vanishes.

In an interlude, a villager recounts the story of the deity of Kazuraki and the priest En no Gyōja. The priest asked her to build a bridge between Mount Kazuraki and Mount Ōmine, but the deity was ashamed of her appearance and refused to work in daylight. For that reason, Gyōja bound her with vines and left her to her destiny. The deity eventually returns and performs a dance during the play, but not before closing the stone door to keep light from illuminating her figure. The story of a deity concealing her appearance is reminiscent of a famous account in the *Records of Ancient Matters* (*Kojiki*) (712), Japan's earliest chronicle. The story recounts how the sun deity Amaterasu hid in a cave and plunged the world into darkness before eventually being lured out.

Kōgyo's print of *Kazuraki* shows the deity speaking about the *shimoto* branches of the mountain, a metaphor for her punishment. Next to her is a stylized rendering of Mount Kazuraki itself, the vines and snow a visualization of her prison.

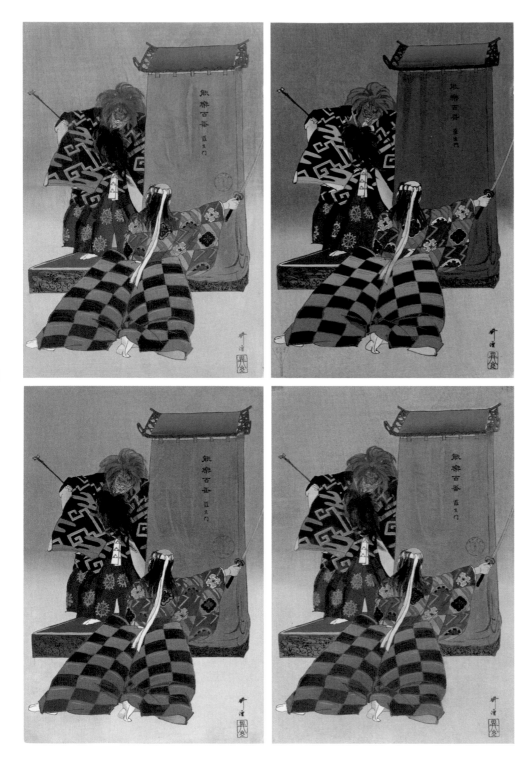

144

40-1, 40-2, 40-3, and 40-4 *Rashōmon,* **from the series** *Nōgaku hyakuban*

Tsukioka Kōgyo (1869–1927); Publisher: Matsuki Heikichi; Japan, Taishō era, ca. 1922–25. Woodblock print; ink and color on paper; 37.9 × 25.7 cm. Robert O. Muller Collection, Arthur M. Sackler Gallery, National Museum of Asian Art, Smithsonian Institution, S2003.8.2963–2964 and S2003.8.2969–2970

Unlike many plays in the noh repertoire that are linked to Zeami (ca. 1363–ca. 1443) or are of unknown attribution altogether, the authorship of *Rashōmon* is known to be by the fifteenth-century performer and playwright Kanze Nobumitsu (1435/1450–1516). The dynamic play recounts the encounter between the warrior Watanabe no Tsuna (953–1025)—a companion of Minamoto no Yorimitsu of the play *Tsuchigumo*—and the demon inhabiting the Rashōmon gate. Tsuna and Yorimitsu were favorite monster slayers in both Japanese noh and kabuki theater.

The play begins when a group of warriors, including Tsuna, are at a banquet and learn about a demon that allegedly lives inside one of Kyoto's city gates, the Rashōmon. The demon is said to accost people trying to pass through the gate, making it unsafe for everyone. Tsuna resolves to take up the challenge and slay the demon on behalf of the people of Kyoto.

The second half of the play takes place at the Rashōmon. The pace is slow until Tsuna encounters the demon, named Ibaraki, lurking behind the gate. Kōgyo has rendered a stylized version of the gate, with the young Tsuna in front of it. Soon the two are engulfed in an epic fight that results in the warrior cutting off the demon's arm. Though harmed, Ibaraki escapes from the scene, and Tsuna returns home with the arm as his trophy and stores it in a box. A few days later, an old woman appears and asks to see the appendage. When Tsuna shows it to her, the woman reveals herself as the demon Ibaraki and snatches the arm from him. Escaping with the appendage, the demon never again sets foot in Kyoto, leaving the city's people in peace.

The four different impressions of Kōgyo's print illustrate the effect that printing had on the atmosphere of his works. Each print's color gradation achieves a distinctive resonance with the viewer and evokes different associations, ranging from dark and brooding to light and reassuring.

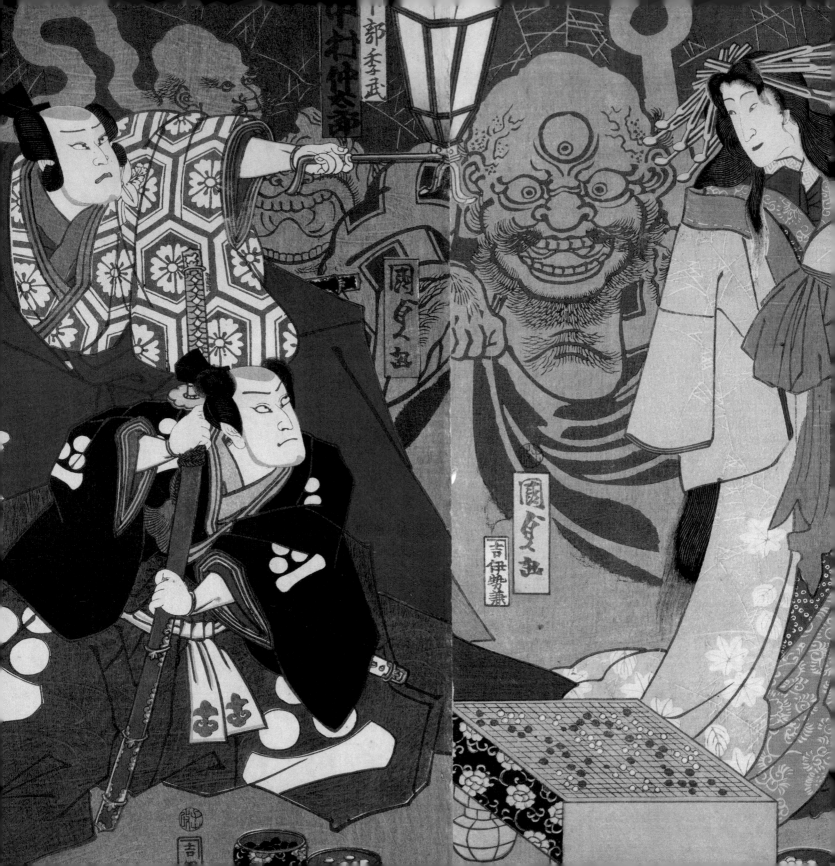

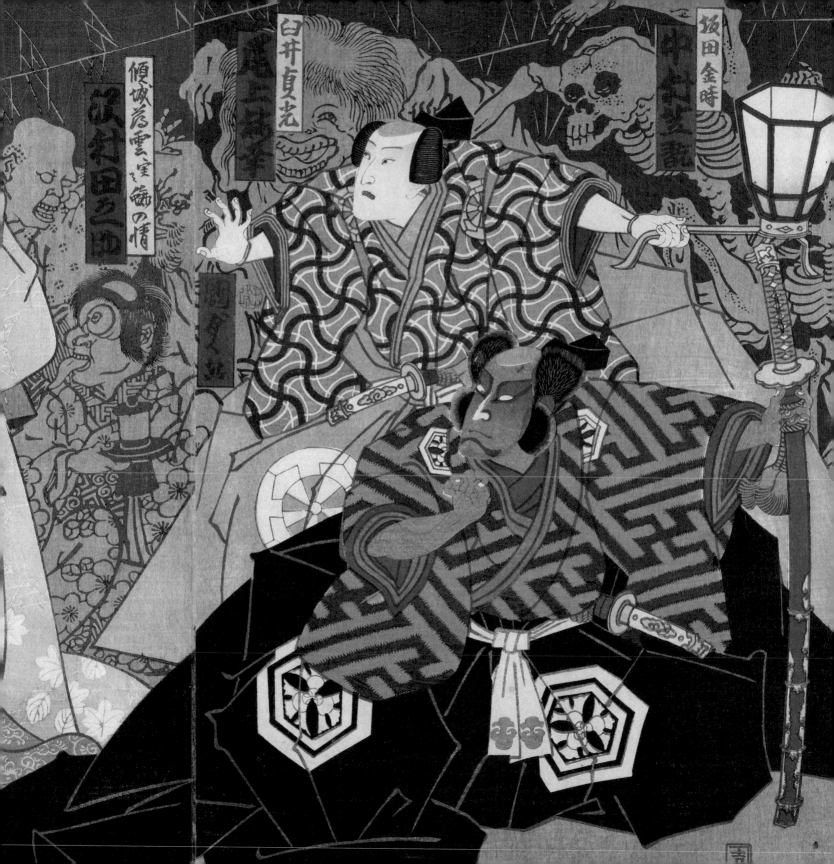

The Process of Making a Woodblock Print

In the Edo period (1603–1868) and the Meiji era (1868–1912), the process of most commercial woodblock printing began with a publisher, or *hanmoto* (literally, "origin of the block"). The *hanmoto* was responsible for the financial backing of the project and sold the finished works in a store they owned. A *hanmoto* usually began by identifying a subject they thought would be commercially successful, such as a new play or a popular novel, and then commissioned a suitable artist to produce a design or a series of designs on that subject. To execute the design, the *hanmoto* also commissioned woodblock carvers and printers who usually worked separately from the artist in specialist studios. The *hanmoto* operated as an artistic director throughout the process, coordinating the efforts of all the different specialists.

The artist produces a series of sketches on thin mulberry paper, reworking the composition until they are satisfied with the design. The final composition of neat, black lines is known as a *hanshita-e* (block-ready drawing). The *hanshita-e* is passed to the block carver (*horishi*) and is pasted face down onto a block of cherry wood using *nori* rice paste. A cloth soaked in camelia oil is rubbed on the back of the paper to make it translucent and to expose the ink lines of the drawing. If the paper is especially thick, the paper fibers are dampened with water and the upper layer rolled away in clumps for the same effect. The carver uses these lines as a guide and carves away the surrounding wood so the design remains as raised lines. A sharp, flat chisel is used to carve close to the line, while a mallet and chisels with larger, curved blades are used to remove the surrounding wood (figs. 1 and 2). The design now on the block is a mirror image of both the original drawing and the final print. This woodblock with the carved outlines of the design is known as the keyblock.

A printer takes the keyblock and places it on a slanted desk (fig. 3), with the carved surface of the woodblock facing up and toward them. The printer will usually wet the blocks with a wide brush to prevent the pigments from drying out. A smaller brush called a *hakobi* is used to transfer ink to the raised outlines of the design—usually the carbon black ink *sumi*, which is then spread using a wide brush with short bristles (figs. 4 and 5). A thick piece of mulberry paper is placed on top and set into registration marks known as *kentō* to ensure the design is printed in the same place on each sheet of paper (fig. 6).

The paper is rubbed from the back with a type of printing pad known as a *baren* (figs. 7 and 8). Many printers make their own *baren*, which is formed from a lacquer disc and a coil of bamboo to provide a durable surface. The coil is then covered with a bamboo leaf, which ensures the roughness of the coil does not damage the paper and spreads the pressure evenly across the surface of the pad.

Figs. 1 and 2 Mallet and chisel

Figs. 3 and 4 Slanted desk and brushes

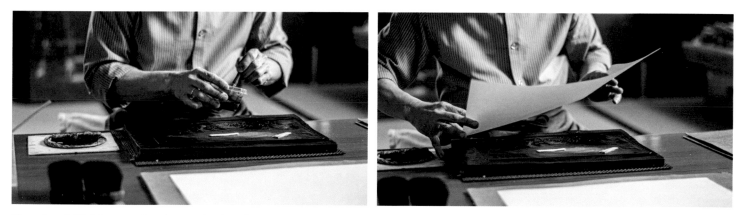

Figs. 5 and 6 Ink is spread and paper is placed

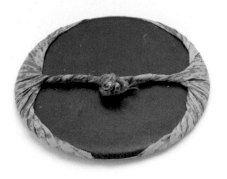
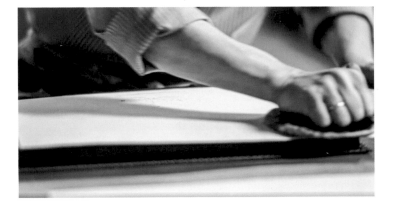

Figs. 7 and 8 A *baren* is used to rub the paper from the back

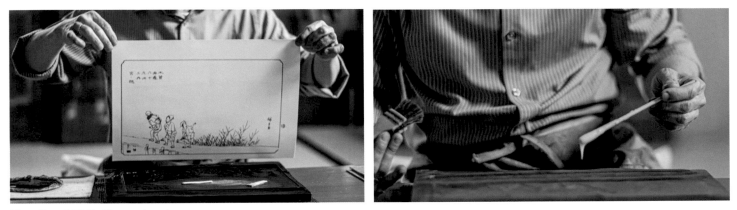

Figs. 9 and 10 Outline and paste

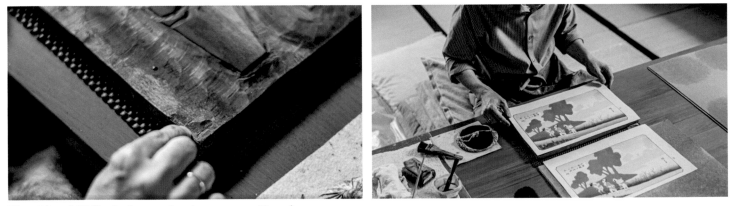

Figs. 11 and 12 Block alignment and process continued

The resulting printed sheet showing the outlines of the design is then used by the block carver to determine the additional blocks that need to be carved to produce the colored areas in the design (fig. 9). The number of blocks needed and the areas in which they are carved are guided by economical decisions, and woodblocks are usually carved on both sides to maximize the use of resources. Lighter colors are usually printed before darker colors.

To print the color blocks, pigment is applied with a small brush directly to the block on the area that will be printed with that color. Then the pigment is spread using a wide brush with short, stiff bristles. *Nori* rice paste is often added to the color to alter the consistency and make it easier to control its distribution (fig. 10). Japanese woodblock prints can achieve remarkable color alignment across the different blocks since *kentō*, which are used to guide the paper into the perfect position, are carved in the same place on every block (fig. 11). Brushes are used to spread the color, and then the paper is fitted into the registration marks. This process is repeated until all the colors have been printed (fig. 12).

Bibliography

Brandon, James R. "Introduction." In *Nō and Kyōgen in the Contemporary World*, 3–18. Honolulu: University of Hawai'i Press, 1997.

Brandon, James R., and Samuel L. Leiter, eds. *Kabuki Plays on Stage*. Vol. 3, *Darkness and Desire, 1804–1864*. Honolulu: University of Hawai'i Press, 2002.

Clark, Timothy. *Kuniyoshi: From the Arthur R. Miller Collection*. London: Royal Academy of the Arts, 2009.

Crandol, Michael. *Ghost in the Well: The Hidden History of Horror Films in Japan*. London: Bloomsbury Academic, 2021.

Cross, Barbara Jane. "Shikitei Sanba (1776–1822) and Woodblock Print." PhD diss., School of Oriental and African Studies, University of London, 2006.

Dermois, Tina. "Depicting No Theatre: A Brief History of Meiji No and Tsukioka Kōgyo's No Aesthetics." *Andon* 108 (October 2019): 21–32.

Feltens, Frank. *Ogata Kōrin: Art in Early Modern Japan*. New Haven; London: Yale University Press, 2021.

Furuido Hideo. *Tsuruya Nanboku*. Tokyo: Yoshikawa Kōbunkan, 2020.

Gerstle, C. Andrew. "Heroic Honor: Chikamatsu and The Samurai Ideal." *Harvard Journal of Asiatic Studies* 57, no. 2 (1997): 307–81.

Gunji Masakatsu. "Tōkaidō Yotsuya Kaidan." In *Shinchō Nihon Koten Shūsei*. Vol. 45, 401–39. Tokyo: Shinchōsha, 1981.

Harper, Thomas J., and Edward Seidensticker, trans. *In Praise of Shadows*. Sedgwick, ME: Leete's Island Books, 1977.

Heisig, James W. *Philosophers of Nothingness: An Essay on the Kyoto School*. Honolulu, University of Hawai'i Press, 2001.

Herwig, Henk, and Joshua S. Mostow. *The Hundred Poets Compared: A Print Series by Kuniyoshi, Hiroshige, and Kunisada*. Leiden: Hotei, 2007.

Keyes, Roger, and Keiko Mizushima. *The Theatrical World of Osaka Prints: A Collection of Eighteenth and Nineteenth Century Japanese Woodblock Prints in the Philadelphia Museum of Art*. Philadelphia: Philadelphia Museum of Art, 1973.

Kincaid, Zoë. *Kabuki: The Popular Stage of Japan*. New York: Arno Press, 1977.

Kuroda Genji. *Kamigata-e ichiran*. Kyoto: Satō Shōtarō Shōten, 1929.

Leiter, Samuel L. "*Keren*: Spectacle and Trickery in *Kabuki* Acting." In *Frozen Moments: Writings on* Kabuki*, 1966–2001*, 74–91. Ithaca, NY: Cornell University East Asia Series, 2002.

———. "'What Really Happens Backstage': A Nineteenth-Century Kabuki Document." In *Frozen Moments: Writings on* Kabuki*, 1966–2001*, 92–109. Ithaca, NY: Cornell University East Asia Series, 2002.

Marks, Andreas. *Publishers of Japanese Woodblock Prints: A Compendium*. Leiden: Hotei Publishing, 2011.

Miyamoto Keizō. *Kamigata nōgakushi no kenkyū*. Osaka: Izumi Shoin, 2005.

Nagao, Kazuo. "A Return to the Essence through Misconception: From Zeami to Hisao." In *Nō and Kyōgen in the Contemporary World*, 111–24. Honolulu: University of Hawai'i Press, 1997.

Nelson, Lindsay. *Circulating Fear: Japanese Horror, Fractured Realities, and New Media*. Lanham, MD: Lexington Books, 2021.

Oikawa, Shigeru. "A Brief Note on *Shikake-e* Woodblock Prints." *Andon*, no. 110 (2020): 19–35.

Rimer, J. Thomas. "Tsukioka Kōgyo and His Times." In *The Beauty of Silence: Japanese Nō and Nature Prints by Tsukioka Kōgyo 1869–1927*, 9–17. Leiden; Boston: Hotei Publishing, 2010.

Rimer, J. Thomas, and Yamazaki Masakazu, trans. *On the Art of the Nō Drama: The Major Treatises of Zeami*. Princeton, NJ: Princeton University Press, 1984.

Rodd, Laurel Rasplica, and Mary Catherine Henkenius, trans. *Kokinshū: A Collection of Poems Ancient and Modern*. Princeton: Princeton University Press, 1984.

Sadamura, Koto. *Kyōsai: The Israel Goldman Collection*. London: Royal Academy of Arts, 2022.

Sakamaki Kōgyo. "Nō to nōga." Translated by Richard J. Smethurst. *Bijutsu no Nihon* 6, no. 1 (1914): 4–5.

Schaap, Robert. "A 'Silent Beauty' in Ukiyo-e: Printed Imagery of the Nō Theater." In *The Beauty of Silence: Japanese Nō and Nature Prints by Tsukioka Kōgyo 1869–1927*, 18–31. Leiden; Boston: Hotei Publishing, 2010.

Schwaab, Dean J. *Osaka Prints*. London: Murray, 1989.

Shimazaki, Satoko. *Edo Kabuki in Transition: From the Worlds of the Samurai to the Vengeful Female Ghost*. New York: Columbia University Press, 2016.

———. "The End of the 'World': Tsuruya Nanboku IV's Female Ghosts and Late-Tokugawa Kabuki." *Monumenta Nipponica* 66, no. 2 (2011): 209–46.

———. "The Ghost of Oiwa in Actor Prints: Confronting Disfigurement." *Impressions* 29 (2007–2008): 76–97.

Shirane, Haruo, ed. *Early Modern Japanese Literature: An Anthology, 1600–1900*. New York: Columbia University Press, 2002.

Suzuki Kenkō. "Santō Kyōden 'Fukushū kidan Asaka no numa' to 'Jakotsu Jizō engi' Kohada Koheiji denshō no engen wo saguru." *Nihon shūkyō bunkashi kenkyū*, no. 25 (2021): 51–68.

Takada Mamoru. *Oiwa to Iemon: "Yotsuya kaidan" no shinsō*. Tokyo: Yōsensha, 2002.

Takeuchi, Melinda. "Kuniyoshi's 'Minamoto Raikō' and 'the Earth Spider': Demons and Protest in Late Tokugawa Japan." *Ars Orientalis* 17 (1987): 5–38.

Thompson, Sarah E. *Utagawa Kuniyoshi: The Sixty-nine Stations of the Kisokaidō*. San Francisco: Pomegranate, 2009.

Thornhill, Arthur H. "Yūgen after Zeami." In *Nō and Kyōgen in the Contemporary World*, 36–64. Honolulu: University of Hawai'i Press, 1997.

Tyler, Royall, trans. *Japanese Nō Dramas*. London and New York: Penguin Books, 2004.

Ulak, James T., Ann Yonemura, Alessandro Bianchi, and Julie Nelson Davis, eds. *The World of the Japanese Illustrated Book*. Washington, DC: National Museum of Asian Art, Smithsonian Institution, n.d. https://pulverer.si.edu/node/732/title.

Wilson, William Scott. *The Flowering Spirit: Classic Teachings on the Art of Nō*. Tokyo: Kodansha International, 2006.

Yokoyama Yasuko. *Edo kabuki no kaidan to bakemono*. Tokyo: Kodansha, 2008.

———. *Yotsuya kaidan wa omoshiroi*. Tokyo: Heibonsha, 1997.

Yonemura, Ann. *Masterful Illusions: Japanese Prints from the Anne van Biema Collection*. Washington, DC; Seattle: Arthur M. Sackler Gallery, Smithsonian Institution; University of Washington Press, 2002.

Endnotes

Pictorializing the Paranormal in Kabuki Ghost Plays

1. The trajectory for the development of kabuki ghost plays has been analyzed in Satoko Shimazaki, *Edo Kabuki in Transition: From the Worlds of the Samurai to the Vengeful Female Ghost* (New York: Columbia University Press, 2016), to which the present essay is greatly indebted.

2. Nanboku's biography has recently received a comprehensive treatment in Furuido Hideo, *Tsuruya Nanboku* (Tokyo: Yoshikawa Kōbunkan, 2020). Authoring approximately 120 plays over the course of his career, Nanboku is also credited as the creator of the related genre of *kizewamono*, or "realistic domestic plays." Although the supernatural character of his ghost plays may seem definitively unrealistic to skeptical modern audiences—like the bombastic character of kabuki plays more generally—the description "realistic" applies to the dynamics of the characters portrayed and their low social status. For instance, Nanboku is also alleged to have incorporated episodes from his own life into his plays, such as an incident when his wife was forced to sell their mosquito netting to buy food for the family. This extreme act was incorporated into *Yotsuya kaidan* when Oiwa's villainous husband sells their mosquito netting as part of his plan to drive her away (Zoë Kincaid, *Kabuki: The Popular Stage of Japan* [New York: Arno Press, 1977], 247); the corresponding section of the play, where Iemon tears the mosquito net from Oiwa's hands with so much force that it rips out her fingernails, was censored during a 1909 production as it was deemed too cruel (Shimazaki, *Edo Kabuki in Transition*, 244).

3. The stage effects used in *Tenjiku Tokubei* were apparently so impressive that both Nanboku and Matsusuke were investigated by the authorities, as it was suspected they were practicing genuine magic learned from hidden Christians or from Dutch traders (*Kabuki Plays on Stage*, ed. James R. Brandon and Samuel L. Leiter, vol. 3, *Darkness and Desire, 1804–1864* [Honolulu: University of Hawai'i Press, 2002], 16), although this may have been a rumor started by Nanboku and Matsusuke themselves (*Kabuki Plays on Stage*, 3:35).

4. Yokoyama Yasuko, *Edo kabuki no kaidan to bakemono* (Tokyo: Kodansha, 2008), 122.

5. Hanagata is labeled with his pseudonym Rosuke.
 This same dynamic of Hanagata ghostwriting an illustrated light fiction novel ostensibly written by Kikugorō III was used for the *gōkan* (literally, "combined volume") editions of the *Yotsuya kaidan* story: *Headstart on the Tōkaidō Journey: Ghost Stories at Yotsuya (Tōkaidōchū kadode no sakigake Yotsuya kaidan)* and *The Flowers of Kikugorō's Farewell Performance: Ghost Stories at Yotsuya (Nagori no hana Yotsuya kaidan)*. Both were illustrated by the popular artist Keisai Eisen (1790–1848) and were published in 1826, capitalizing on the success of the play's debut the previous year.

6. This painting has most recently been discussed in Koto Sadamura, *Kyōsai: The Israel Goldman Collection* (London: Royal Academy of Arts, 2022), 64.

7. Some events were reported in official documents, such as the *Yotsuya machikata kakiage*. However, tracing the lineage of the development of Oiwa's story is complicated by the fact that this text was only published in 1827, two years after *Yotsuya kaidan*'s debut. Other contemporary authors reference a manuscript circulating in the Bunka era (1804–18), the *Yotsuya zōdan*, but its precise contents cannot be confirmed. For the various earlier texts and their relation to Nanboku's script, see Takada Mamoru, *Oiwa to Iemon: "Yotsuya kaidan" no shinsō* (Tokyo: Yōsensha, 2002), 32–57.
 Acts II–III of *Yotsuya kaidan* are translated into English in Haruo Shirane, ed., *Early Modern Japanese Literature: An Anthology, 1600–1900* (New York: Columbia University Press, 2004), 847–84, and Acts III–V in *Kabuki Plays on Stage*, 3:139–63. An annotated version of the complete text in Japanese is available in Gunji Masakatsu, "Tōkaidō Yotsuya Kaidan," in *Shinchō Nihon Koten Shūsei* 45 (Tokyo: Shinchōsha, 1981), 401–39.

8. Although Oiwa and Iemon's child remains a plot element, the birth scene is not shown. For the significance of Oiwa's motherhood in the context of the *ubume*, a Japanese folkloric creature of a woman who dies in childbirth, see Satoko Shimazaki, "The End of the 'World': Tsuruya Nanboku IV's Female Ghosts and Late-Tokugawa Kabuki," *Monumenta Nipponica* 66, no. 2 (2011): 209–46.

9. Shirane, *Early Modern Japanese Literature*, 843.

10. Samuel L. Leiter, *"Keren*: Spectacle and Trickery in *Kabuki* Acting," in *Frozen Moments: Writings on* Kabuki, *1966–2001* (Ithaca, NY: Cornell University East Asia Series, 2002), 89. For an overview of this text, see Leiter, "'What Really Happens Backstage': A Nineteenth-Century Kabuki Document," in *Frozen Moments*, 92–109.

11. For a character change to be considered a true *hayagawari*, the actor must change roles within the same scene and not merely within the same play.

12. For an overview of *shikake-e*, see Shigeru Oikawa, "A Brief Note on *Shikake-e* Woodblock Prints," *Andon*, no. 110 (2020): 19–35.

13. Yokoyama Yasuko, *Yotsuya kaidan wa omoshiroi* (Tokyo: Heibonsha, 1997), 238.

14. For insights into the metabolism of Japanese ghost stories in the twentieth and twenty-first centuries as well as their roots in older narratives, see Michael Crandol, *Ghost in the Well: The Hidden History of Horror Films in Japan* (London: Bloomsbury Academic, 2021) and Lindsay Nelson, *Circulating Fear: Japanese Horror, Fractured Realities, and New Media* (Lanham, MD: Lexington Books, 2021).

15. One goal of the kabuki reform movements at the end of the nineteenth century was to reduce the perceived overreliance on *keren*. However, modern theater design is also less capable of incorporating complicated stage mechanics, as metal and concrete are less forgiving than earth and wood structural components, not to mention the restrictions now imposed by industry safety standards. Reform away from traditional ukiyo-e aesthetics in woodblock prints came later in the twentieth century with the *shin-hanga* ("revival print") and *sōsaku hanga* ("creative print") movements.

Kabuki entries

1. The book was reprinted twice during the Edo period, in 1839 and in 1842, and as reproduction editions in the Meiji era.

2. For an account of Sanba's theater-related publications in the broader context of the representation of performance in Edo-period fiction, see Barbara Jane Cross, "Shikitei Sanba (1776-1822) and Woodblock Print" (PhD dissertation, School of Oriental and African Studies, University of London, 2006).

3. See commentary by Kaguraoka Yōko in James T. Ulak, Ann Yonemura, Alessandro Bianchi, and Julie Nelson Davis, eds., *The World of the Japanese Illustrated Book* (Washington, DC: National Museum of Asian Art, Smithsonian Institution, n.d.). https://pulverer.si.edu/node/732/title.

4. This impression was previously published in Ann Yonemura, *Masterful Illusions: Japanese Prints from the Anne van Biema Collection* (Washington, DC; Seattle: Arthur M. Sackler Gallery, Smithsonian Institution; University of Washington Press, 2002), 124–25, cat. 36.

5. This impression was previously in the collection of Okada Isajirō and was published in Kuroda Genji, *Kamigata-e ichiran* (Kyoto: Satō Shōtarō Shōten, 1929), cat.79.

6. The same compositional strategy of an umbrella turned inside out by the sudden wind of a ghost's arrival is also used by Toyohara Kunichika (1835–1900) in cat. 12.

7. Another impression of the right-hand sheet is in The Pearl and Seymour Moskowitz Collection (S2021.5.520).

8. This impression is reproduced in Yonemura, *Masterful Illusions*, 172–73, cat. 60.

9. Another print in The Pearl and Seymour Moskowitz Collection shows Kikugorō III in the role of Oiwa in 1848, just a year before his death, when the actor was temporarily based in Osaka and was using the name Ōgawa Hashizō (S2021.5.467).

10. Despite being an amateur artist whose primary profession was as a merchant in the paper industry, Shunkōsai Hokushū was one of the most prolific figures in the Osaka print community in the nineteenth century (for background on Hokushū, see, for example, Dean J. Schwaab, *Osaka Prints* [London: Murray, 1989], 22–24). Since this print does not have a publisher's mark, it is likely it was a private commission and was

not available for public sale. Different impressions also feature different seals, suggesting other circumstances for their production.

11. The three states are proposed by art historian Roger Keyes in Roger Keyes and Keiko Mizushima, *The Theatrical World of Osaka Prints: A Collection of Eighteenth And Nineteenth Century Japanese Woodblock Prints In The Philadelphia Museum Of Art* (Philadelphia: Philadelphia Museum of Art, 1973), 108. For an example of the third state, with a lighter background and an inscription in black ink, see an impression in the collection of the Museum of Fine Arts, Boston, 21.5393.

12. 今より六とせまへに父松緑が工夫せし亡魂のわざおきも御評判をとりしと又此春古めかしくも人々のすゝめいなみかたく.

13. つもらずに消るめでたし春の雪. Poem translated by Satoko Shimazaki, "The Ghost of Oiwa in Actor Prints: Confronting Disfigurement," *Impressions* 29 (2007–2008): 77.

14. In total, the names of thirty-one different contributors appear on the seventy-two prints in the series—sixty-nine post stations, two additional locations, and the title sheet (Sarah E. Thompson, *Utagawa Kuniyoshi: The Sixty-nine Stations of the Kisokaidō* [San Francisco: Pomegranate, 2009], 6). Thompson's volume provides background to the series and an explanation of each of the designs. From the same series, no. 65, *Takamiya*, also shows a scene from the *Yotsuya kaidan*, where Iemon is about to fish out from the river the raindoor bearing Oiwa's and Kohei's corpses.

15. Several *shikake-e* prints of the *Yotsuya kaidan*'s raindoor flip date to this production in 1861. The wooden stakes in the background announce phrases like "big hit" and "great success," anticipating the positive reception of this production.

16. Jizō is associated with children, as he presides over a type of Buddhist purgatory in which the souls of young children are trapped in a dry riverbed.

17. Oiwa refers to poem 77 by the retired emperor Sutoku: "Because the current is swift/even though the rapids/blocked by a boulder/ are divided, like them, in the end/we will surely meet, I know" (Henk Herwig and Joshua S. Mostow, *The Hundred Poets Compared : A Print Series by Kuniyoshi, Hiroshige, and Kunisada* [Leiden: Hotei, 2007], 188).

18. The actor Ichikawa Sainyū I (1843–1916) used the name Udanji (as recorded on this print) from the 8th month of 1862 until December 1908, giving this design the earliest publishing date of 1862. However, Ichikawa Enzō I (1835–1855) died in 1855 at the age of twenty, making it seemingly impossible for a performance including both actors to have occurred. Perhaps this was a type of memorial image for Enzō, or one that allowed Sainyū the chance to "perform" with a beloved relative in a way he had been unable to in life.

19. Three acts from a related play, *The Martyr of Sakura* (*Sakura giminden*), that deal with the same subject are translated into English in Samuel L. Leiter and James R. Brandon, *Kabuki Plays on Stage*, vol. 3, *Darkness and Desire, 1804–1864* (Honolulu: University of Hawai'i Press, 2002), 220–47.

20. Timothy Clark, *Kuniyoshi: From the Arthur R. Miller Collection* (London: Royal Academy of the Arts, 2009), 239, cat. 112.

21. For a note on the different theories regarding the meaning of the *shita-uri* seal, see Andreas Marks, *Publishers of Japanese Woodblock Prints: A Compendium* (Leiden: Hotei Publishing, 2011), 479.

22. In his childhood, Kintoki was known as Kintarō (Golden Boy) and is a popular figure in folklore, often seen wrestling giant animals and fish or with his mother, the Yamauba.

23. The *tsuchigumo* could then appear in plays to represent an oblique power struggle with the authorities (C. Andrew Gerstle, "Heroic Honor: Chikamatsu and The Samurai Ideal," *Harvard Journal of Asiatic Studies* 57, no. 2 [1997]: 349).

24. For an in-depth analysis of this print, see Melinda Takeuchi, "Kuniyoshi's 'Minamoto Raikō' and 'the Earth Spider': Demons and Protest in Late Tokugawa Japan," *Ars Orientalis* 17 (1987): 5–38.

25. The origins and fictionalization of Koheiji by Kyōden are analyzed in Suzuki Kenkō, "Santō Kyōden 'Fukushū kidan Asaka no numa' to 'Jakotsu Jizō engi' Kohada Koheiji denshō no engen wo saguru," *Nihon shūkyō bunkashi kenkyū*, no. 25 (2021): 51–68.

26. In real life, Danjūrō was stabbed to death by fellow actor Ikushima Hanroku (d. 1704), who was immediately taken into custody and died by either execution or suicide approximately a month and a half after the incident.

27. A later edition, in which Bakin's text is illustrated by Tsukioka Yoshitoshi (1839–1892), is in the Pulverer Collection (FSC-GR-780.678.1–2).

28. Tadasuke continued to be popular in the late twentieth century, as a prime-time television historical fiction series based on his life, *Ōoka Echizen*, ran for 402 episodes from 1970 to 1999 on the Japanese channel TBS.

29. This is poem no. 169 from the ninth-century poetry anthology the *Kokinshū*: 秋来ぬと　目にはさやかに　見へねとも　風の音にそ　おとろかれぬる. Translation by Laurel Rasplica Rodd and Mary Catherine Henkenius, trans., *Kokinshū: A Collection of Poems Ancient and Modern* (Princeton: Princeton University Press, 1984), 97.

The Noh Theater Through the Eyes of Tsukioka Kōgyo

1. Royall Tyler, trans., *Japanese Nō Dramas* (London and New York: Penguin Books, 2004), 1.

2. For an overview of the medieval evolution of noh, see William Scott Wilson, *The Flowering Spirit: Classic Teachings on the Art of Nō* (Tokyo: Kodansha International, 2006), 13–57.

3. J. Thomas Rimer and Yamazaki Masakazu, trans., *On the Art of the Nō Drama: The Major Treatises of Zeami* (Princeton, NJ: Princeton University Press, 1984).

4. James R. Brandon, "Introduction," in *Nō and Kyōgen in the Contemporary World* (Honolulu: University of Hawai'i Press, 1997), 10.

5. Robert Schaap, "A 'Silent Beauty' in Ukiyo-e: Printed Imagery of the Nō Theater," in *The Beauty of Silence: Japanese Nō and Nature Prints by Tsukioka Kōgyo 1869–1927* (Leiden; Boston: Hotei Publishing, 2010), 18–31.

6. See Miyamoto Keizō, *Kamigata nōgakushi no kenkyū* (Osaka: Izumi Shoin, 2005), 18–99. For a specific example of the urban commoner and artist Ogata Kōrin (1658–1716) studying noh chanting and dancing, see Frank Feltens, *Ogata Kōrin: Art in Early Modern Japan* (New Haven; London: Yale University Press, 2021), 21–25, 59–63.

7. See, for example, J. Thomas Rimer, "Tsukioka Kōgyo and His Times," in *The Beauty of Silence: Japanese Nō and Nature Prints by Tsukioka Kōgyo 1869–1927* (Leiden; Boston: Hotei Publishing, 2010), 9–17; and Tina Dermois, "Depicting No Theatre: A Brief History of Meiji No and Tsukioka Kōgyo's No Aesthetics," *Andon* 108 (October 2019): 21–32.

8. Nagao Kazuo, "A Return to the Essence through Misconception: From Zeami to Hisao," in *Nō and Kyōgen in the Contemporary World* (Honolulu: University of Hawai'i Press, 1997), 117.

9. Sakamaki Kōgyo, "Nō to nōga," *Bijutsu no Nihon* 6, no. 1 (1914): 4–5. Translated by Richard J. Smethurst, accessed January 24, 2023, https://exhibit.library.pitt.edu/kogyo/kogyowords.html.

10. Rimer and Yamazaki, *On the Art of the Nō Drama*, xxi. The text, written by Zeami in the late fourteenth or early fifteenth century, explained some of the core aesthetic principles and the criteria for achieving excellence in noh performance.

11. See Arthur H. Thornhill, "Yūgen after Zeami," in *Nō and Kyōgen in the Contemporary World* (Honolulu: University of Hawai'i Press, 1997), 36–64.

12. Brandon, "Introduction," 9.

13. James W. Heisig, *Philosophers of Nothingness: An Essay on the Kyoto School* (Honolulu: University of Hawai'i Press, 2001).

14. Tanizaki Jun'ichirō, *In Praise of Shadows*, trans. Thomas J. Harper and Edward Seidensticker (Sedgwick, ME: Leete's Island Books, 1977).

Image credits

Pictorializing the Paranormal in Kabuki Ghost Plays

Fig. 1. Utagawa Toyokuni I (1769–1825), *Onoe Matsusuke I as the Ghost of Iohata and Matsumoto Kojirō as Mokuemon*. Japan, Edo period, 1804, 7th month. Woodblock print; ink and color on paper; 38.5 × 26 cm. The Anne van Biema Collection, Arthur M. Sackler Gallery, National Museum of Asian Art, Smithsonian Institution, S2004.3.107

Fig. 2. Author: Onoe Kikugorō III (1784–1849), Illustrator: Utagawa Kunisada (1786–1865), *Ghost Stories of Onoe Shōroku (Onoe Shōroku hyakumonogatari)*, vol. 1. Japan, Edo period, 1826. Woodblock printed book; ink on paper; 17.7 × 12.3 × 0.4 cm. Senshū University Library Collection

Fig. 3. Kawanabe Kyōsai (1831–1889), *Ghost*. Japan, Meiji era, ca. 1868–70. Hanging scroll; ink, light color, and gold on silk; 105.6 × 32 cm. Israel Goldman Collection, London. Photo: Art Research Center, Ritsumeikan University

Fig. 4. Author: Santei Shunba (d. 1852), Illustrators: Utagawa Kunisada II (1823–1880), Utagawa Yoshitsuya II (1822–1866), Utagawa Kunitsuna (1805–1868), "Ghost coming out of a lantern (Chōchin no deru yūrei)" from *What Really Happens Backstage (Okyōgen gakuya no honsetsu)*, vol. 2. Japan, Edo period, 1859. Woodblock printed book; ink on paper; 18 × 11.8 × 0.9 cm. Collection of Waseda University Theater Museum

Fig. 5. Unknown photographer, *Onoe Baikō VI as the Ghost of Oiwa in the Hermitage at Snake Mountain* in the play *Katamigusa Yotsuya kaidan.* Japan, Meiji era, October 1909. Silver bromide photograph; 13.8 × 8.7 cm. National Theater Collection, BM003749

Fig. 6. Utagawa Sadahiro (act. ca. 1830–53), *Onoe Kikugorō III as the ghost of Usugumo*. Japan, Edo period, 1835. Woodblock print; ink and color on paper; 36.2 × 25.6 cm. The Pearl and Seymour Moskowitz Collection, Arthur M. Sackler Gallery, National Museum of Asian Art, Smithsonian Institution, S2021.5.603

Fig. 7. Hasegawa Sadanobu III (1881–1963), *Oiwa* in the play *Tōkaidō Yotsuya kaidan* from the series *Collection of One Hundred Makeups from Kabuki (Kabuki kumadori hyakumenshū)*, vol. 2. Printed Japan, Taisho era, November 15, 1925. Woodblock print; ink on paper; 19.8 × 17.9 cm. Darrel C. Karl Collection

Fig. 8. Katsukawa Shunshō (1726–1793), *The actors Ichikawa Danjūrō V as a skeleton, spirit of the renegade monk Seigen (left), and Iwai Hanshiro IV as Princess Sakura (right)*. Japan, Edo period, 1783. Woodblock print; ink and color on paper; 32.9 × 15 cm (right); 32.9 × 15.2 cm (left). Clarence Buckingham Collection, Institute of Art Chicago, 1938.491

Fig. 9. Author: Santei Shunba (d. 1852), Illustrators: Utagawa Kunisada II (1823–1880), Utagawa Yoshitsuya II (1822–1866), Utagawa Kunitsuna (1805–1868), "Oiwa's Hair-combing Trick (Oiwa kamisugi no shikake)" from *What Really Happens Backstage (Okyōgen gakuya no honsetsu)*, vol. 2. Japan, Edo period, 1859. Woodblock printed book; ink on paper; 18 × 11.8 × 0.9 cm. Collection of Waseda University Theater Museum

Fig. 10. Author: Santei Shunba (d. 1852), Illustrators: Utagawa Kunisada II (1823–1880), Utagawa Yoshitsuya II (1822–1866), Utagawa Kunitsuna (1805–1868), Raindoor flip stage effect from *What Really Happens Backstage (Okyōgen gakuya no honsetsu)*, vol. 2. Japan, Edo period, 1859. Woodblock printed book; ink on paper; 18 × 11.8 × 0.9 cm. Collection of Waseda University Theater Museum

Fig. 11. Prop of raindoor (*toita*) used in productions of *Yotsuya kaidan*. Japan, Showa era, ca. 1947–68. Door: wood, straw rope; skeleton: papier-mâché with bamboo "bones"; 179 × 85 cm. Fujinami Prop Company. Image credit: National Museum of Japanese History

Fig. 12. Utagawa Kunisada (1786–1865), Kataoka Nizaemon VIII as Tamiya Iemon with Bandō Hikosaburō V as the Ghost of Oiwa (*Oiwa no bōrei*), 1861, 7th month. Woodblock print; ink and color on paper; 37.5 × 27.5 cm. The Pearl and Seymour Moskowitz Collection, Arthur M. Sackler Gallery, National Museum of Asian Art, Smithsonian Institution, S2021.5.504a–c

Fig. 13. Utagawa Kunisada (1786–1865), Kataoka Nizaemon VIII as Tamiya Iemon with Bandō Hikosaburō V as the Ghost of Kobotoke

Kohei (*Kobotoke Kohei bōrei*), 1861, 7th month. Woodblock print; ink and color on paper; 37.5 × 27.5 cm. The Pearl and Seymour Moskowitz Collection, Arthur M. Sackler Gallery, National Museum of Asian Art, Smithsonian Institution, S2021.5.504a–c

Fig. 14. Unknown artist, *Kabuki Playbill (Tsuji banzuke) for Plays at the Nakamura Theater: Mukashi Mukashi Oiwa no Kaidan, Kiku mo Ureshi Kinuya no Mutsugoto*. Japan, Edo period, 1844, 7th month. Woodblock print; ink on paper; 29.4 × 41 cm. William Sturgis Bigelow Collection, Museum of Fine Arts, Boston, 11.27706

The Noh Theater Through the Eyes of Tsukioka Kōgyo

Fig. 1. Tsukioka Kōgyo (1869–1927), *Akogi*, from the series *Nōgaku zue*. Japan, Meiji era, March 1, 1899. Woodblock print; ink and color on paper; 22.9 × 33.2 cm. Robert O. Muller Collection, Arthur M. Sackler Gallery, National Museum of Asian Art, Smithsonian Institution, S2003.8.2898

Fig. 2. Artist: Tsukioka Kōgyo (1869–1927), Publisher: Matsuki Heikichi, *Dōjōji, maejite*, from the series *Nōgaku hyakuban*. Japan, Taishō era, 1925. Woodblock print; ink and color on paper; 37.8 × 25.6 cm. Robert O. Muller Collection, Arthur M. Sackler Gallery, National Museum of Asian Art, Smithsonian Institution, S2003.8.2850

Fig. 3. Suzuki Harunobu (1724–1770), *Parody of the Noh play Hakurakuten*. Japan, Edo period, 1769–70. Woodblock print; ink and color on paper; 28.4 × 21.3 cm. Gift of Alan, Donald, and David Winslow from the estate of William R. Castle, Freer Gallery of Art Study Collection, National Museum of Asian Art, Smithsonian Institution, FSC-GR-24

Fig. 4. Kawanabe Kyōsai (1831–1889), *Drawing of the noh play Takasago*, from an album. Japan, Meiji era, ca. 1880s. Ink on paper; 26.7 × 38.8 cm. Purchase—Charles Lang Freer Endowment, Freer Gallery of Art, National Museum of Asian Art, Smithsonian Institution, F1975.29.14

Fig. 5. Katsushika Hokusai (1760–1849), *Fisherman*. Japan, Edo period, 1849. Ukiyo-e print; ink and color on silk; 113 × 39.6 cm. Gift of Charles Lang Freer, Freer Gallery of Art, National Museum of Asian Art, Smithsonian Institution, F1904.181

Fig. 6. Hishikawa Sōri (act. ca. 1797–1813), *Fisherman*. Japan, Edo period, 1770–1820. Color on paper; 86.3 × 28.1 cm. Gift of Charles Lang Freer, Freer Gallery of Art, National Museum of Asian Art, Smithsonian Institution, F1900.58

Fig. 7. Tsukioka Kōgyo (1869–1927), *Sesshōseki*, from the series *Nōgaku hyakuban*. Japan, Taishō era, ca. 1922–25. Woodblock print; ink and color on paper; 37.8 × 25.7 cm. Gift of the Embassy of Japan, Washington, D.C., Freer Gallery of Art Study Collection, National Museum of Asian Art, Smithsonian Institution, FSC-GR-402

Fig. 8. Artist: Tsukioka Kōgyo (1869–1927), Publisher: Matsuki Heikichi, *Shakkyō*, from the series *Nōgaku hyakuban*. Japan, Taishō era, 1922–27. Woodblock print; ink and color on paper; 37.9 × 51.4 cm. Robert O. Muller Collection, Arthur M. Sackler Gallery, National Museum of Asian Art, Smithsonian Institution, S2003.8.2884

Fig. 9. Artist: Tsukioka Kōgyo (1869–1927), Publisher: Matsuki Heikichi, *Kamo*, from the series *Nōgaku zue*. Japan, Meiji era, 1897–1901, Smithsonian Libraries

Fig. 10. Tsukioka Kōgyo (1869–1927), *Asagao*, from the series *Nōgaku zue*. Japan, Meiji era, May 1, 1902. Woodblock print; ink and color on paper; 22.7 × 32.9 cm. Robert O. Muller Collection, Arthur M. Sackler Gallery, National Museum of Asian Art, Smithsonian Institution, S2003.8.2907

Fig. 11. Tsukioka Kōgyo (1869–1927), *Atsumori*, from the series *Nōgaku zue*. Japan, Meiji era, 1897. Woodblock print; ink and color on paper; 22.8 × 33.6 cm. Robert O. Muller Collection, Arthur M. Sackler Gallery, National Museum of Asian Art, Smithsonian Institution, S2003.8.2953

Fig. 12. Tsukioka Kōgyo (1869–1927), *Tadanori*, from the series *Nōgaku zue*. Japan, Meiji era, July 15, 1898. Woodblock print; ink and color on paper; 22.7 × 33.2 cm. Robert O. Muller Collection, Arthur M. Sackler Gallery, National Museum of Asian Art, Smithsonian Institution, S2003.8.2888

Fig. 13. Tsukioka Kōgyo (1869–1927), *Ukai*, from the series *Nōgaku hyakuban*. Japan, Taishō era, ca. 1922–27. Woodblock print; ink and color on paper; 37.8 × 25.7 cm. Gift of the Embassy of Japan, Washington, D.C., Freer Gallery of Art Study Collection, National Museum of Asian Art, Smithsonian Institution, FSC-GR-352

Fig. 14. Tsukioka Kōgyo (1869–1927), *Sakuragawa*, from the series *Nōgaku hyakuban*. Japan, Taishō era, ca. 1922–25. Woodblock print; ink and color on paper; 37.8 × 25.7 cm. Gift of the Embassy of Japan, Washington, D.C., Freer Gallery of Art Study Collection, National Museum of Asian Art, Smithsonian Institution, FSC-GR-402

Fig. 15. Tsukioka Kōgyo (1869–1927), *Sanemori*, from the series *Nōgaku hyakuban*. Japan, Taishō era, ca. 1922–25. Woodblock print; ink and color on paper; 37.8 × 25.7 cm. Gift of the Embassy of Japan, Washington, D.C., Freer Gallery of Art Study Collection, National Museum of Asian Art, Smithsonian Institution, FSC-GR-414

Fig. 16. Tsukioka Kōgyo (1869–1927), *Atago Kūya*, from the series *Nōgaku hyakuban*. Japan, Taishō era, ca. 1922–25. Woodblock print; ink and color on paper; 37.8 × 25.7 cm. Gift of the Embassy of Japan, Washington, D.C., Freer Gallery of Art Study Collection, National Museum of Asian Art, Smithsonian Institution, FSC-GR-334

Fig. 17. Tsukioka Kōgyo (1869–1927), *Hashi Benkei*, from the series *Nōgaku hyakuban*, Japan, ca. 1922–25. Woodblock print; ink and color on paper; 37.9 × 25.6 cm. Gift of William E. Harkins, Arthur M. Sackler Gallery, National Museum of Asian Art, Smithsonian Institution, S1998.295

Fig. 18. Tsukioka Kōgyo (1869–1927), *Matsukaze*, from the series *Nōgaku hyakuban*. Japan, Taishō era, ca. 1922–25. Woodblock print; ink and color on paper; 37.8 × 25.7 cm. Gift of the Embassy of Japan, Washington, D.C., Freer Gallery of Art Study Collection, National Museum of Asian Art, Smithsonian Institution, FSC-GR-425

Fig. 19. Tsukioka Kōgyo (1869–1927), *Sesshōseki*, from the series *Nōgaku hyakuban*. Japan, Taishō era, ca. 1922–25. Woodblock print; ink and color on paper; 37.8 × 25.7 cm. Gift of the Embassy of Japan, Washington, D.C., Freer Gallery of Art Study Collection, National Museum of Asian Art, Smithsonian Institution, FSC-GR-359

Fig. 20. Tsukioka Kōgyo (1869–1927), *Dōjōji, nochijite*, from the series *Nōgaku hyakuban*. Japan, Taishō era, ca. 1922–27. Woodblock print; ink and color on paper; 37.8 × 25.7 cm. Gift of the Embassy of Japan, Washington, D.C., Freer Gallery of Art Study Collection, National Museum of Asian Art, Smithsonian Institution, FSC-GR-346

Fig. 21. Tsukioka Kōgyo (1869–1927), preparatory drawing of *Kokaji*, from the series *Nōgaku hyakuban*. Japan, Taishō era, ca. 1922–27. Preparatory drawing; ink and color on paper; 32.1 × 27.2 cm. Darrel C. Karl Collection

Fig. 22. Artist: Tsukioka Kōgyo (1869–1927), Publisher: Matsuki Heikichi, *Kokaji*, from the series *Nōgaku hyakuban*. Japan, Taishō era, 1922–27. Woodblock print; ink and color on paper; 37.6 × 51.4 cm. Robert O. Muller Collection, Arthur M. Sackler Gallery, National Museum of Asian Art, Smithsonian Institution, S2003.8.2879

Fig. 23. Tsukioka Kōgyo (1869–1927), preparatory drawing of *Tōru*, from the series *Nōgaku hyakuban*. Japan, Taishō era, ca. 1922–25. Preparatory drawing; ink and color on paper; 29.4 × 22.6 cm. Darrel C. Karl Collection

Fig. 24. Tsukioka Kōgyo (1869–1927), *Tōru*, from the series *Nōgaku hyakuban*. Japan, Taishō era, ca. 1922–25. Woodblock print; ink and color on paper; 37.8 × 25.4 cm. Robert O. Muller Collection, Arthur M. Sackler Gallery, National Museum of Asian Art, Smithsonian Institution, S2003.8.2851

Fig. 25. Artist: Natori Shunsen (1886–1960), Publisher: Watanabe Shōzaburō (1885–1962), *Nakamura Kichiemon in the Role of Takechi Mitsuhide*. Japan, Taishō era, 1925. Woodblock print; ink and color on paper; 40.3 × 27.7 cm. Robert O. Muller Collection, Arthur M. Sackler Gallery, National Museum of Asian Art, Smithsonian Institution, S2003.8.1547

The Process of Making a Woodblock Print

Fig. 1. Mallet. Japan, 1950–56. Wood; 25 × 7 × 5 cm. Robert O. Muller Collection, Arthur M. Sackler Gallery, National Museum of Asian Art, Smithsonian Institution, S2003.8.3833.59

Fig. 2. Chisel (*maru-nomi*). Japan, 1950–56. Metal and wood; 20.7 × 1.5 × 2.2 cm. Robert O. Muller Collection, Arthur M. Sackler Gallery,

National Museum of Asian Art, Smithsonian Institution, S2003.8.3833.4

Fig. 3. Bench for carving printing blocks. Japan, 1950–56. Wood; 11 × 64.2 × 32 cm. Robert O. Muller Collection, Arthur M. Sackler Gallery, National Museum of Asian Art, Smithsonian Institution, S2003.8.3833.35

Fig. 4. Group of eight brushes (*hakobi*). Japan, 1950–56. Bamboo; 16 × 1.2 cm. Robert O. Muller Collection, Arthur M. Sackler Gallery, National Museum of Asian Art, Smithsonian Institution, S2003.8.3833.58.1–8

Fig. 7. *Baren*. Japan, 1950–56. Bamboo skin and interior unidentified disk; 1.2 × 14 cm. Robert O. Muller Collection, Arthur M. Sackler Gallery, National Museum of Asian Art, Smithsonian Institution, S2003.8.3833.61

Figs. 5, 6, 8–12. Stills from Keiji Shinohara. "The Ukiyo-e Technique: Traditional Japanese Printmaking." Video, 17 minutes. https://pulverer.si.edu/node/190. National Museum of Asian Art, Smithsonian Institution

Detail images

Pages 2-3: Utagawa Kuniyoshi (1798–1861), Publisher: Wakau (act. ca. 1842–1850), *Scene from a Ghost Story: The Okazaki Cat Demon (Mukashi banashi no tawamure nekomata wo hete koji ni kai wo nasu zu)*. Japan, Edo period, 1847, 7th month. Woodblock print; ink and color on paper; 35.5 × 25.5 cm (each sheet, approx.). The Pearl and Seymour Moskowitz Collection, Arthur M. Sackler Gallery, National Museum of Asian Art, Smithsonian Institution, S2021.5.562a–c

Pages 4-5: Tsukioka Kōgyo (1869–1927), *Tsuchigumo*, from the series *Nōgaku zue*. Japan, 1904. Woodblock print; ink and color on paper; 22.7 × 33.5 cm. Robert O. Muller Collection, Arthur M. Sackler Gallery, National Museum of Asian Art, Smithsonian Institution, S2003.8.2908

Page 11: Toyohara Kunichika (1835–1900), *The Typhoon at Daimotsu Bay in Settsu Province in 1188 (Bunji yonen Sesshū Daimotsu no ura nanpū no zu)*. Japan, 1860, 4th month. Woodblock print; ink and color on paper. The Pearl and Seymour Moskowitz Collection, Arthur M. Sackler Gallery, National Museum of Asian Art, Smithsonian Institution, S2021.5.356a–c

Tsukioka Yoshitoshi (1839–1892), Publisher: Tsunajima Kamekichi (act. ca. 1868–1900), *A Ghost Jizō Startles a Near-sighted Old Man at Asajigahara*, from the series *Crazy Pictures of Famous Places in Tōkyō (Tōkyō kaika kyōga meishō)*. Japan, 1881. Woodblock print; ink and color on paper. The Pearl and Seymour Moskowitz Collection, Arthur M. Sackler Gallery, National Museum of Asian Art, Smithsonian Institution, S2021.5.363

Page 12: Utagawa Hiroshige (1797–1858), Publisher: Ibaya Kyubei, *Futakawa: Yaji and Kitahachi from Hizakurige,* from the series *Fifty-three Pairings for the Tōkaidō (Tōkaidō gojūsan tsui)*. Japan, ca. 1845–46. Woodblock print; ink and color on paper. The Pearl and Seymour Moskowitz Collection, Arthur M. Sackler Gallery, National Museum of Asian Art, Smithsonian Institution, S2021.5.474

Pages 146-147: Utagawa Toyokuni IV (1823–1880), Publisher: Iseya Kanekichi (act. ca. 1837–1875), Nakamura Shikan IV as Sakata Kintoki and Onoe Baikō (Kakunosuke) as Usui Sadamitsu (R); Sawamura Tanosuke III as Usugumo, Actually the Spirit of a Spider (*Jitsu wa kumo no sei*) (C); Nakamura Chūtarō as Urabe no Suetake and Ichikawa Kuzō III as Watanabe no Tsuna (L). Japan, Edo period, 1864, 10th month. Woodblock print; ink and color on paper; 35.8 × 24.7 cm (right); 35.9 × 24.7 cm (center); 35.9 × 24.7 cm (left). The Pearl and Seymour Moskowitz Collection, Arthur M. Sackler Gallery, National Museum of Asian Art, Smithsonian Institution, S2021.5.610a–c

Page 167: Utagawa Kunisada (1786–1865), Publisher: Moritaya Hanzō (act. ca. 1825–1835), Seki Sanjūrō II as Kamiya Niemon and Onoe Kikugorō III from Kamigata (*Kudari*) as the Lantern Ghost, Applauded throughout the Three Cities (*Sanganotsu gohyōban no chōchin no yūrei*). Japan, Edo period, 1831, 2nd month. Woodblock print; ink and color on paper; 36.8 × 25.3 cm (right); 36.8 × 25.6 cm (left). The Pearl and Seymour Moskowitz Collection, Arthur M. Sackler Gallery, National Museum of Asian Art, Smithsonian Institution, S2021.5.505a–b

Page 168: Artist: Tsukioka Kōgyo (1869–1927), Publisher: Matsuki Heikichi, *Kamo*, from the series *Nōgaku zue*. Japan, Meiji era, 1897–1901, Smithsonian Libraries

Glossary

Terms

chōchin nuke	提灯抜け	"lantern escape" technique used in *Yotsuya kaidan*
chūban	中判	standardized print size of roughly 19.5 × 26.5 cm
Daikokuya	大黒屋	Publishing house, act. ca. 1820s–1910s
dengaku	田楽	"field entertainment"
gaikotsu	骸骨	skeleton
Genpei kassen	源平合戦	Genpei War (1180–85)
gōkan	合巻	"combined volume"
hayagawari	早変わり	quick costume change by same character within a scene in kabuki
hengemono	変化物	dance transformation genre of kabuki
hyakki yagyō	百鬼夜行	"night parade of one hundred demons"
iroaku	色悪	evil but attractive main character in kabuki
janen	邪念	spurned monks
jōgo	漏斗	funnel-shaped robe worn by ghosts in kabuki
kabuki	歌舞伎	theatrical form; stylized dance-drama
kaibyō	怪猫	monster cat
kaiki	怪奇	strange tales genre
kamisuki	髪梳	hair-combing scene in *Yotsuya kaidan*
keren	外連	stage tricks used in kabuki
kizewamono	生世話物	realistic domestic plays in kabuki
komusōgasa	虚無僧笠	woven hat that obscures the entire head
kosode	小袖	short-sleeved garment
kowairo	聲色	voice mimicry
kowairozukai	声色遣	voice imitator
kumadori	隈取	stage makeup worn by kabuki actors
kurogo	黒子	kabuki stagehands
mitate	見立	double entendre
murasaki-bōshi	紫帽子	purple cloth cap worn by *onnagata* in kabuki
nō	能	noh
ōban	大判	standardized print size of roughly 39.4 × 26.5 cm
Obon chōchin	お盆提灯	paper lanterns used in the Obon festival
onmyō	陰陽	yin and yang
onnagata	女形	female role specialists in kabuki
rōnin	浪人	masterless samurai
sarugaku	猿楽	"monkey entertainment"
shikake-e	仕掛け絵	"trick picture"
shimai	仕舞	dancing
shimoto	しもと	a type of firewood associated with Mount Kazuraki

shin-hanga	新版画	"revival print"
shinka	神火	spirit flame
shirabyōshi	白拍子	female dancers and singers
shita-uri	シタ賣	woodblock prints sold discreetly
shōchūbi	焼酎火	cotton soaked in alcohol to form a spirit flame used as a stage prop
sōsaku hanga	創作版画	"creative print"
sosei	蘇生	reanimated people
suō	蘇芳	sappanwood
toitagaeshi	戸板返し	"raindoor flip" technique used in *Yotsuya kaidan*
tsuchigumo	土蜘蛛	the earth spider
ubume	産女	ghost of a mother who died during childbirth
utai	謡い	chanting
yakusha nigao-e	役者似顔絵	actor likeness pictures
yamai hachimaki	病鉢巻	thin headband worn in kabuki to signify illness
yūgen	幽玄	interiority
yūrei	幽霊	ghost

Plays

Akogi	阿漕	*Akogi*
Aoi no ue	葵上	*Lady Aoi*
Asagao	朝顔	*Asagao*
Atsumori	敦盛	*Atsumori*
Chūshingura	忠臣蔵	*A Treasury of Loyal Retainers*
Dōjōji	道成寺	*Dōjōji*
Fukushū kidan Asaka no numa	復讐奇談安積沼	*The Bizarre Tale of Revenge at Asaka Marsh*
Hagoromo	羽衣	*Feathered Cloak*
Hakurakuten	白楽天	*Bo Juyi*
Hanjo	班女	*Hanjo*
Higashiyama sakura no sōshi	東山桜荘子	*A Storybook of Cherry Blossoms in the Eastern Hills of Kyoto*
Hitori tabi gojūsan tsugi	一人旅五十三次	*A Solo Journey Along the Fifty-three Stations*
Irohagana Yotsuya kaidan	いろは仮名四谷怪談	Osaka version of *Yotsuya kaidan*
Iroiri otogi zōshi	彩入御伽草	*A Colorful Storybook*
Kamo	加茂	*Kamo*
Kanawa	鉄輪	*The Iron Crown*
Kazuraki	葛城	*Kazuraki*
Keisei tsurigane zakura	けいせい釣鐘桜	*The Courtesan and the Bell on the Cherry Tree*
Kinsatsu	金札	*Kinsatsu*
Kokaji	小鍛冶	*The Blacksmith*
Kubekiyoi kumo no itosuji	来宵蜘蛛線	*The Spider's Web in the Early Evening*
Kurama tengu	蔵馬天狗	*Kurama tengu*
Matsukaze	松風	*Pining Wind*
Meiyo jinsei roku	名誉仁政録	*Record of Honorable and Benevolent Rulers*
Nani takashi temariuta jitsuroku	松高手毬諷実録	*True Record of the Famous Song for Handballs*

Nonomiya	野宮	*Nonomiya*
Nue	鵺	*Nue*
Onoe Kikugorō ichidai banashi	尾上梅寿一代噺	*The Lifetime of Onoe Kikugorō*
Rashōmon	羅生門	*Rashōmon*
Sarayashiki keshō no sugatami	皿屋敷化粧姿視	*The Mansion of Plates and the Cursed Makeup Mirror*
Sesshōseki	殺生石	*Killing Stone*
Shakkyō	石橋	*Stone Bridge*
Shunkan	俊寛	*Shunkan*
Takasago	高砂	*Takasago*
Tenjiku Tokubei ikoku banashi	天竺徳兵衛韓噺	*The Tale of Tenjiku Tokubei from India*
Tōkaidōchū Hizakurige	東海道中膝栗毛	*Shank's Mare*
Tōkaidō Yotsuya kaidan	東海道四谷怪談	*Ghost Story of Yotsuya on the Tōkaidō*
Tōru	融	*Tōru*
Tsuchigumo	土蜘蛛	*Earth Spider*
Ukai	鵜飼	*Cormorant Fisher*
Ume yanagi sakigake zōshi	梅柳魁双紙	*The Earliest Story of the Plum and Willow*
Yamanba	山姥	*Yamanba*
Yoshitsune senbon zakura	義経千本桜	*Yoshitsune and the Thousand Cherry Trees*

Books

Aoto Fujitsuna moryō-an	青砥藤綱模稜案	*The Story of Aoto Fujitsuna*
Ehon tsūhō shi	絵本通宝志	*Illustrated Wish for Riches*
Genji monogatari	源氏物語	*The Tale of Genji*
Heike monogatari	平家物語	*The Tale of the Heike*
Hyakunin isshu	百人一首	*One Hundred Poets, One Poem Each*
In'ei raisan	陰翳礼讃	*In Praise of Shadows*
Kadensho	花伝書	*Teachings on Style and the Flower*
Kakusha hyōbanki	客者評判記	*Critique of the Audience*
Kojiki	古事記	*Records of Ancient Matters*
Kyōganoko musume Dōjōji	京鹿子娘道成寺	*The Maiden of Dōjōji, Tie-dyed in the Capital*
Nagori no hana Yotsuya kaidan	名残花四ツ家怪譚	*The Flowers of Kikugorō's Farewell Performance: Ghost Stories at Yotsuya*
Nōgaku hyakuban	能楽百番	*One Hundred Noh Plays*
Nōgaku zue	能楽図絵	*Pictures of Noh*
Nōga taikan	能画大鑑	*Great Book of Noh Pictures*
Okyōgen gakuya no honsetsu	御狂言楽屋本説	*What Really Happens Backstage*
Onoe Shōroku hyakumonogatari	尾上松緑百物語	*Ghost Stories of Onoe Shōroku*
Sakura giminden	佐倉義民伝	*The Martyr of Sakura*
Senzaishū	千載集	*Collection of a Thousand Ages*
Shibai kinmō zui	劇場訓蒙図彙	*Illustrated Encyclopedia of the Theater*
Tōkaidōchū kadode no sakigake Yotsuya kaidan	東街道中門出之魁四ツ家怪談	*Yotsuya kaidan* story, *Headstart on the Tōkaidō Journey: Ghost Stories at Yotsuya*
Ukan sandai zue	羽勘三台図会	*Illustrated Guide to the Three Edo Kabuki Theaters*
Ukiyo buro	浮世風呂	*The Ukiyo Bath*

Yakusha gakuya tsū	俳優楽室通	Guide to the Actors' Dressing-rooms
Yakusha sangaikyō	俳優三階興	Amusements of Actors on the Third Floor
Yotsuya machikata kakiage	四谷町方書上	Records of the Townsman Area of Yotsuya
Yotsuya zōdan	四谷雑談	Various Tales from Yotsuya

Historical People

Abe no Seimei 安倍晴明 (921–1005)
Ariwara no Yukihira 在原行平 (818–893)
Bandō Hikosaburō V 坂東彦三郎 (1832–1877)
Bandō Mitsugorō III 坂東三津五郎 (1775–1831)
Bo Juyi 白居易 (772–846)
En no Gyōja 役小角 (634–706)
Fujiwara no Toshiyuki 藤原敏行 (d. 901 or 907)
Hanagasa Bunkyō 花笠文京 (1785–1860) (aka Rosuke 魯助)
Hasegawa Kanbei XI 長谷川勘兵衛 (1781–1841)
Hishikawa Sōri 菱川宗理 (act. ca. 1797–1813)
Hotta Masanobu 堀田正信 (1631–1680)
Ichikawa Danjūrō VII 市川 團十郎 (1791–1859)
Ichikawa Danjūrō IX 市川團十郎 (1838–1903)
Ichikawa Enzō I 市川猿蔵 (1835–1855)
Ichikawa Kodanji IV 市川小団次 (1812–1866)
Ichikawa Omezō I 市川男女蔵 (1781–1833)
Ichikawa Sainyū I 市川斎入 (1843–1916) (Ichikawa Udanji 市川右團次)
Ikushima Hanroku 生島半六 (d. 1704)
Iwai Hanshirō V 岩井半四郎 (1776–1847)
Jakushō 寂照 (ca. 962–1034)
Kamo no Yasunori 賀茂保憲 (917–977)
Kanmu 桓武天皇 (737–806)
Kanze Nobumitsu 観世信光 (1435/1450–1516)
Katsukawa Shun'ei 勝川春英 (1762–1819)
Katsukawa Shunshō 勝川春章 (1726–1793)
Kawanabe Kyōsai 河鍋暁斎 (1831–1889)
Keisai Eisen 渓斎英泉 (1790–1848)
Kumagai Jirō 熊谷次郎 (1141–1208)
Kyokutei Bakin 曲亭馬琴 (1767–1848)
Matsuki Heikichi 松木平吉 (mid-19th c.–early 20th c.)
Minamoto no Yorimasa 源頼政 (1106–1180)
Minamoto no Yorimitsu 源頼光 (948–1021)
Minamoto no Yoritomo 源頼朝 (1147–1199)
Minamoto no Yoshitsune 源義経 (1159–1189)
Musashibō Benkei 武蔵坊弁慶 (1155–1189)
Nakamura Tomijūrō II 中村富十郎 (1786–1855)
Nakamura Utaemon III 中村歌右衛門 (1778–1838)

Nakamura Utaemon IV 中村歌右衛門 (1798–1852)
Naoeya Jūbei 直江屋重兵衛 (1781–1831)
Nishida Kitarō 西田喜太郎 (1870–1945)
Okada Isajirō 岡田伊三次郎
Onoe Baikō VI 尾上梅幸 (1870–1934)
Onoe Kikugorō III 尾上菊五郎 (1784–1849) (aka Ōgawa Hashizō 大川橋蔵)
Onoe Kikugorō V 尾上菊五郎 (1844–1903)
Onoe Matsusuke I 尾上松助 (1744–1815) (aka Shōroku 松緑)
Ōoka Tadasuke 大岡忠相 (1677–1752)
Santō Kyōden 山東京伝 (1761–1816)
Sawamura Tanosuke III 沢村田之助 (1845–1878)
Segawa Jōko III 瀬川如皐 (1806–1881)
Shikitei Sanba 式亭三馬 (1776–1822)
Shūgansai Shigehiro 秀丸斎重広 (act. ca. 1860s–1878)
Shunkan 俊寛 (1143–1179)
Shunkōsai Hokushū 春好齋北洲 (act. ca. 1802–1832)
Suzuki Harunobu 鈴木春信 (1724–1770)
Taira no Atsumori 平敦盛 (1169–1184)
Taira no Tomomori 平知盛 (1152–1185)
Tanizaki Jun'ichirō 谷崎潤一郎 (1886–1965)
Tokugawa Ieyoshi 徳川家慶 (1793–1853)
Toyohara Kunichika 豊原国周 (1835–1900)
Tsukioka Kōgyo 月岡耕漁 (1869–1927)
Tsukioka Yoshitoshi 月岡芳年 (1839–1892)
Tsuruya Nanboku IV 鶴屋南北 (1755–1829)
Umewaka Minoru 梅若実 (1828–1909)
Utagawa Kunisada 歌川国貞 (1786–1865)
Utagawa Kuniyoshi 歌川国芳 (1798–1861)
Utagawa Toyokuni I 歌川豊国 (1769–1825)
Watanabe no Tsuna 渡辺綱 (953–1025)
Yosa Buson 与謝蕪村 (1716–1784)
Yūten Shōnin 祐天上人 (1636–1718)
Zeami 世阿弥 (ca. 1363–ca. 1443)

Places

Ashiya	芦屋	Mount Kazuraki	葛城山
Dōjōji	道成寺	Mount Ōmine	大峰山
Ichinotani	一ノ谷	Myōkōji	妙行寺
Kiyomizudera	清水寺	Sanjūsangendō	三十三間堂
Mount Agero	上路山	Shiogama	塩釜

Roles

Adachi Takurō (aka Adachi Sakurō)	安達多九郎 (安達左九郎)	Oryū	お柳
Akiyama Chōbei	秋山長兵衛	Osode	お袖
Amatsu-futodama-no-mikoto	天太玉命	Otsuka	お塚
Aoi	葵上	Oume	お梅
Aoyama Tessan	青山鉄山	Rokujō	六条御息所
Asakura Tōgo	浅倉当吾	Sakata no Kintoki	坂田金時
(aka Kozakura Tōgo or Sakura Sōgo)		Sakurahime	桜姫
Enya Hangan	塩冶判官	Satō Yomoshichi	佐藤与茂七
Gonsuke	権助	Seigen	清玄
Hanago	花子	Shiragikumaru	白菊丸
Heitarō	平太郎	shite	シテ
Hitorimusha	一人武者	Takuetsu	宅悦
Iga Shikibunojō Mitsumune	伊賀式部之丞光宗	Tamamo	玉藻
Inabanosuke	因幡之助	Tamiya Iemon	民谷伊右衛門
Iohata	五百機	Teranishi Kanshin	寺西閑心
Itō Kihei	伊藤喜兵衛	tsure	ツレ
Kamada Matahachi	鎌田又八	Ushiwakamaru	牛若丸
Kasane	累	Wakeikazuchi	別雷
Kikuno	菊野	Yamanba or Yamauba	山姥
Kintarō	金太郎		
Kiyohime	清姫		
Kohada Koheiji	小幡小平次		
Kohei	小平		
Kō no Moronao	高師直		
Kyōdai	経題		
maejite	前ジテ		
Magosaku	孫作		
Mari no Kanemitsu	毬埒兼満		
Matsukaze	松風		
Murasame	村雨		
Naosuke Gonbei	直助権兵衛		
nochijite	後ジテ		
Oiwa	お岩		
Okiku	お菊		
Orikoshi Masatomo	織越政和		

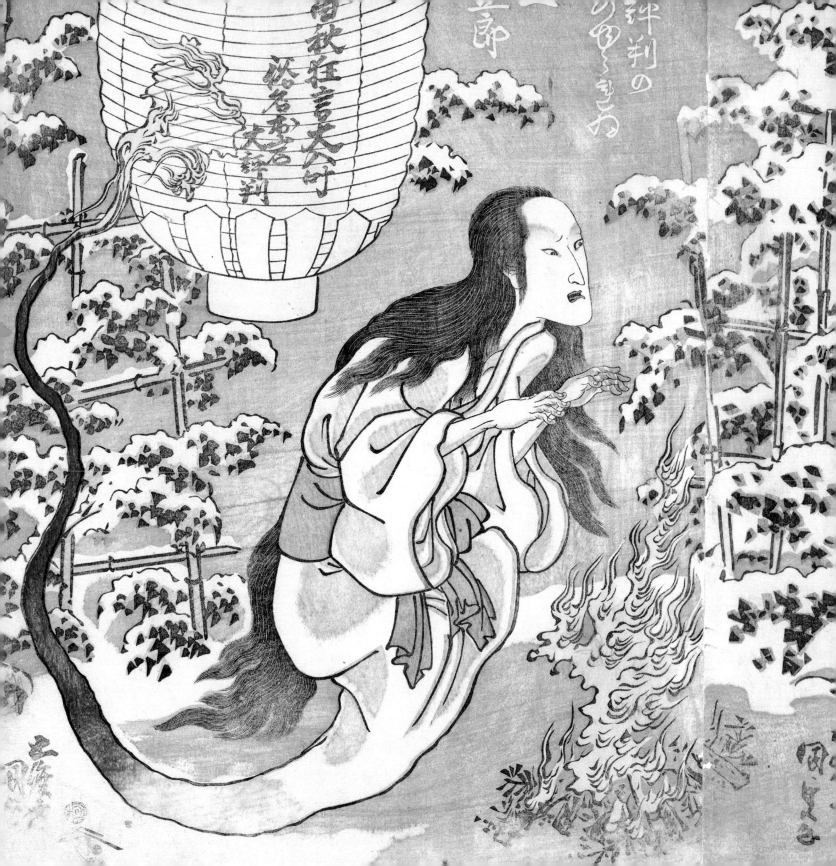

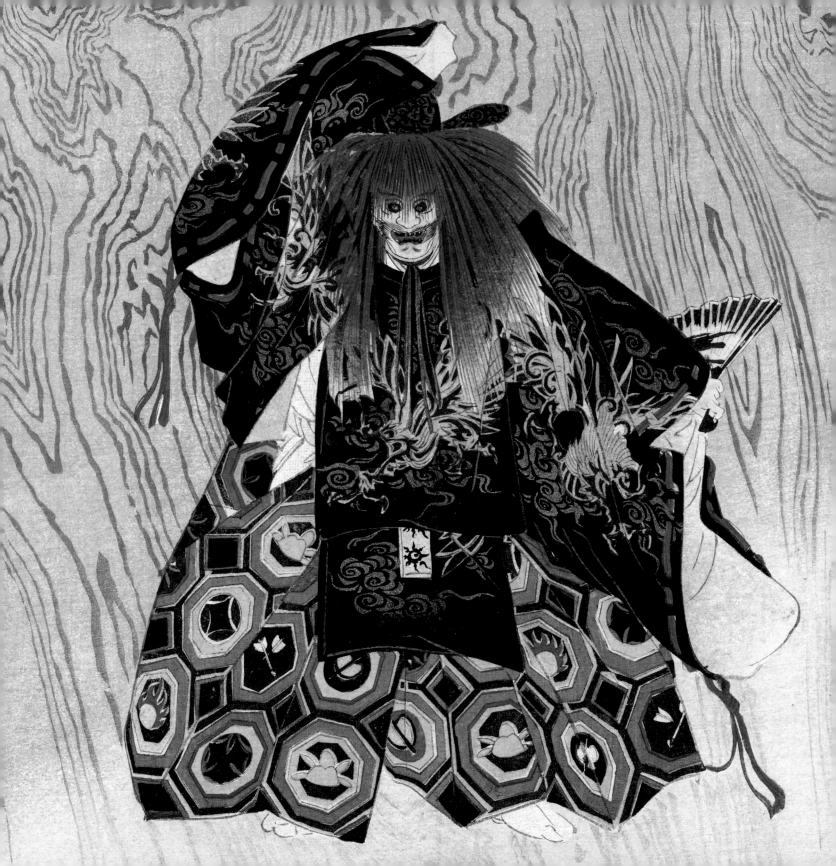